CULTURAL CONNECTIONS

Charles Willson Peale
The Artist in His Museum (detail)
1822

Politics and culture often overlapped when Philadelphia was the political center of the new American nation. Charles Willson Peale (1741–1827) enjoyed Thomas Jefferson's patronage when he opened his museum of natural history in the mid-1780s. Soon outgrowing his Lombard Street house, Peale moved his museum first into the American Philosophical Society building and then into the larger State House (Independence Hall), to whose second-floor galleries he invites visitors in this self-portrait. Peale's collection was a hodgepodge of scientific curiosities, stuffed animals and birds, patriotic symbols, and his own paintings of heroes of the American Revolution. His museum promised knowledge—the chance to see the real thing, to approach what might otherwise be beyond one's experience. By reaching out to educate the general public, cultural institutions like Peale's museum helped create the informed citizenry on which the Republic depended.

PAFA

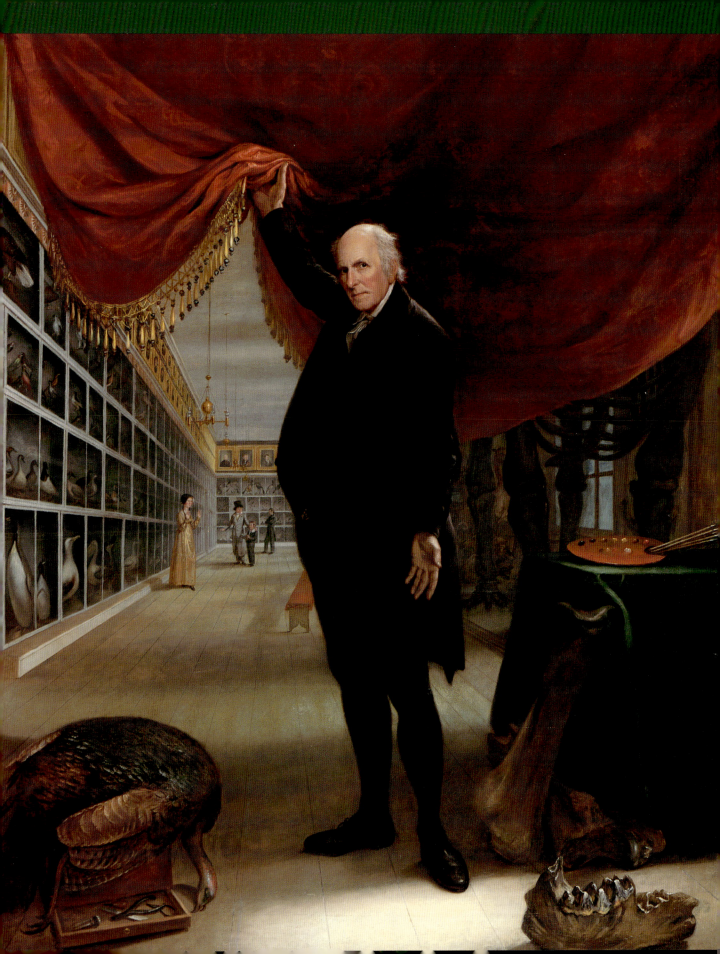

*Publication of this book, the first
in a series celebrating the cultural resources
of Philadelphia and the Delaware
Valley, has been supported by a grant from
The William Penn Foundation.*

MORRIS J. VOGEL

Cultural Connections

Museums and Libraries
of Philadelphia
and the Delaware Valley

DESIGN BY KATZ WHEELER

Temple University Press
Philadelphia

To Ruth, who lent me her Janson

Temple University Press
Philadelphia 19122

© 1991 by The William Penn Foundation
All rights reserved

Published 1991

Manufactured in Japan

Library of Congress Cataloging-in-Publication
Data

Vogel, Morris J. (1945–)
Cultural connections : museums and libraries of
Philadelphia and the Delaware Valley/Morris J.
Vogel.
 p. cm.
Includes index.
ISBN 0–87722–840–X (cloth).
1. United States—Civilization. 2. Museums—
Pennsylvania—Philadelphia. 3. Museums—
Delaware River Valley (N.Y.–Del. and N.J.).
4. Library resources—Pennsylvania—Phila-
delphia. 5. Library resources—Delaware River
Valley (N.Y.–Del. and N.J.). I. Title.
E169.1.v88 1991
069'.0974—dc20 90–21874

CONTENTS

The Essays

Introduction
American Nationality
Victoriana
Discovery and Exploration
The World We Have Lost

The Institutions

Profiles

FOREWORD

This is the first of a series of guidebooks being developed to enhance awareness and enjoyment of the Greater Philadelphia area for residents and visitors alike. The series was inspired, in part, by *Philadelphia Architecture,* published in 1984 by the Foundation for Architecture. The publication of that book suggested to the William Penn Foundation the possibilities inherent in a series of works highlighting some of the city's many cultural resources. The Foundation has always had an interest in improving the quality of life for citizens of the region. These guides will help us appreciate the quality and diversity of what is already here.

The first book is about museums, and this is appropriate. One could argue that Philadelphia itself is a living museum of 300 years of American life, politics, and culture, with its 80-odd collecting institutions analogous to the objects on display. Each of them, however, is infinitely richer, more complicated, and wondrous to behold than any single museum object. They show what we as a people think is important, but they are also a reflection of who we think we are.

The Philadelphia area has a collection of museums, historic sites, and cultural resources that is unsurpassed in this nation. Because these resources are distributed across a wide geographic area, however, it is not always easy to sense their collective mass and gravity. This first book is one effort to bring together in a single place, if only conceptually, the Delaware Valley's rich array of "cultural capital."

Each of the books in this series will spread before the reader a panorama of the region's assets. These wide-ranging and instructive descriptions of places, objects, and institutions will help the reader visit and enjoy them.

The Foundation wishes to thank David Bartlett, Director of the Temple University Press, for accepting the responsibility for overseeing the publication of this series. We are particularly grateful to Professor Morris Vogel, a distinguished historian and a fine writer, for agreeing to bring his considerable talents to the authorship of this first book.

BERNARD C. WATSON, PH.D.
PRESIDENT AND CHIEF EXECUTIVE OFFICER
THE WILLIAM PENN FOUNDATION

The William Penn Foundation commissioned this book to expand the audience for this region's collecting institutions. It is by now a truism that too few Philadelphians—and still fewer visitors—are aware of how great a treasure our local cultural institutions represent. Our museums, libraries, gardens, and historic structures do not touch the lives of many of our citizens; even many regular museum-goers rarely venture beyond the best-known sites. The Foundation sought to remedy that situation by underwriting a comprehensive guidebook to acquaint Philadelphians with the cultural wealth that is part of their birthright.

I interpreted the Foundation's mandate broadly. I rejected the book-length, institution-by-institution listing of a traditional guidebook. Doing full justice to the rich diversity and extensive holdings of all the members of the Museum Council of Philadelphia and the Delaware Valley would require an encyclopedic volume that might discourage much of our intended audience—thus defeating our purpose. I thought I could best respect the spirit of the Foundation's intentions by exploring not just the holdings of our museums and libraries but the reasons our society has come to treasure certain works of art and artifice, and particular books, manuscripts, and natural specimens. This approach dovetailed with my interest as a historian in studying how institutions evolve, what roles they play in the broader society, and how various groups—patrons and professionals, volunteers and visitors—interact within their walls.

I have selected chapter topics—American Nationality, Victoriana, Discovery and Exploration, and The World We Have Lost—that allowed me to draw on and display the strengths of area collections. I might just as easily have settled on different chapter themes and a different organizing scheme. But the chapters follow a deeper logic as well; they present my argument about the nature of the cultural enterprise, particularly as it concerns collecting institutions in the United States. The first chapter traces the origins of Philadelphia's cultural and scientific institutions to the formative years of the American republic. It argues that our cultural and political institutions responded to similar needs and influenced each other in like ways. The second chapter focuses on the rise of fortunes—national and personal, large and small—in the mid- and late 19th century, and the growth of a culture that reflected, celebrated, and even promoted economic expansion. "Discovery and Exploration" is concerned with the notion of progress, the uses to which it has been put, and the central place it occupies in the institutions of our formal culture. "The World We Have Lost" recognizes that much of the dynamism in our collecting institutions—and their continuing relevance to contemporary life—stems from the regular reinterpretation of the past on which this chapter focuses.

You can follow the thematic approach in the main body of this book in organizing museum and library visits. Or you can use this as you would a more traditional guidebook. Listings on pages 176–231 are arranged alphabetically by institution, suggesting the scope of museum and library holdings, and providing the telephone number of each. Remember that many area museums possess vast collections and generally display only a small fraction of their holdings at any given time. If you are in doubt about what you may find exhibited when you visit, call ahead. Call ahead as well to determine admission fees, hours of operation, and handicapped access. This volume points out that institutions change over time; with ever more two-wage-earner (and one-parent) families and with ever less public funding, museums and libraries can be expected to shift their hours and change their fees.

A final word on using this volume. Rather than regard it as an exhaustive and detailed catalogue of what can be seen on the walls during a museum visit, you might more usefully consider this a guide to the culture of which Philadelphia's museums, libraries, and gardens are a part. Use it to reflect on how Americans have thought about culture, broadly defined, in making sense of their experience as a people.

ABBREVIATIONS

*Abbreviations at the end of illustration
captions identify the institutions where
the illustrated objects can be found.*

AAM	Afro-American Historical and Cultural Museum
AKM	Atwater Kent Museum
ANS	Academy of Natural Sciences
APS	American Philosophical Society
ASM	American Swedish Historical Museum
ATH	Athenaeum of Philadelphia
BAL	Balch Institute for Ethnic Studies
BRM	Brandywine River Museum
BRN	Barnes Foundation
BRT	Bartram's Garden
CHS	Chester County Historical Society
CIGNA	CIGNA Museum
CMD	Camden County Historical Society
CPL	College of Physicians Library
DAM	Delaware Art Museum
DRX	Museum at Drexel University
FAM	Samuel S. Fleisher Art Memorial
FI	Franklin Institute Science Museum
FLP	Free Library of Philadelphia
HCL	Haverford College Library
HGL	Hagley Museum and Library
HSP	Historical Society of Pennsylvania
INHP	Independence National Historical Park
JMC	Jefferson Medical College of Thomas Jefferson University
LCP	Library Company of Philadelphia
MER	Mercer Museum
MOR	Morris Arboretum
MRV	Moravian Pottery and Tile Works
MTR	Mütter Museum
MUM	Mummers Museum
NMAJH	National Museum of American Jewish History
PAFA	Pennsylvania Academy of the Fine Arts
PAH	Pennsylvania Hospital
PMA	Philadelphia Museum of Art
POH	Port of History Museum
PTM	Please Touch Museum
ROS	Rosenbach Museum and Library
RYS	Ryerss Museum and Library
SC	Friends Historical Library of Swarthmore College
UM	University Museum of Archaeology and Anthropology
VFHS	Valley Forge Historical Society
WFI	Wagner Free Institute of Science
WMR	Woodmere Art Museum
WTR	Winterthur
ZOO	Zoological Gardens

CULTURAL CONNECTIONS

Introduction

Philadelphia is richly endowed with artifacts and images that record the story of civilization. This book is a guide to that cultural heritage. It is meant to help readers find their way to and around the collections of the eighty-some art and science museums, libraries, gardens, and historic sites that belong to the Museum Council of Philadelphia and the Delaware Valley. Within their walls and on their grounds are items familiar in our own time and place, and the creations of distant lands, peoples, and eras. Collectively, these institutions tell the story of human aspiration and achievement.

This guide differs from most such books in that it treats the area's museum collections as a whole. It draws connections between the holdings of one museum and those of others. It suggests, for example, how an examination of scientific discoveries may deepen appreciation for the paintings of the same period; together these may provide useful insights into such seemingly disparate materials as plants in an arboretum and documents in a historical society. The guide points as well to continuities that transcend social and historical barriers. It identifies common themes in diverse places: in one case, it links the rituals of late 19th-century American Indian reservations, the biblical story of Isaiah, the Mummers' Parade, and the revival of colonial architecture in the United States. Our premise is that the appreciation of culture is enhanced when artifacts and images are considered within broad contexts—the values, the experiences, the very lives of the individuals and the societies with which the works under scrutiny are associated. Viewed outside this human context, museums can be excessively formal, yielding secrets only to the initiated. A too narrow focus on one facet of human expression—art standing by itself, science viewed in the abstract, the work of one time or one place—is intellectually disabling, making it difficult for museum-goers to

use their own experiences to grasp what they view. This guide extends the web of connections among institutions to Philadelphia as a whole, integrating our museum holdings into the rich and diverse physical and social fabric of the city. In so doing, we are suggesting that one way to understand the culture represented in formal collections is to root it in the familiar. Our museums and their collections are, after all, products of our own time and place as well as of other times and places, other intellects and sensibilities. Our museums display art and artifacts from ancient Egypt, medieval Europe, imperial China, bronze age Africa—and colonial Philadelphia for that matter—because of the way our own time and place understands and values those earlier cultural expressions.

To look only for the familiar, however, is to overlook the fact that museums and libraries are not merely expressions of our own interests. But we should not, at the same time, too readily assume the opposite: that these institutions stand immutably outside history. Libraries and museums change even as the values they reflect change. They have social and cultural functions beyond the preservation and display of universally valued objects. Those functions may not be intuitively obvious to visitors accustomed to regarding museums as repositories of human achievement. When we walk through an institution that proclaims its permanence through its imposing architecture and the enduring worth of the centuries-spanning collections it preserves, it does not come naturally to us to ask why particular objects are on exhibit and what broader social roles the museum fills.

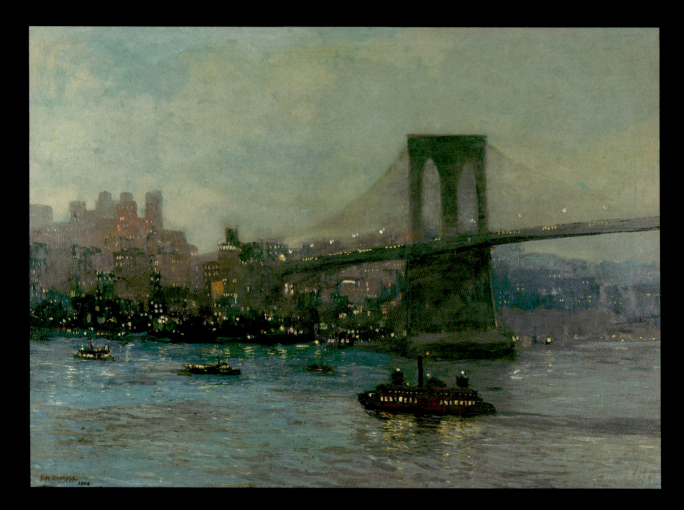

18

Edward Redfield
**Brooklyn Bridge
at Night**
1909
*Some contemporary busi-
nesses acquire and display
art—and underwrite high-
culture programming on
public television—as a
hallmark of good corporate
citizenship. The CIGNA art
collection traces its origins
to the fire engines and
marine art collected by*
*CIGNA's predecessor, the
Philadelphia-based Insur-
ance Company of North
America, an insurer of
marine and fire risks. CIGNA
today promotes its identity
as a local citizen by col-
lecting cityscapes of the
many cities in which it
has offices.* CIGNA

Museums and libraries are not just empty spaces filled with prized objects; these institutions may not always articulate or completely follow their agendas, but they have them nonetheless. The first cultural institutions in the American Republic self-consciously set out, for example, to promote an American identity. Peale's museum, the American Philosophical Society, the Pennsylvania Academy of the Fine Arts, and the Academy of Natural Sciences pursued democratic and nationalistic goals in expanding the public audience for art and knowledge. The formal culture of Revolutionary France did much the same, while in most of early 19th-century Europe, by contrast, art collections reflected and legitimated the power of a hereditary aristocracy. Differences divided members of the same nations as well. Even as democracy expanded in the early 19th-century United States, historical societies converted culture into an instrument of privilege serving the well-born. American robber barons and an aspiring middle class had followed suit by the end of the 19th century, identifying themselves with the higher arts to legitimate their social claims. American museums responded; some began to specialize in the rarefied connoisseurship of formal art, abandoning their historic role of provoking and satisfying the curiosity of the masses.

Museums and libraries sometimes discard (or de-accession, in the formal terms of museum craft) some of their holdings. Similarly, they sometimes cast off—or look beyond—earlier roles. The Pennsylvania Academy of the Fine Arts continues—as it has for almost two centuries—to train artists. But the Philadelphia Museum of Art and the Franklin Institute no longer fill some of the roles for which they were intended in the expanding industrial economy of the 19th century. The Museum of Art—which originated in the Pennsylvania Museum and School of Industrial Art—no longer trains draftsmen and designers; the Franklin Institute no longer educates machine builders or evaluates steam boilers and other technological innovations.

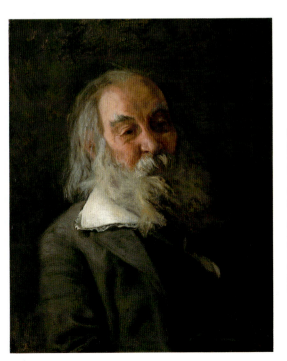

Thomas Eakins
Walt Whitman
1888
Thomas Eakins (1844–1916) taught painting at the Pennsylvania Academy of the Fine Arts until an 1886 controversy over his use of an art student as a nude model led to his resignation from the faculty. He painted his friend Whitman when the latter lived in Camden, New Jersey.
PAFA

Few cultural institutions escape their pasts altogether. But those that survive—and not all do—most commonly do so by accommodating to the challenges of their time. Mounting costs in recent years have, for example, forced many to look beyond their traditional source of financial support in upper-class benevolence. Some have sought to raise income by expanding membership rolls. Most have discovered new funding sources in foundation and government grants. These grants often come with strings attached; they generally ask cultural institutions to prove their value to the community by attracting more visitors. Not all museums have been equally successful in resolving the conflict between externally imposed requirements that they reach out to new audiences and their long-standing roles—art museums particularly—as focal points of privileged connoisseurship. The same kind of tension and the same mixed results have accompanied the transformation of curatorship from a field long entered essentially through privileged birth and apprenticeship into a professional career based on academic preparation. As individuals from a broader range of social backgrounds have gained acceptance in museum positions, they have, in some cases, shifted the programming of cultural institutions to subjects attractive to broader publics.

The professionalized museum staffs of today are less likely than their predecessors to limit their presentations of artifacts and images to questions of taste and connoisseurship. A virtual frenzy of reinterpretation has swept colonial and Victorian house museums; professional curators now present many of these sites to the public according to ever more exacting standards of historical accuracy. New interpretations often reject the myths and traditions long identified with the houses in favor of more critical readings of both the role the house played in the past and the furnishings that fill it in the present. Some of these sites now present issues of contemporary relevance in dealing with the past. Houses that once welcomed visitors as hallmarks of gracious living are, for example, as likely now to explain that earlier values and lifestyles—genteel though they were—severely constrained the opportunities available to women. In a parallel way, zoos—which used to show caged animals for their entertainment value—have joined with natural history museums to breed and protect endangered species.

20

Venturi and Rauch, architects
Benjamin Franklin House
1973–1976
Rather than reconstruct a building for which it could find no image, the National Park Service chose to honor Benjamin Franklin by erecting a stylized three-dimensional outline of his house. The stark white steel outline symbolized as well the decision to present Franklin as a man and not as a myth. Built for the Bicentennial celebration of 1976, the structure is part of Independence National Historical Park.
INHP

Pierre Gentieu
The Gaino Family
1890
This photograph of the Gaino family, posing in front of their home in Squirrel Run Village, graced the cover of The Workers' World at Hagley, the catalogue accompanying an exhibit of the same name that opened at the Eleutherian Mills–Hagley Foundation in 1981. The exhibit's focus on the ordinary men, women, and children who worked in the du Pont powder mills,

and lived in the industrial villages along the Brandywine River, marked an important departure for a museum that had from its inception been primarily concerned with the du Pont family—as entrepreneurs and as social figures—and with the technology they employed in their mills.
HGL

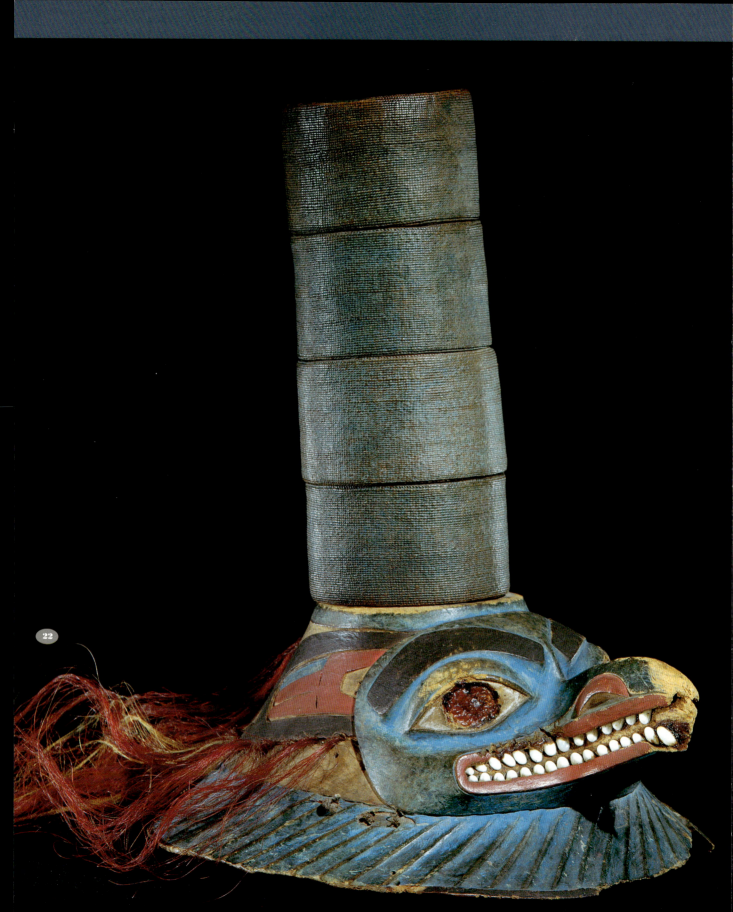

"Raven's Journey: The World of Alaska's Native People" opened in 1986, the 100th anniversary of the University Museum of Archaeology and Anthropology. Many of the materials featured in the exhibit had been in the museum's collections since the 1910s but had rarely been exhibited. *"Raven's Journey"* highlighted the process through which the University Museum developed this collection and called attention to the role of Louis Shotridge, a Tlingit Indian who served on the museum's staff from 1912 to 1932. Shotridge collected and documented treasured clan possessions —including this Ganook hat—and recorded Tlingit myths and legends even as contact with white societies was transforming his culture. Crest hats like this one were among the proudest Tlingit possessions. The hereditary right to display a crest was originally achieved through a supernatural event; its value stemmed from the social rank and history of its owners. UM

Changes in staffing and orientation have, by and large, been more pronounced in history and anthropology museums than in art museums. The former are also more likely to recognize that museums may sometimes be called on to sacrifice some of their holdings in order to respond sensitively to the needs of other peoples. There is a growing awareness, for example, that museums risk impoverishing the cultures whose art and artifacts they accession. History, anthropology, and archaeology museums have taken the lead on the question of cultural patrimony, realizing that some objects may be so significant to the peoples originally associated with them that our interest in keeping them as museum artifacts recedes in importance. They have, in effect, shifted more fully from connoisseurship to context, from understanding objects in terms of how they strike us to explaining what role the objects played in the times and places in which they were created and used. This latter kind of scholarship often depends on continued access to other lands and thus requires that anthropology and archaeology museums cultivate good relations with foreign nations. The University Museum of Archaeology and Anthropology continues to conduct a wide-ranging program of archaeological excavations abroad, but staff members also speak about "excavating the basement": studying more closely the materials that arrived in Philadelphia in years past and developing a more complete knowledge of the cultures in which those objects originated. Closely related to these concerns about contextualization is a growing willingness to abandon some of the assumptions that have long been at the core of our culture—that the way we do things is of necessity best and that our time is better than earlier times.

Narrowly restricted definitions of culture have shattered in recent years. The near monopoly that privilege long exercised in the museum world has given way as groups once disenfranchised from the cultural mainstream have established institutions of their own. The Mummers Museum, the Afro-American Historical and Cultural Museum, the National Museum of American Jewish History, and the Balch Institute for Ethnic Studies—all products of the 1970s—stand as landmarks of cultural democracy. Very similar is the movement to organize children's museums, in which Philadelphia's Please Touch Museum is a notable pioneer.

Many museums have expanded their educational programs—explaining exhibits to visitors whom they cannot automatically presume to be in the know—as they have pursued their outreach strategies in recent years. Education has once again firmly joined the traditional museum functions of collection, preservation, and display. The logic of outreach now extends even farther, to massive and spectacular crowd-pleasing events. Museums today more and more understand themselves to be competing for the public's recreational spending with sporting events, restaurants, and theme parks—Disney-like museums of the make-believe. We may not be entirely comfortable watching the most august institutions of our high culture move in this direction, but Charles Willson Peale—much of whose museum collection was acquired by P. T. Barnum—would likely have been pleased.

Super Sunday
1989
Philadelphia's Super Sunday began in 1970 as a festival sponsored by the museums located along the Parkway. Mixing public entertainment, food sales, and craft booths in a carnival-like atmosphere, the "citywide block party," as it was quickly dubbed, drew over one million people to the front stoops of some of the city's museums.

Mandell Futures Center, Franklin Institute Science Museum
1990
The Franklin Institute's new Futures Center and Tuttleman Omniverse Theater blur distinctions between science and entertainment, between serious cultural institutions and theme parks. Colorful graphics, spectacular movies, crowd-pleasing exhibits—and a candid acknowledgment that the Institute competes with spectator sports, recreational activities, and other mass amusements for the public's leisure time and its entertainment budget—are a far cry from the earnest didacticism of the Franklin Institute's early 19th-century origins. But it is easy to exaggerate the differences between past and present. The Institute's founders would likely recognize—and applaud—its present-day mission of promoting technological literacy.

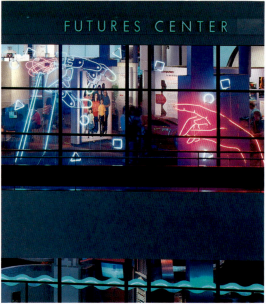

Both the elephant shape
of Leo Sewell's sculpture
and its texture—it is
composed of toys and com-
mon household objects
molded together—make
this Please Touch Museum
artifact attractive to chil-
dren. The museum's prem-
ise is that a cultural
institution can pay serious
attention to a child's view
of the world. PTM

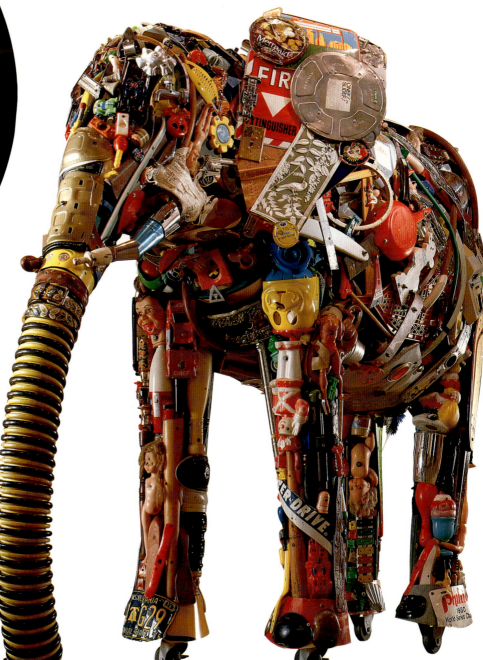

**Presidential Jazz
Weekend, 1991**
*The Afro-American His-
torical and Cultural Mu-
seum has offered a variety
of African and African-
American performing arts
programs since its opening
in 1976. It has presented
spirituals, gospel music,
jazz, and classical music
concerts; dance perfor-
mances; and teaching
workshops in the arts of
Africa. Jazz has been par-
ticularly popular; the mu-
seum is now collaborating
with West Philadelphia's
Mill Creek Community
Center to showcase com-
munity-based jazz artists,
returning jazz to its roots
in the experience of every-
day life. Here, a member
of the Carol Harris Quartet
performs at the Presiden-
tial Jazz Weekend, held at
the museum 15–17 Febru-
ary 1991.*

25

David Bustill Bowser
The Phoenix
c. 1855–1870

David Bustill Bowser (1820–1900) was one of 19th-century Philadelphia's more important commercial artists. He often used nationalistic images—this eagle-like phoenix is one example—in the signs and paraphernalia he painted for the city's volunteer fire companies. AKM

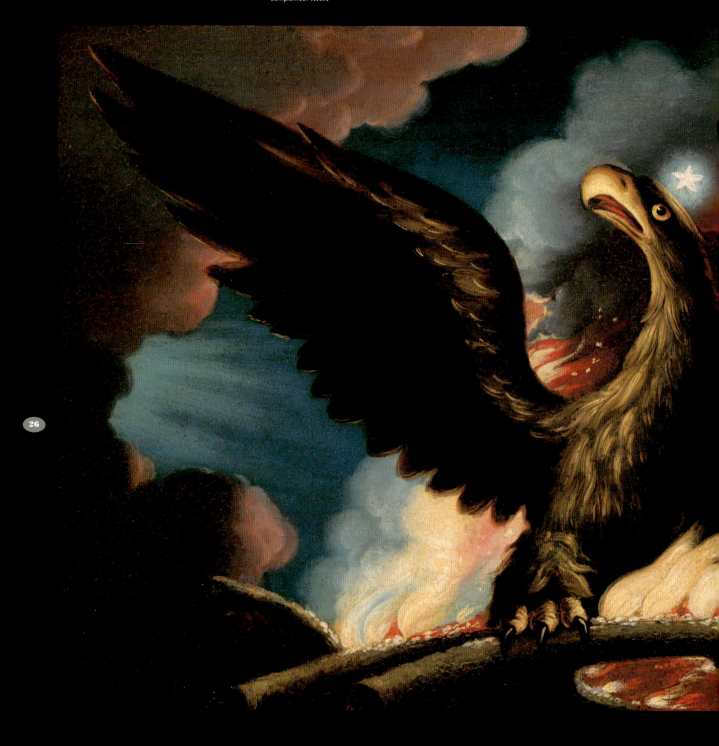

From its birth, the American Republic—more than any other nation—was nurtured and sustained by culture. Out of necessity more than out of aesthetic inclination, newly independent Americans turned to creating cultural artifacts that would express and promote their national identity. The founding generation embraced art not because it had inherited a rich cultural tradition, but rather because it had so little. Indeed, citizens of the new Republic shared few of the traditions and common bonds that would ordinarily define a people. Culture furnished and organized the ideological symbols that assumed extraordinary importance to the first generations of the Republic.

Americans lacked the shared attributes that united the citizens of other lands. Residents of 13 separate colonies, they practiced diverse religions, stemmed from different ethnic stocks, and identified themselves as Virginians, Pennsylvanians, and the like. Their concerns were highly local, issues of the frontier, of long-settled agricultural towns, of a plantation region, or of such urban centers as Boston, New York, and Philadelphia. They entered the Revolution defending their rights as Englishmen, but only the barest majority were English in origin. Indeed, their most salient bond was their brief history of common resistance and revolution against the British Crown. Americans ended their Revolutionary era with a new Constitution and a government that united them politically and within which they could develop as a people and determine their peoplehood.

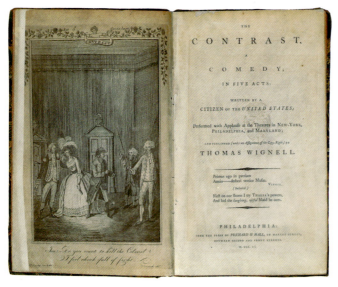

Royall Tyler
The Contrast
1790
Royall Tyler's The Contrast *is generally considered the first American play; its title suggests its basic premise: the contrast between American virtues and European vices. The play's "American" characters—most notably Colonel Manly—are selfless, sincere, plain-speaking, and unaffectedly straightforward; its "British" characters are foppishly overrefined, devious, and decadent. Tyler (1757–1826) echoed the American conviction that the old empire was corrupt and decayed, and that the future belonged to their own simple and rough-hewn society.* LCP

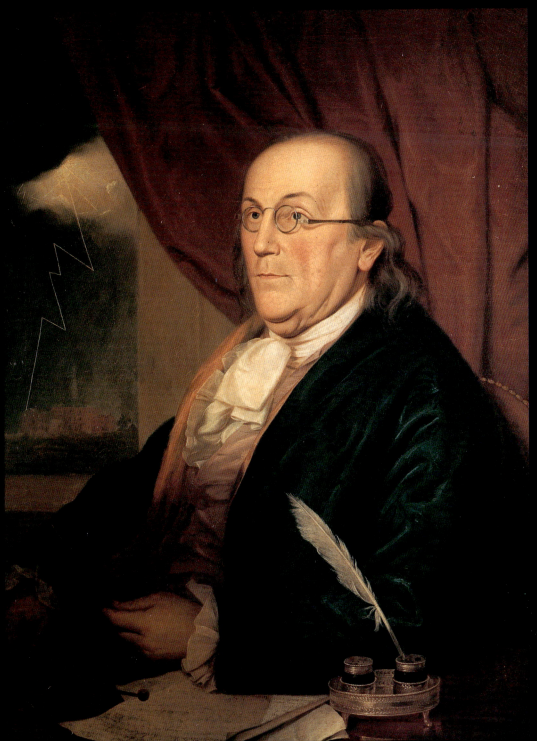

Charles Willson Peale
Benjamin Franklin
1789
In his autobiography, Benjamin Franklin consciously set out to portray himself as the first American, a model for his fellow citizens in creating a new people. His was the story of a young man breaking free from family and tradition, prototypically American in his willingness to tie his future to a new community. Resourceful and inventive, Franklin assumed ever more important roles in his adopted Philadelphia and ultimately in the new Republic. Serving his province and later his nation abroad in the Revolutionary era, he impressed Europeans with his vigor and intelligence, a worthy representative of a rising people. HSP

29

A modern world history of failed revolutions and new nations plagued by instability suggests that a frame of government and a set of ideas about sovereignty and rights —however brilliantly conceived and exalted in intent—would ordinarily be insufficient to secure a stable government, let alone create a national identity. The Constitution took its place as one element—though clearly an essential one—within the larger ideological framework to which Americans turned to establish their nationality. The Revolution and the Constitution established that we governed ourselves differently from other peoples. Political liberty and representative government prevailed in this new country more than in the Old World; so too did religious freedom, relative equality, and personal opportunity. It was to such differences—to contrasts with European nations—that Americans looked to stake their claims to a distinctive nationality.

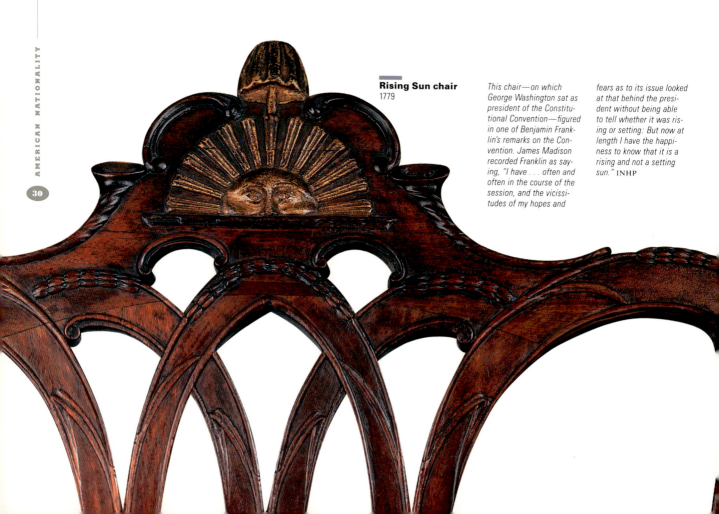

Rising Sun chair
1779

This chair—on which George Washington sat as president of the Constitutional Convention—figured in one of Benjamin Franklin's remarks on the Convention. James Madison recorded Franklin as saying, "I have . . . often and often in the course of the session, and the vicissitudes of my hopes and fears as to its issue looked at that behind the president without being able to tell whether it was rising or setting: But now at length I have the happiness to know that it is a rising and not a setting sun." INHP

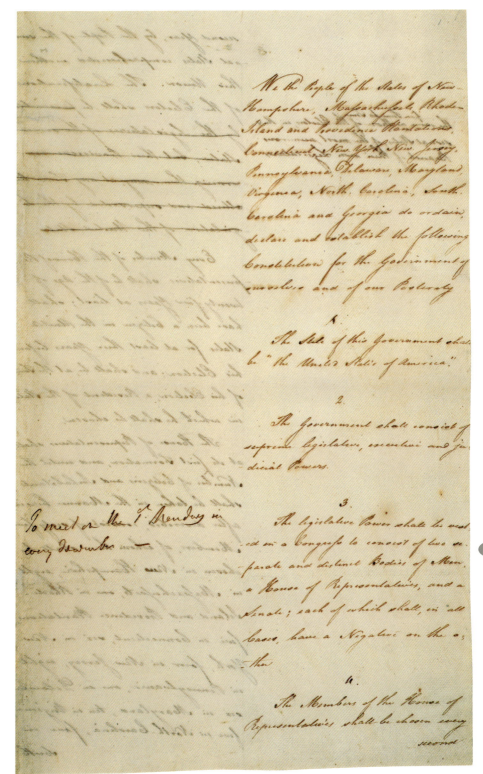

We the People of the States of New-
Hampshire, Massachusetts, Rhode-
Island and Providence Plantations,
Connecticut, New York, New Jersey,
Pennsylvania, Delaware, Maryland,
Virginia, North. Carolina, South.
Carolina and Georgia do ordain,
declare and establish the following
Constitution for the Government of
ourselves and of our Posterity

1.

The Stile of this Government shall
be "the United States of America."

2.

The Government shall consist of
supreme legislative, executive and ju-
dicial Powers.

3.

The legislative Power shall be vest-
ed in a Congress to consist of two se-
parate and distinct Bodies of Men,
a House of Representatives, and a
Senate; each of which shall, in all
cases, have a Negative on the o-
ther.

4.

The Members of the House of
Representatives shall be chosen every
second

To meet on the 1st Monday in
every December

**Draft of the United
States Constitution**
1787
*James Wilson (1742–
1798), one of Pennsylvania's
delegates to the Constitu-
tional Convention of 1787,
probably recorded this,
the earliest extant written
version of the Constitution,
when the Convention
finished its preliminary
deliberations.* HSP

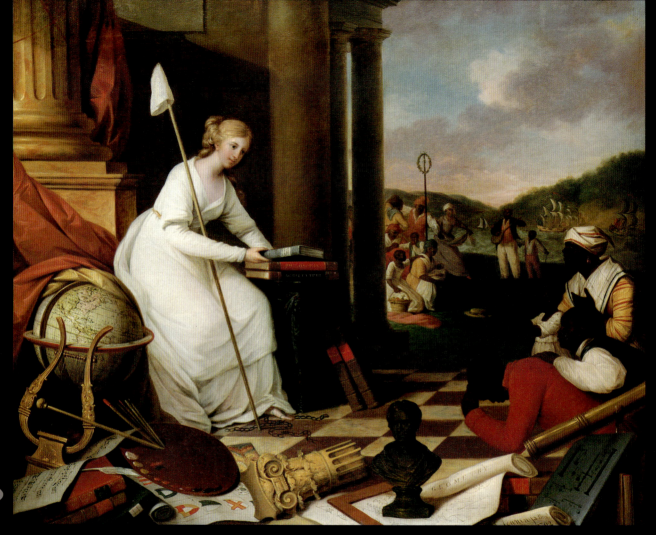

32

Samuel Jennings
**Liberty Displaying
the Arts and
Sciences**
1792
Born and raised a Phila-
delphian, Samuel Jennings
(c. 1755–c. 1834) spent
most of his adult life in
London. He made a second
copy of this painting for a
British engraving, trans-
forming Liberty into Britan-
nia presiding over the
abolition movement by
placing next to her a
shield adorned with the
Union Jack. LCP

A nationalism based on ideology was both powerful and exceptionally fragile. People could become Americans by embracing an idea, but abstractions were also elusive. Leaders and citizens alike understood that to inspire loyalty and patriotism they had to transform ideals into symbols and ceremonies, images and rituals. Even as the Continental Congress voted for Independence, John Adams hoped that future generations would commemorate the event "with pomp and parade," with "games, sports, guns, bells, bonfires, and illuminations from one end of the continent to the other from this time forward forevermore." Other rituals and icons took their place alongside Fourth of July celebrations. Among the most powerful symbols of national identity were those expressed in art and architecture.

A rtists apotheosized the American nation as Liberty. Samuel Jennings, for example, celebrated the bright prospects of the arts and sciences in the new Republic in a painting commissioned by Philadelphia's Library Company. Because the Library directors shared the antislavery sentiments gaining support in the wake of the Revolution, they asked that Jennings include a group of Blacks freed from their chains. This extended allegory, with its labored inclusion of several Republican themes, was in many ways typical of the didactic burden that art carried in the highly politicized, and extremely self-conscious, first generation of American independence.

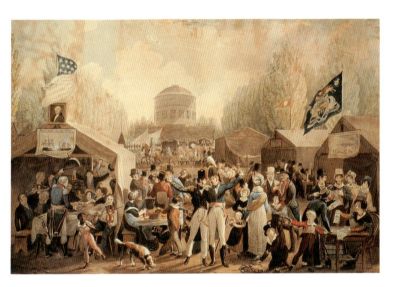

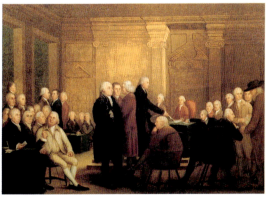

Robert Pine and Edward Savage
Congress Voting Independence
1780s–c. 1800
This oil—evidently begun by one artist in the 1780s and completed by the other about the turn of the 19th century—provides a fairly accurate portrait of the State House interior around the time the Continental Congress voted for Independence. HSP

John Lewis Krimmel
Fourth of July Celebration in Center Square, Philadelphia, 1819
1819
John Adams had imagined that the American people would commemorate the formal vote of independence on July 2. When Congress actually established Washington's Birthday and Independence Day as the first national holidays in 1800, popular practice had already settled on the Fourth of July, the day John Hancock and other delegates signed the Declaration. HSP

The core beliefs of American nationality also came to be personified in George Washington, the central hero of the Revolution. In life, Washington embodied American ideals; at his death in 1799, he ascended to the status of a deity. A cult developed around the memory of this founding father; Americans cherished items he had used, scraps of his clothing, and bits of his hair as our fragments of the true cross. The public facts of Washington's life de-fined virtue—the personal behavior that placed nation and community ahead of self-interest. Washington was Cincinnatus, the Roman general who left his plow to defend the republic and then, his duty done, returned to his fields.

While the first generation of Americans sought a distinct identity, they did not mean to withdraw from the broader currents of world history. Indeed, the goddess Liberty herself, like the toga in which artists sometimes cloaked George Washington and Benjamin Franklin, was only one of a number of references to democratic Greece and republican Rome, whose promise Americans believed themselves to be realizing. In choosing the name Senate for one of their legislative bodies, in placing the Latin phrase "novus ordo seclorum" on the great seal of the United States, and in naming the cities established in the years immediately after the Revolution—Cincinnati, Troy, Utica, Syracuse, Ithaca, Athens—Americans sought to emphasize continuity with that heroic legacy.

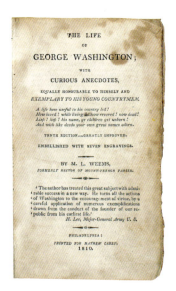

Mason Weems
The Life of George Washington
1810
Weems (1759–1825) created some of the myths —among them the story of the cherry tree—that later generations associated with Washington. Grasping the opportunities presented by Washington's death, Weems wrote to Philadelphia publisher Mathew Carey: "Washington, you know, is gone! Millions are gaping to read something about him. I am nearly prim'd and cock'd for 'em." LCP

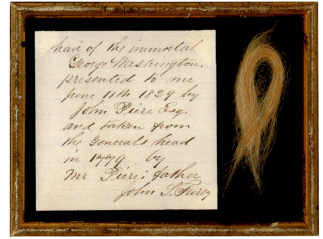

Lock of Washington's hair
This lock of Washington's hair was auctioned in 1864 at Philadelphia's Great Central Fair to help underwrite the Union's Civil War effort. Tradition has it that the hair was taken from the General's head in 1779. AKM

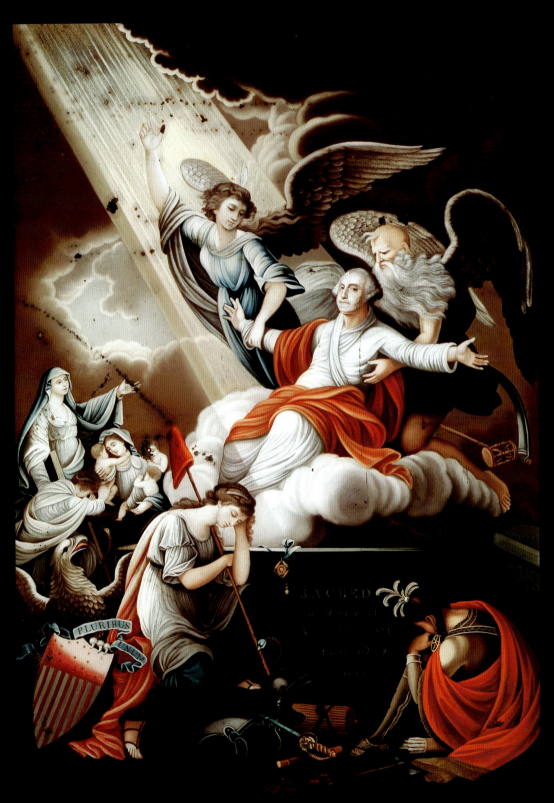

**Memorial to
George Washington**
c. 1800
*This reverse painting on
glass, made in China for
the U.S. export trade about
1800, is based on a print
engraved by Simon Chau-
dron and John J. Barralet
in Philadelphia. In the fore-
ground, Liberty, an Indian
warrior, and the American
eagle—all symbolic of the
Republic—mourn while a
celestial host guide Wash-
ington, his arms raised as
if in blessing, heavenward.*
WTR

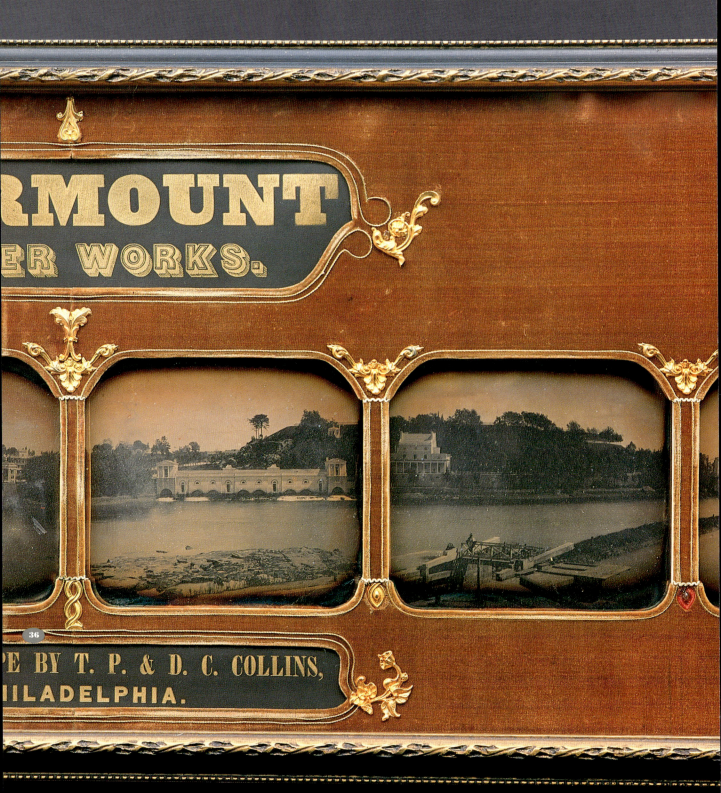

T. P. and D. C. Collins
Fairmount Water Works (detail)
c. 1846

The Fairmount Water Works, designed by Frederick Graff and built in the years 1812 to 1815, supplied Philadelphians with the "uncommonly pure" water of the Schuylkill River until the early 20th century. The complex, meant to recall a series of Roman temples, became the nucleus of Fairmount Park. This daguerreotype panorama dates from about 1846. FI

So, too, the neoclassical style of the turn of the 19th century took its inspiration from the republican past. As a style, neoclassicism appeared at the same time in Europe, where it was part of a high-culture rejection of the rococo and excessively ornamented. But classicism gained an especially strong hold in the United States. Here, its plain, spare, practical, and disciplined design lent itself perfectly to the rejection of monarchy and aristocracy and their presumed decadence. The logic of republicanism dictated the classical appearance of the United States Capitol Building in Washington, and the Fairmount Water Works and the Second Bank of the United States, among other structures, in Philadelphia. Furniture and interior decorative motifs, like building design, also showed the influence of republican simplicity.

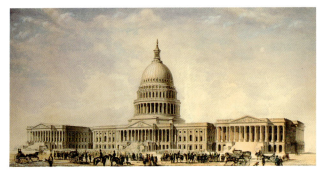

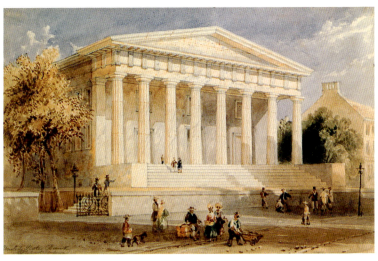

William Henry Bartlett
Second Bank of the United States
1836–1839
William Strickland (1787–1854) designed this Greek Revival building to house the ill-fated Second Bank of the United States in 1818. This watercolor is by William Henry Bartlett (1809–1854), who recorded many of the city's more important buildings in the mid-19th century, giving us some of our most striking images of the Federal city. INHP

Thomas Ustick Walter
United States Capitol
1855
Thomas Ustick Walter (1804–1887), a Philadelphian, designed the Capitol dome as well as the Senate and House wings while he was government architect in Washington from 1851 to 1865. The original building had been the work of William Thornton, a physician and amateur architect whose Philadelphia commissions included the Library Company building (since demolished and reconstructed) on Fifth Street across from Independence Hall. ATH

Montmorenci staircase
c. 1822
The Montmorenci staircase was originally constructed about 1822, probably by a local craftsman, for a house in Shoco Springs, North Carolina. A turn-of-the-century English builder's handbook may have influenced the staircase design, whose severe beauty and striking geometry exemplify the restrained neoclassicism so prototypically representative of the republican aesthetic. WTR

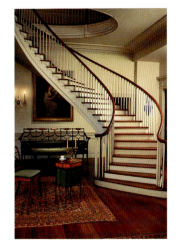

The effort to link American nationality with classical traditions was one immediate legacy of the Revolution. But Independence also unleashed other forces that ultimately undermined the ideology of republican virtue as a means of defining the American people. It was natural that allusions to the classical past would diminish in significance as Americans came to feel intense pride in their achievement as a free people. Inherited—and universalistic—ideals of republicanism understandably gave way as Americans turned their attention to their own special destiny. Americans came to see their future in the West, and its seemingly boundless prospects quickly moved to the center of the national imagination. The West offered extraordinary possibilities for economic expansion, a setting in which to build a Republic incomparably greater than Greece or Rome, and—in its uniqueness—providential ratification of the special character of this land and its people. The ideological—and republican—definition of American nationality would never altogether disappear, but it would lose its monopoly.

Though Thomas Jefferson did much to define American nationality in terms of republican citizenship, his actions also helped to refocus the nation's attention into its interior. Purchasing the Louisiana Territory in 1803—doubling the country's size—and embargoing Atlantic trade in 1807 were political acts completing the work of the Revolution. It was as a scientist as well as a political leader that Jefferson sent Meriwether Lewis and William Clark to explore the trans-Mississippi West. Members of the expedition kept extensive journals, recording their experiences with Native Americans and their observations about animal and plant life. In commissioning Lewis and Clark, Jefferson was following in the footsteps of his American Philosophical Society colleague, Philadelphian John Bartram (1699–1777), who, as botanist to the King, had apprised Europeans of the wonders of American nature. Bartram's explorations had predated the Republic; for Jefferson, nationalism and science went hand in hand. By exploring the interior, Americans could assume their rightful place as contributors to the store of knowledge about the natural world. Surveys would also open the West to trade, settlement, and national expansion.

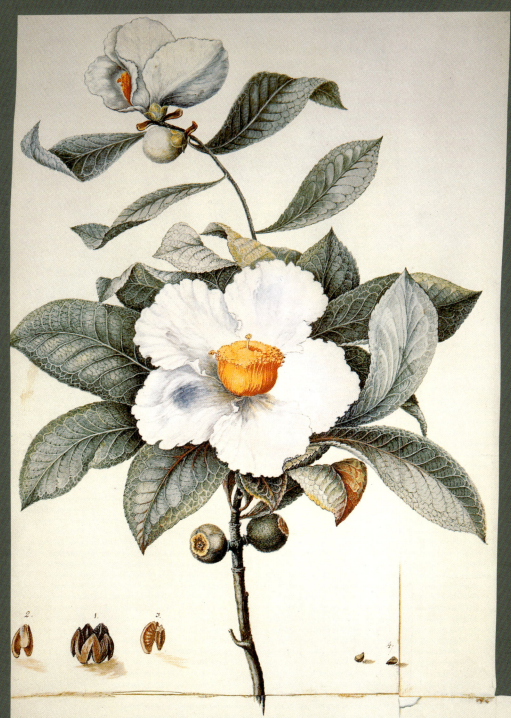

Franklinia alatamaha. A beautiful flowering Tree,
discovered growing near the banks of the R. Alatamaha in Georgia.

Will.ᵐ Bartram. Delin.
1788.

William Bartram
Franklinia
1788
*John Bartram (1699–1777)
and his son, William
(1739–1823), discovered
this fragrant, white-
flowering plant in a Geor-
gia swamp in 1765 and
—as was their custom—
brought living branches
home to propagate. Frank-
linia, which William later
named in honor of his
father's friend, and the
Venus flytrap were among
the more than two hun-
dred native plant species
that the Bartrams shipped
to European collectors.*
BRT

Monday February 24th 1806.

Meriwether Lewis and
William Clark
**Lewis and Clark
Journals**
1804–1806

This entry by Meriwether Lewis (1774–1809) dates from 24 February 1806; the Lewis and Clark expedition was then on the Pacific coast at the mouth of the Columbia River. Most of the entry describes a smelt-like fish, a quantity of which were brought in trade to the explorers by the Clatsop Indians. Lewis sketched the eulachon, or candlefish, in his journal. APS

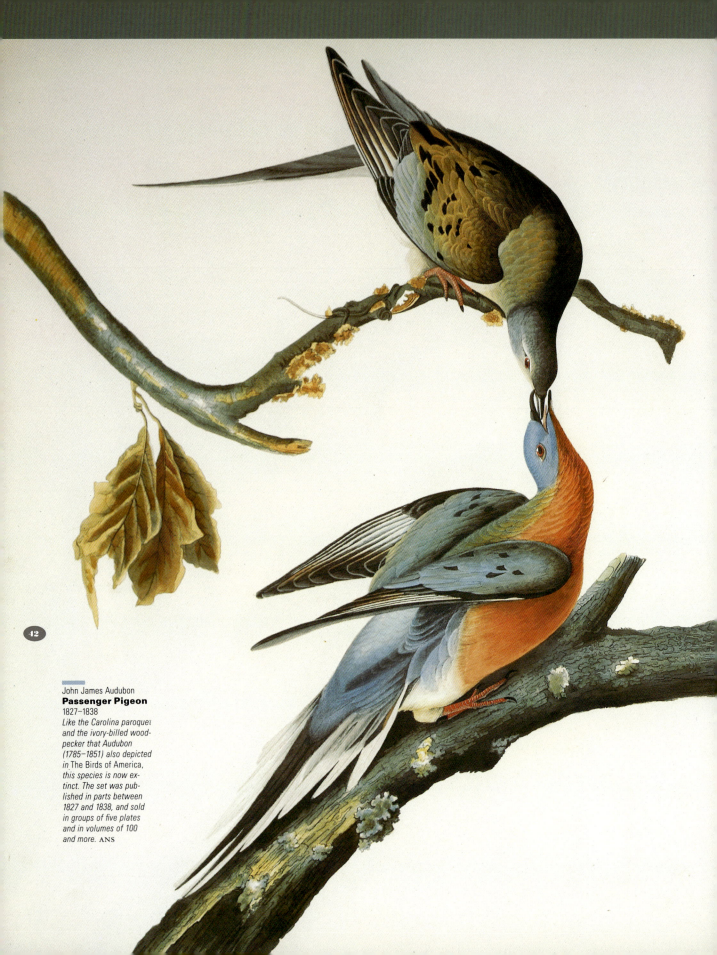

42

John James Audubon
Passenger Pigeon
1827–1838
*Like the Carolina paroquet
and the ivory-billed wood-
pecker that Audubon
(1785–1851) also depicted
in* The Birds of America,
*this species is now ex-
tinct. The set was pub-
lished in parts between
1827 and 1838, and sold
in groups of five plates
and in volumes of 100
and more.* ANS

Western exploration filled the national imagination with detailed knowledge about animal and plant life peculiar to the American natural world. The fact that so much was unique to their landscape and simply not part of the experience of Europeans enriched the common store of symbols upon which Americans could draw in pointing to what they shared as a people. The boundaries of colonial experience, and the histories of individual colonies, gave way as the West became the great common legacy and future of the American nation. In sending a pair of Missouri bears collected by explorer Zebulon Pike to Charles Willson Peale for exhibit in his Philadelphia museum, Jefferson clearly hoped to expand the benefits of the Western surveys he chartered beyond scientific and economic ends to the civic education of his fellow citizens.

So too, John James Audubon's lifework—his paintings of American birds and animals—presented native images warmly received by a society creating itself from scratch. This adopted American and sometime Philadelphian understood that he was no mere illustrator, but that his was a significant cultural role. *The Birds of America* was, in the artist's own words, an "extraordinary work." Its 435 individually hand-printed and hand-colored elephant-folio plates, each measuring 39½ by 26½ inches, portrayed 1,065 birds, and even the largest were lifesize. There was a grandeur and a passion in these depictions that departed from the canon of scientific illustration. The price ($1,000 per set) limited American sales to just over half of the three hundredsome original subscriptions, but the work quickly became a national icon. Daniel Webster and Henry Clay, two of the more ardent nationalists of the day, were among the original purchasers.

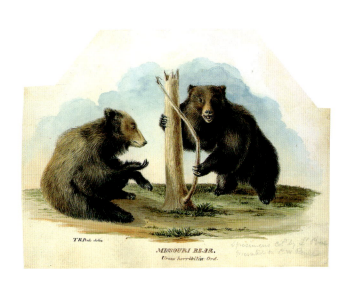

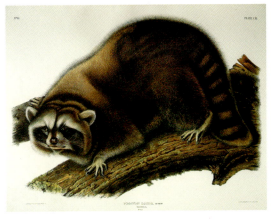

Titian Peale
Missouri Bear, Ursus horribilis: Ord.
c. 1822
Titian Peale (1799–1885) —who was among the first Americans to sketch the animal and plant life of the Great Plains—drew these bears after they had been stuffed and placed in his father's museum. He first exhibited this watercolor in 1822. APS

John James Audubon
Raccoon
1845–1849
Audubon's volumes on American mammals, The Viviparous Quadrupeds of North America, published from 1845 to 1849, did not achieve the recognition of his work on birds. Audubon used the relatively new process of lithography in the volumes about quadrupeds. The invention of lithography at the end of the 18th century led to notable illustrated volumes on the natural histories of England and France, as well as that of the United States. ANS

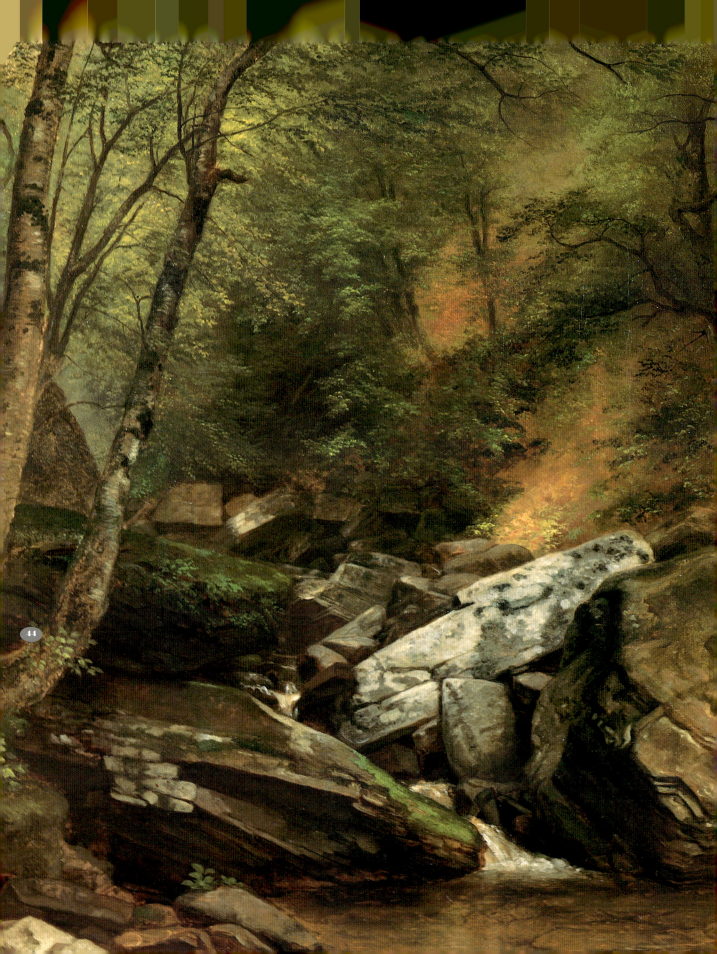

Americans transformed the land itself into a wellspring of nationalism. The precise features of their environment—the interplay of shadow, light, and color across particular valleys, glens, forest glades, hillsides, waterfalls, and streams—enriched the store of American images and contributed to the notion that a special providence had uniquely endowed this land and its people. The natural face of the country differed from the European landscape; so too did the meaning it acquired. Artists represented the local scenes to which they began to turn their attention in the 1820s as wild nature, untamed by man and untouched by European decay. The achievements of the Old World belonged to the past; the rising glory of America was everywhere evident in its awe-inspiring and majestic landscape.

Many of the artists of the Hudson River School—and those who depicted similar natural vistas elsewhere in the American interior—were, to be sure, influenced by contemporary European art. But their belief that American nature deserved artistic expression, that art was not limited to subjects and themes whose worth had already been established within the European cultural canon, constituted a cultural declaration of independence and helped shape American identity.

Themes derived from nature were not uniquely American in this period; indeed, natural imagery was near the heart of the romantic movement that captured the European imagination in the late 18th and early 19th centuries. Western culture had for centuries been discomfited by the wilderness, by the state of nature in which mankind—tainted by original sin—had acted on its corrupt instincts. But romanticism was an optimistic faith, born of an age freeing itself from centuries of tradition and fear. Many European romantics idealized the American Revolution—and for that matter the American experience itself—as proof that mankind could break away from its history of regimented over-civilization. With mankind by nature good, personal feelings no longer required the discipline of formal learning or societal control. Picturesque wilderness scenes appealed directly to the emotions, minimizing the need for rationality or artifice; the glorification of nature also signaled that imagination and intuition held primacy over intellect.

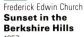

Asher B. Durand
Landscape with Rocks and Stream
(detail)
c. 1850
Durand (1796–1886) was America's leading landscape painter after the 1848 death of Thomas Cole. This is one of his studies from nature, a minute portrait of rocks, trees, leaves, and water that he executed out-of-doors during one of his regular summer pilgrimages to the Hudson River Valley. Durand was a pioneer in painting with oils directly from nature; this fidelity to nature was a way to express reverence for it. He incorporated elements of these studies into finished paintings in his studio during the winter. CIGNA

Frederick Edwin Church
Sunset in the Berkshire Hills
1857
Thomas Cole (1801–1848), who had begun studying and painting nature in the Catskills in 1825, wrote of the American interior that "all nature here is new to art." Church (1826–1900), like the other artists who followed Cole into the hills along the Hudson River, did more than document the landscape. Nature overwhelmed art in the seemingly endless sweep of his luminous sunset panorama. WMR

But American romanticism differed from the European cultural tradition to which it traced its origins and from which it borrowed much of its expressive style. Even as European romantics idealized their landscape, they could not escape the history that filled those settings. Memories of war, persecutions, and unhappy tribalisms darkened even their most picturesque forests, valleys, and hillsides. History had contaminated European nature; it required ritual cleansing before it could evoke the pristine purity of the Creation. Thomas Gainsborough, for example, placed a shepherd, sheep, and goats in the foreground of a rocky British landscape to establish a pastoral idyll in a European countryside that also held associations both less fortunate and more artificial. The Italianate hill town, rising in the middle distance, was another

technique serving the same ends. Classical allusions recalled an idealized antiquity for the European romantics, neutralizing centuries of their unhappy history. European romantic landscapes often featured ruins as well. Besides their picturesque quality and obvious emotional resonance, ruins—especially of abbeys, castles, and other decayed symbols of authority—declared the eventual triumph of nature over artifice and pretense.

Americans tracing the outlines of their nationalism in the works of nature had a complex relationship with the native peoples of their continent. The destruction of native cultures and peoples during westward movement raised moral questions even for some Americans sharing the nearly universal faith in manifest destiny. Americans proclaiming the moral superiority of the rough-and-tumble frontier spirit that set them apart from overcivilized Europeans recognized their kinship

with the "noble savage" with whom they shared the continent. That Indians were powerfully symbolic of the new land did not forestall conquest and dispossession, but it made their victimization and eventual disappearance particularly troubling.

Once the precarious uncertainty of early European settlement yielded to the substantial achievement of the new Republic, the Indian became an uncomfortable reminder to white Americans that they were not working out their destinies in an empty continent. In the decades preceding the Civil War, artists regularly participated in expeditions charting the West. They documented Indian cultures even as exploration sealed their doom.

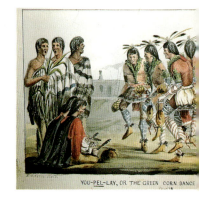

Edward B. Kern
You-Pel-Lay, or The Green Corn Dance of the Jémez Indians
1849
Edward (1823–1863) and Richard Kern (1821–1853), Philadelphia brothers, were trained in the drawing school of the Franklin Institute. They were civilian artists attached to an army unit operating in the southwestern territories recently seized from Mexico when Edward made this watercolor of a Pueblo Indian ritual in 1849. ANS

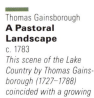

Thomas Gainsborough
A Pastoral Landscape
c. 1783
This scene of the Lake Country by Thomas Gainsborough (1727–1788) coincided with a growing artistic interest in the English countryside. PMA

Karl Bodmer
Pehriska-Ruhpa (Two Ravens), Chief of the Hidatsa, Dog Dancer

c. 1843

The Swiss-born 23-year-old Karl Bodmer was already a highly skilled artist when he arrived in the United States to accompany Prince Maximilian on an 1833–1834 journey retracing the route of Lewis and Clark up the Missouri River. Bodmer (1809–1893) recorded the Plains Indians with an ethnographic precision and a romantic sensibility. His drawings capture the exotic elegance of a heroic and doomed people. This image is from an atlas of 81 plates in the rare book collection of the Free Library.

FLP

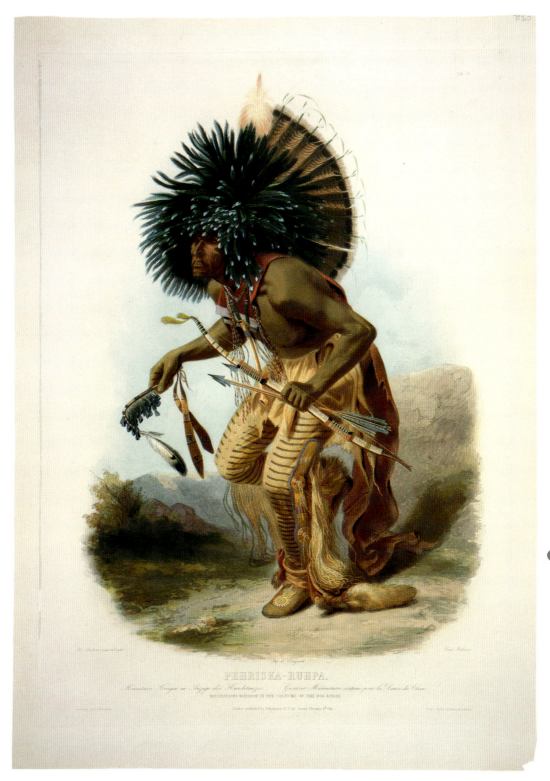

PEHRISKA-RUHPA.

MENNITARRI WARRIOR IN THE COSTUME OF THE DOG DANSE.

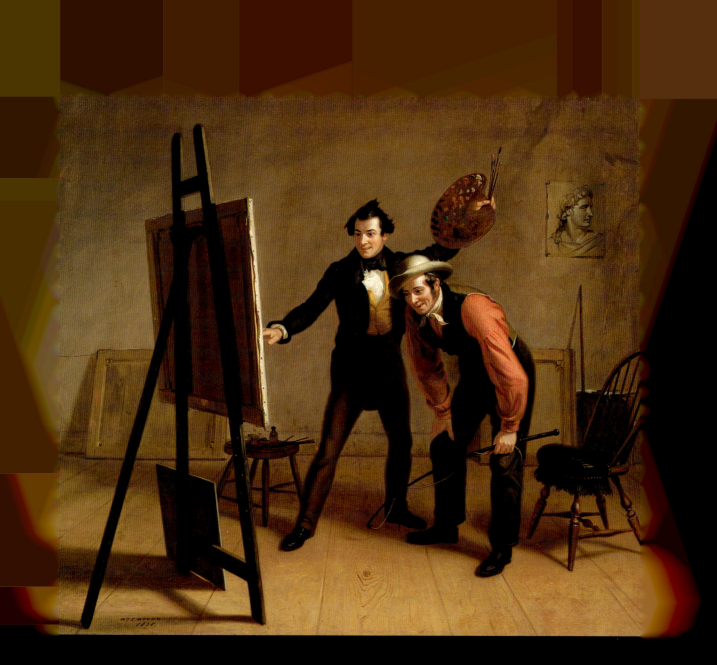

William Sidney Mount
The Painter's Triumph
1838
In The Painter's Triumph, *the farmer's rural innocence allows him pleasure in his portrait while the viewer is left to wonder whether the farmer is being had by the dandified and even somewhat sinister artist.* PAFA

Americans found equally enduring images of nationhood in their own backcountry tradition. Trappers and traders, intrepid frontiersmen and unsophisticated farmers—American originals all—marked this a people rooted in unique experience, a people comfortable with the rough edges that set them off from more polite society. Balladeers and storytellers, journalists and playwrights contributed exploits of shrewd Yankees, western explorers, and "Brother Jonathan" to the national folklore. William Sidney Mount (1807–1868), who worked in rural Long Island, was particularly notable among the artists who turned their attention to down-home country scenes. His portrayals of the unaffected, unmannered, and unschooled demonstrate the dignity of those living by the honest values of the soil.

Sturdy yeomen and self-reliant backwoodsmen became icons of national identity in the decades leading up to the Civil War. But even as the log cabin and hard cider moved to the center of popular culture and the political stage, the nation was undergoing a dramatic transformation that eroded the reality behind those sentimentalized ideals. The frontiersman was, after all, often a real estate speculator; rustic cottages were reduced to fond memories as their occupants eagerly took advantage of the unprecedented mobility of a society on the make. It is little wonder that an urbanizing and industrializing America found reassurance in comfortable images from a fading past. Americans invested heavily in nostalgia and created in it one of the most substantial bonds uniting them as a people in a fiercely competitive age.

The sense of nationhood that had taken shape by mid-century could not contain the strains leading to Civil War. Indeed, the original national ideology based on Independence and Revolution proved profoundly subversive of national unity when the southern states adopted the language and the logic of the Declaration of Independence to justify their own secession. War disintegrated the bonds uniting North and South; it demonstrated the inadequacy of the ideas, images, and institutions around which the nation had cohered. Americans would never fully outgrow or escape basing their national identity on republican ideology or on the special bounty bestowed on their land. But with the coming of the Civil War, Americans shifted to an instinctual patriotism, one based more on inheritance and obligation than on a voluntary adherence to generous ideals.

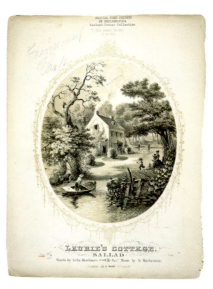

Abraham Lincoln's visit to Philadelphia's State House on his way to Washington to take up the presidency in the critical days after the South seceded propelled the building to the status of a national shrine. In subsequent years, the structure came to overshadow the ideas with which it had, for an extraordinary moment, been associated. The unhappy history of the State House in the years after the Declaration of Independence suggests the complex relationship of values and images. Abandoned by the Commonwealth after the state capital shifted to Harrisburg in 1799 and by the federal government when Washington became its seat in 1800, the structure was a white elephant. The city impounded dogs in the basement in the 1810s. A gas works, a more hazardous version of a modern oil refinery, occupied part of the building at about the same time. Standing on its front steps in 1861 during the deepest crisis in U.S. history and evoking the memory of Washington, Lincoln helped transform the building into an American icon. It was during World War II, a later conflict threatening national survival, that the city of Philadelphia initiated planning for the mall and the neighborhood revitalization that were meant to rescue the shrine from its decaying environment.

The Civil War marked a watershed in how we defined ourselves as a people. The fires of war tempered American nationality, hardening an American identity formed by nearly a century of national life. Nationality became a consequence of birth and rearing for most Americans.

The particular instruments of nation building—culture notable among them—receded in importance as characteristics thought to be innate in a people assumed ever greater significance. To be sure, art and ritual, schoolrooms and celebrations, continued to indoctrinate immigrants and remind long-established Americans of their civic responsibilities. But race, origin, and birth assumed ever greater roles in defining the American character and, indeed, in determining who could be an American. The Americanization of outsiders remained a possibility, but the very word suggested compulsion and the imposition of inflexible standards of behavior and belief on newcomers.

Schoolhouse
c. 1875
The late 19th-century public school took responsibility for considerably more than the three R's. It socialized the children of immigrants and longer-settled Americans alike; it promoted patriotism and taught citizenship. Children began to recite the new Pledge of Allegiance in the 1890s in classrooms like this. CMD

HARPER'S WEEKLY.
A JOURNAL OF CIVILIZATION.

Vol. V.—No. 219.] NEW YORK, SATURDAY, MARCH 9, 1861. [Price Five Cents.

Entered according to Act of Congress, in the Year 1861, by Harper & Brothers, in the Clerk's Office of the District Court for the Southern District of New York.

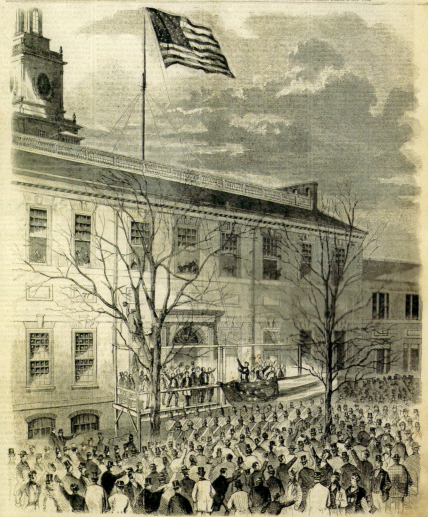

PRESIDENT LINCOLN HOISTING THE AMERICAN FLAG WITH THIRTY-FOUR STARS UPON INDEPENDENCE HALL, PHILADELPHIA, FEBRUARY 22, 1861.
FROM PHOTOGRAPHS BY F. D. RICHARDS, PHILADELPHIA.—[SEE NEXT PAGE.]

70.—2, 19, '81.—200 Books.

AMERICAN LINE.

Report or Manifest of all the Passengers taken on Board the

whereof _George N. Hodge_ is Master, from

3104 Tons and o

of _Philadelphia_ and bound to

NAMES.	AGE.	SEX.	OCCUPATION.	To what Country belonging.	Coun
Aaron Auguste	23	M	Engraver	France	X
Moses Antoo	20	'	Lab'r	Russia	X
Baruch Broslawski	21	''	'	''	X
Simele Bernhard	27	'	'	'	X
Fuja '	23	F	wife	'	X
Ruoko ''	4	''	Child	'	X
W Braice	60	M	Contractor	U.S	
Moses Broksen	29	''	Lab'r	Russia	X
Nachman Badnier	22	''	'	''	X
Marg't Baxon	56	F	wife	England	X
Louisa '	24	''	Spin	'	X
Francis '	11	M	Child	'	X
Sydney '	9	''	'	'	X
Wm Bunby	41	''	Printer	U.S	
Isaac Bestrycki	41	''	Tailor	Russia	X
Chaje '	37	F	wife	'	X

The late 19th and early 20th centuries witnessed the greatest surge of immigrants into the United States in its history. Many newcomers met an ambivalent response. An expanding American economy continued to need their labor, and the American ideal of offering a haven for the oppressed did not give way readily. But the "new immigrants"— as arrivals from southern and eastern Europe were called—were suspect. Political leaders reacted to their growing numbers by raising the specter of race suicide, the fear that the new foreign stock would ultimately displace Americans of more traditional origin. The Statue of Liberty rose in New York harbor in 1886, even as increasing numbers of Americans came to fear that allowing immigrants continued unrestricted entry would threaten America's identity.

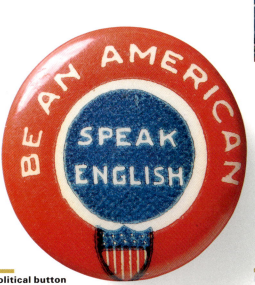

Ship manifest
(detail)
1882
The federal government required ships' captains to fill out and deposit lists of immigrants they brought into American ports. This is part of the manifest filed for the SS Pennsylvania, which carried a sizable proportion of Russian Jews among its passengers when it arrived in Philadelphia from Liverpool in 1882. Passenger manifests are an important source of information for individuals reconstructing their family histories. This manifest is on file at the Balch Institute for Ethnic Studies–Temple University Center for Immigration Research; manifests for ships arriving in Philadelphia and Baltimore are most readily available to researchers—on microfilm —at the Philadelphia branch of the National Archives. BAL

BE AN AMERICAN SPEAK ENGLISH

Political button
c. 1900
The specific context in which this button appeared around the turn of the century is unclear; its message—that immigrants needed to subordinate their backgrounds to American ways in order to participate fully in the life of the nation—is both clear and familiar. BAL

Kurt Jungstedt
The Establishment of Civilization in the Delaware Valley
c. 1959
The American Swedish Historical Museum dates from the mid-1920s. This fanciful tapestry by the Swedish artist Kurt Jungstedt (1894–1963) depicts the first Swedish settlement in this region in 1638 and suggests the celebratory and confident spirit in which the museum originated. Swedish-Americans —as participants in the older migration—did not suffer from the growing xenophobia of the 1920s; their early 20th-century ethnic revival may be understood as a socially acceptable parallel to the colonial revival—and the Anglophilia—of the same period. ASM

Races thought unsuitable for assimilation were denied entry outright or discouraged from migrating to the United States. Exclusion began with the Chinese in 1882, was extended to other Asians early in the 20th century, and culminated in the assignment of restrictive immigration quotas to the various European "races" in the 1920s. The quota systems adopted in that decade permitted almost unrestricted entry to the United States from northern and western Europe—"Nordics" and "Anglo-Saxons" in the racial terminology of the day—while virtually slamming the golden door for Slavic and Mediterranean peoples: Italians, Poles, Russian Jews, and Greeks, among others. The tragedy of the World War II relocation of Japanese-Americans—when American-born citizens of the "wrong" ethnic background were treated as if they were enemy nationals—is a reminder that not even American citizenship carried with it unequivocal rights.

There is, in retrospect, a powerful irony in the wartime relocation of Japanese-Americans. Looking backward from a period that has witnessed a growing respect for civil rights and an increasing tolerance of the diverse origins of the American people, it is clear that World War II marked a watershed in American racial and immigration policy. Faced with the need to mobilize an ethnically heterogeneous population and to rally racially and ethnically diverse allies in a total war whose main theater featured a racist, totalitarian foe, the government eased some of its own more blatantly racist policies toward African-Americans at home and toward Asians and certain Europeans who wanted to immigrate to the United States. A reassertion of democratic ideals as well as wartime exigencies animated this shift. Many Americans fought the war as a struggle against racism; Japanese relocation—the dark side of wartime ethnic policy—highlighted through stark contrast the nation's deepening commitment to an ideology of freedom and equality.

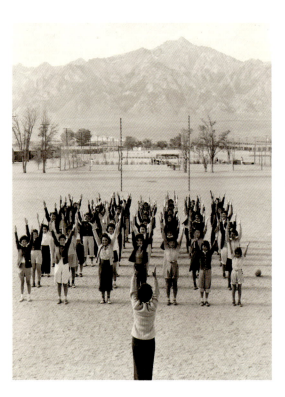

Ansel Adams
Manzanar
1943
Anti-Japanese hysteria gripped the nation after Pearl Harbor; the government responded in March 1942 by ordering Japanese-Americans—many of them American-born citizens—evacuated from the western states and interned in relocation camps. This is one in a series of photographs Ansel Adams (1902–1984) took in late 1943 at the Manzanar Relocation Center on the eastern slope of California's Sierra Nevada. BAL

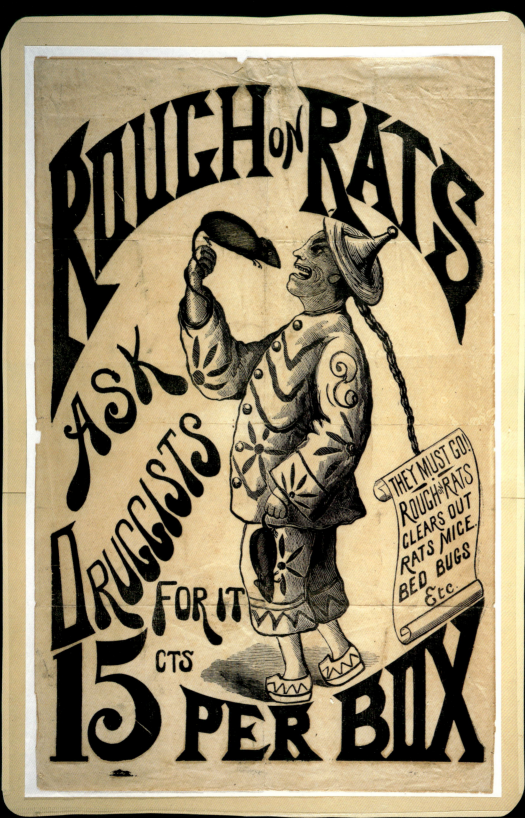

Rough on Rats
c. 1880–1900
This late 19th-century advertisement for rat poison uses a stereotypical image of a Chinese; its double message—"they must go"—reflects the anti-Chinese hysteria of the time. BAL

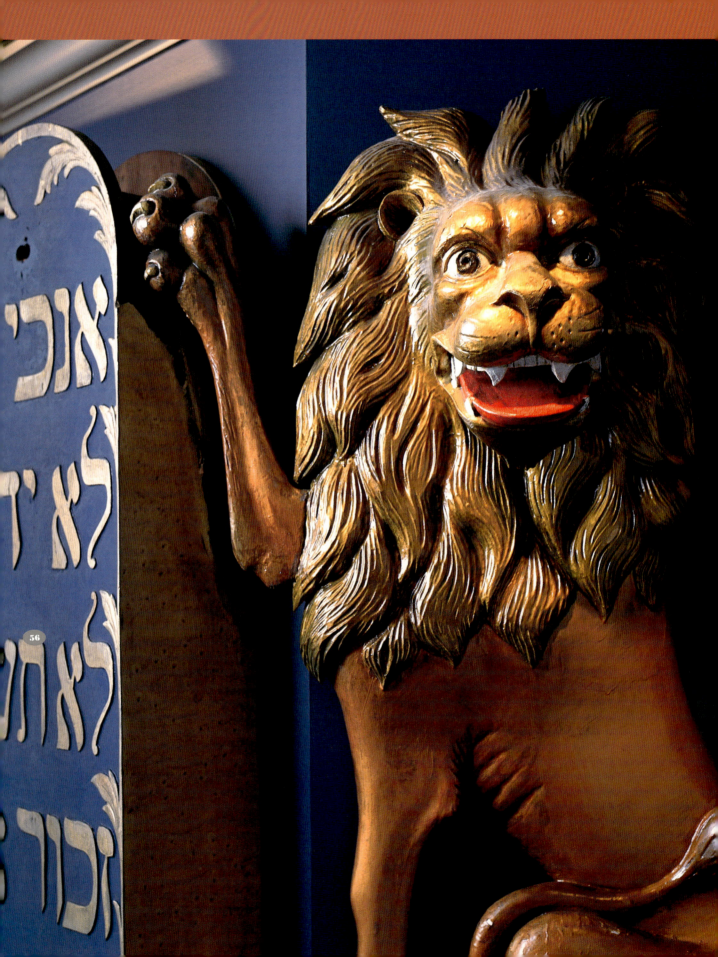

The government eased the blanket exclusion of Asian immigrants during the war—permitting entry to a handful of Filipinos, Indians, and Chinese—and Congress passed several postwar refugee acts that opened our doors, at least temporarily, to European groups that had been effectively barred since the 1920s. Perhaps of greater long-term consequence, the war improved the climate for African-Americans seeking an expansion of their civil rights. It would take until the 1960s for the early progress of the war years—the integration of some wartime employment, the modest integration of the military, and the surge in Black migration to northern cities—to bear fruit in the Civil Rights Acts and the revolution in race relations. As barriers against African-Americans fell in the civil rights current of the 1960s, they carried with them the insidious racial distinctions of the immigration quotas of the 1920s. Legislation enacted in 1965 allowed Asians, Africans, and southern and eastern Europeans the right to immigrate to the United States on the same terms as the formerly privileged—because familiar and thus presumably more easily assimilated—northern and western Europeans. The new laws also granted priority to immigrants from the Americas, in effect acknowledging that our destiny was now indissolubly linked with the peoples of the New World.

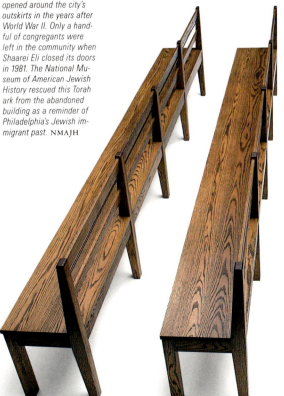

Lion of Judah and tablet from Torah ark

c. 1918

Congregation Shaarei Eli opened in 1919 at Eighth and Porter, in the heart of South Philadelphia's vibrant eastern European Jewish immigrant community. Noticeable numbers of neighborhood residents began to move out of the area in the 1920s; that stream became a torrent as new neighborhoods opened around the city's outskirts in the years after World War II. Only a handful of congregants were left in the community when Shaarei Eli closed its doors in 1981. The National Museum of American Jewish History rescued this Torah ark from the abandoned building as a reminder of Philadelphia's Jewish immigrant past. NMAJH

Ellis Island benches

Reconstruction, 1987

The federal immigration station at Ellis Island, nostalgically remembered as a welcoming beacon to the promised land, presented as well a formidable hurdle. Even before the immigration restriction acts of the 1920s, officials processing immigrants looked for medical conditions that precluded admission. Newcomers waited on benches like these until called; some of the actual benches used at Ellis Island after its opening in 1892 came to the Balch Institute for Ethnic Studies in 1976. The originals were returned in 1987, after the decision to restore Ellis Island as a national historical park. BAL

In our own time, we have grown uncomfortable with racial determinants for American nationality and citizenship. We exalt our immigrant origins. That we are a nation of immigrants has long been a source of pride—a line of St. Patrick's Day parades stretches back into 19th-century Philadelphia—but we have generally assumed that full participation in American life required that we merge our separate identities into a common nationality. The ethnic revival of the last two decades has undermined this long-standing assumption. We are now much more assertive in publicly celebrating the cultural baggage many of us have carried from lands of origin. Few now fear that racial and ethnic identity compromise national loyalty.

Multiple identities are now accepted as part and parcel of a complete American identity. The ethnic revival is particularly noteworthy among southern and eastern Europeans and African-Americans, the very groups whose presence most disconcerted the American mainstream in the late 19th and early 20th centuries. In the 1970s and 1980s we have witnessed the opening of new museums—the Balch Institute for Ethnic Studies, the National Museum of American Jewish History, the Afro-American Historical and Cultural Museum, and the Polish-American Museum—that celebrate our diverse origins. While xenophobia and racism still cast ugly shadows over our public life, our acceptance of new immigrants—southeast Asians, Filipinos, Koreans, and Latinos—and our romanticization of older ones suggests that Americans have grown increasingly comfortable with our multi-ethnic identity.

Baseball uniform
c. 1930–1940s
Black employees of the Pennsylvania Railroad's freight yards at Snyder Avenue and the Delaware River entered a company team, the South Philadelphia Freight, in the railroad's baseball league in the 1930s and 1940s.
AAM

Hmong banner
1983
Hmong refugees produced this banner in a sewing class in Philadelphia's John F. Kennedy Vocational-Technical School in 1983; it is a Hmong version of the American flag.
BAL

Museum, Wagner Free Institute of Science

Built 1859–1865; remodeled late 1880s
Philadelphia merchant and gentleman scientist William Wagner (1796–1885) established the Wagner Free Institute of Science in 1855. The Institute embodies its founder's faith in progress, belief in the supremacy of modern science, and commitment to popular education. The Institute's museum appears today as it did in the late 19th century. Looking very much a Victorian museum, it suggests the confidence that Victorians had in their ability to make sense of the natural world.

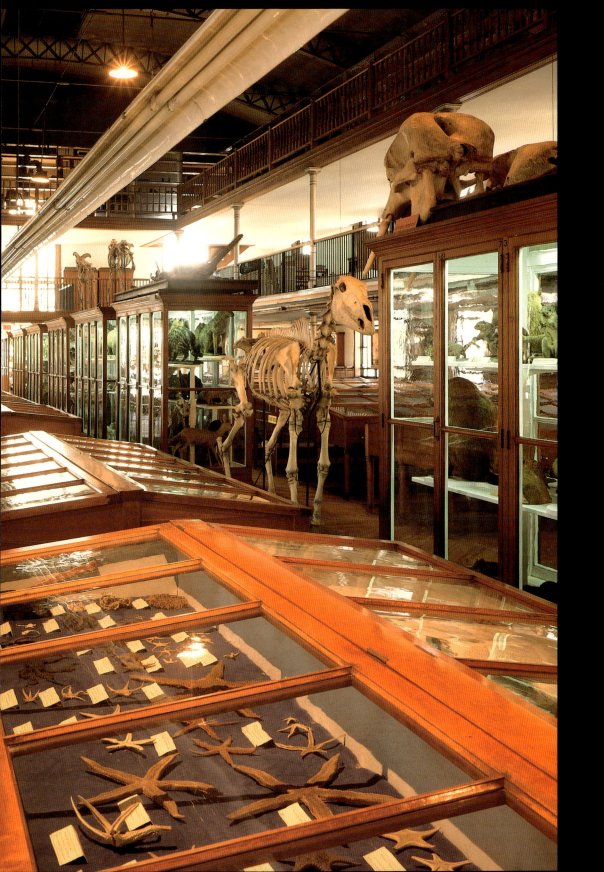

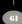

Victorianism is a culture of self-congratulation, a set of values, practices, styles, and generally confident ideas we associate with the growing wealth of the 19th century. We often reduce Victorianism to a style, but even so find it difficult to describe with precision because it was not limited to a single or distinct manner of artistic expression. We can, however, readily recognize Victoriana: a rich profusion of color, texture, and pattern, exoticism for its own sake, an ebulliently diverse jumble of art, artifact, and nature. The very richness and diversity of its elements make simple definitions difficult. Indeed, if any single statement can explain the culture of the Victorians—and separate their era from our own—it is that the self-confidence of the Victorians was not disturbed by the clutter that confuses us.

The difficulty of defining Victorianism stems in part from the long span and broad scope of the era. Queen Victoria herself set a record for longevity on the British throne. In the latter two-thirds of the 19th century, she reigned over the world's greatest empire at the height of its globe-encircling power. This was also a period of enormous transformation, when much of what we think of as modern came into being. Never before had mankind so completely subjugated nature, so thoroughly escaped its limitations, so fully recognized new possibilities. Technology, wealth, scientific advance, imperial conquest, even an increase in life expectancy—all ushered in vast changes. Victorian culture absorbed details from the expanding world, making room for values of the past, products and discoveries of the present, hopes for the future. And like others before and after them, the Victorians also used their culture to make sense of the processes of change.

Frank Leslie's Historical Register of the United States Centennial Exposition, 1876
Main Building, Philadelphia Centennial Exposition
1877
Philadelphia's Centennial Exhibition of 1876 celebrated a century of independence and proclaimed the nation's coming of age. American exhibits displayed the inventive genius of a free people and showed off the prodigious output of the country's farms, mines, and factories. Exhibits from across the world testified to the growing reach of the international economy and the ever more important role that Americans were coming to play in it; exhibits from Japan and the Near East fed the Victorian appetite for the exotic. Like the first of the modern world's fairs, London's 1851 Crystal Palace Exhibition, the Centennial celebrated material progress and widening intellectual horizons, displaying wealth previously undreamed of, products newly available in the world's markets, and curiosities from the far corners of the globe. Much in our museum tradition can trace its origins to the world's fairs of the Victorian era. Indeed, the Philadelphia Museum of Art opened—as the Pennsylvania Museum—in 1877 in Fairmount Park's Memorial Hall, which had housed the Centennial's art galleries. FLP

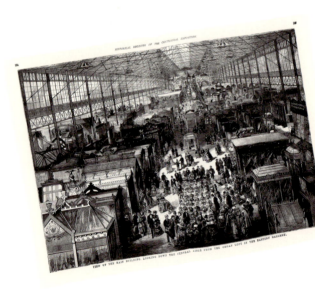

From a photo
by HUGHES & MULLINS,
RYDE.

HER MAJESTY
QUEEN VICTORIA.

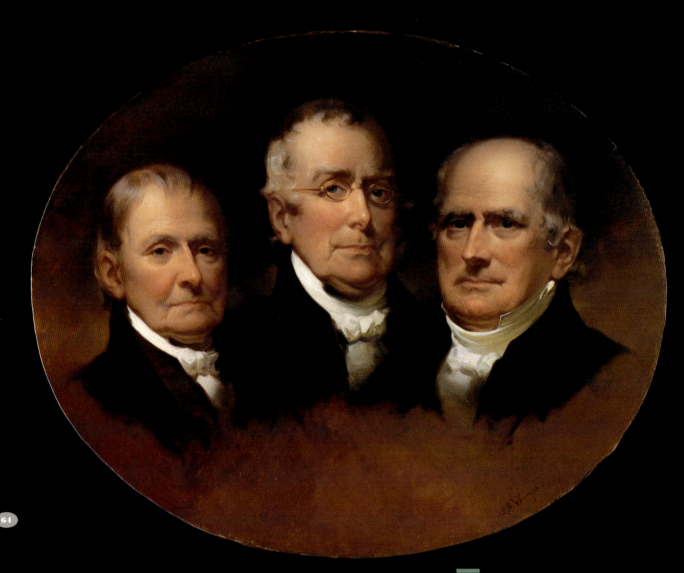

64

Samuel Bell Waugh
The Cope Brothers
1853
*Samuel Bell Waugh (1814–
1885) exhibited frequently
at the Pennsylvania Acad-
emy of the Fine Arts in
the mid-19th century. He
painted the sons of Phila-
delphia merchant Caleb
Cope in 1853.* PAFA

Underlying these changes was the accelerating economic expansion of the North Atlantic community. Cities grew; trade increased; new fortunes appeared. Technologies—steam, rail, and electricity in particular; machinery in general—were put to productive use, realizing the promise of the industrial revolution that had begun in 18th-century England. Though the period took its name from royalty, it was in these new fortunes, and in the more modest prosperity enjoyed by a growing middle class, that Victorian culture appeared.

Visible in the faces of Jasper, Thomas, and Israel Cope, Philadelphia merchant-financiers of the mid-19th century, is the determination that could bring prosperity. The portrait is a study in the stern rectitude, militant sobriety, Protestant religiosity, and conscientious application to hard work that we have come to expect of Victorian males. In this regard, the Cope brothers suggest the continuity with past values that an age beset by rapid change found reassuring. They embodied these older values as Queen Victoria herself did. But the emphasis on those ideals is also peculiarly Victorian, as is competitiveness and a faith that science, technology, industry, commerce, and knowledge would lead ineluctably to progress.

The Victorians were confident that they could keep their moral grounding in the old world even as they created a new one. They had little choice. Most were new people, a new class whose wealth derived from industry, trade, and the expansion of the professions, new ways of earning livelihoods. Religious and conventional in their thinking, owing their very success in large measure to their practice of traditional virtues, they would not have thought to break free publicly from social constraints. Rather, they did precisely the opposite, seeking social recognition for their achievement.

They were bold in advancing their claims. Unlike the gentry or the landed aristocracy, who expected to be accorded status simply because of who they were, because of their family history, the Victorians were often ostentatious in their display of wealth and cultivation. They surrounded themselves with household furnishings and luxuries—sometimes cluttering their homes with bric-a-brac—that bore witness to the currency of their tastes.

Majolica pottery
1880s
This locally made product —from the Phoenixville Pottery—appealed to the tastes of the newly prosperous. The stylized and brightly hand-painted oriental designs enjoyed just over a decade of popularity; such objects even served as premiums for the Atlantic and Pacific Tea Company. The pottery burned down in 1890. That the craze ended before the pottery could be rebuilt testifies to the fickleness of tastes adopted to make striking social statements. CHS

The most well-to-do often sought the badge of refinement conferred by association with high culture. They sent their sons and increasingly their daughters to college, they traveled to Europe to absorb the sophistication of the Old World, and they purchased works of art and emblems of intellect. Robber barons—the preeminent American Victorians—amassed collections of paintings by old masters, sculpture, rare books, and manuscripts. Art helped transform mere wealth into social standing. So too did giving art away. The collector established his intellect and taste in the public eye by donating the collection he had put together to a museum or library; he could also secure recognition for his generosity and civic-mindedness. The advantage was mutual, for the public benefited as cultural institutions strengthened their holdings. Many of the masterpieces acquired by Philadelphian Peter A. B. Widener passed into Washington's National Gallery of Art, but Widener's gift of 500 incunabula—books printed before 1501—launched the Rare Book Department of the Free Library of Philadelphia. John G. Johnson (1841–1917)—who enjoyed considerable personal success as a lawyer representing Widener's streetcar interests—made annual collecting trips to Europe, with Widener his frequent companion. Johnson donated his collection of European painting to the Philadelphia Museum of Art, with the proviso that the gift be kept intact as the John G. Johnson collection.

Most enduringly, the new middle classes and the newly wealthy reconstructed the faces of American cities and small towns as monuments to themselves, creating in the process a golden age for the profession of architecture. Once a handful of architects, artists, and master builders had designed and built formal structures for church, state, and gentry; now, architecture came of age as a discipline in the growing Victorian city. Indeed, when we think of Victorian style or artistic expression, our first images are likely to be architectural.

An expanding urban economy required new kinds of buildings—offices, department stores, exhibition halls, railroad terminals, hotels, merchants' exchanges—posing special design challenges because of their large size and specialized function. While the new temples of commerce did not eclipse the artistic glory of the Renaissance, they mirrored cathedrals and palaces as declarations of the power and aspiration of 19th-century merchant princes. Realizing these structures in bricks and mortar, iron and glass, required expert design and the mastery of often innovative construction technologies associated with the emerging profession of architecture. The master carpenters of the past had generally been limited to subtle alterations in traditional structures; architects, in contrast, relied on their increasingly formal educations to reinvent building forms to address new functional needs, to use new technologies, and to create dramatic facades to accommodate their clients' preferences for strong, personalized statements.

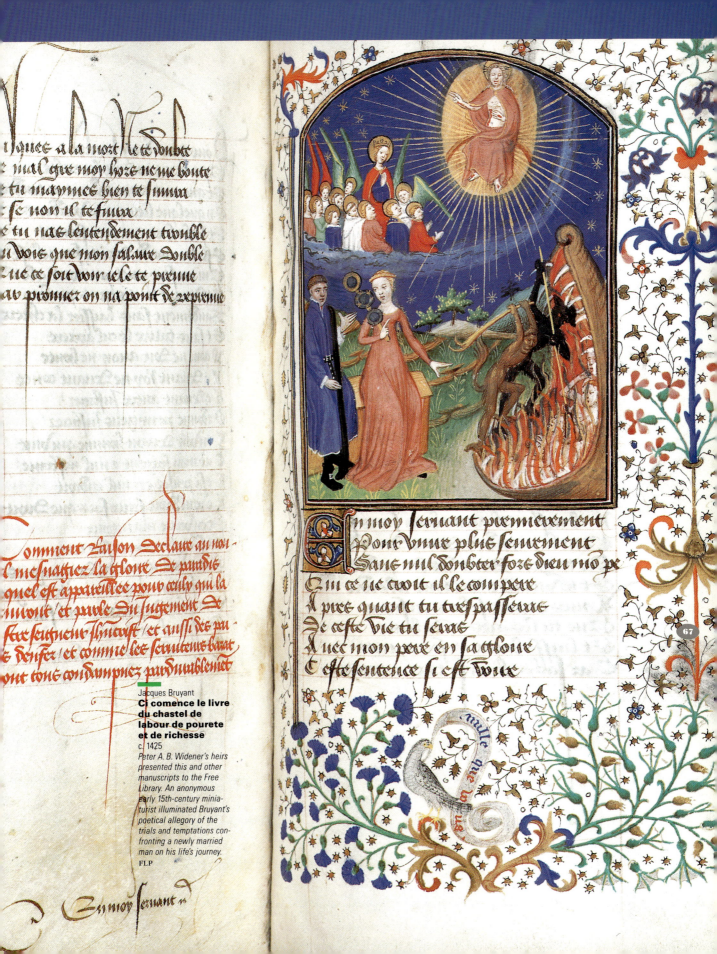

Jacques Bruyant
Ci comence le livre du chastel de labour de pourete et de richesse
c. 1425
Peter A. B. Widener's heirs presented this and other manuscripts to the Free Library. An anonymous early 15th-century miniaturist illuminated Bruyant's poetical allegory of the trials and temptations confronting a newly married man on his life's journey.
FLP

The St. Charles was a typi-
cally Victorian structure in
both purpose and appear-
ance. Erected in 1851 for
business travelers, the
building used the new and
relatively cheap cast iron
construction technology. A
coat of sand paint hid the
cast iron exterior, mimick-
ing—as someone newly
wealthy might—more sub-
stantial and expensive
masonry. With a cast iron
frame rather than masonry
walls, the building could
have large (or bulk, as
they were then called)
windows, opening more of
its interior to view. Depart-
ment stores would make
even greater use of display
windows. In many ways the
central institutions of the
consumer-oriented Victo-
rian culture, the stores
introduced buyers and
browsers alike to a richly
diverse display of alluring
merchandise from all over
the world; they thus served
many of the same func-
tions as museums. The
Gimbel Brothers' Store oc-
cupied the south side of
Market Street, between
8th and 9th Streets. With
Lit Brothers', Snellen-
berg's, Strawbridge &
Clothier, and Wanamaker's,
it was one of the five great
department stores that
dominated east Market
Street until the mid-20th
century. Gimbels' occupied
several Market Street
buildings dating from the
late 1880s through 1900;
this elevation—by Addi-
son Hutton, who designed
the structure at the 9th
Street corner for the origi-
nal occupant, the Cooper
& Conrad Stores—dates
from 1890. The St. Charles
—at 60–66 North 3rd
Street in Philadelphia—
was converted to apart-
ments and office space in
1980; Gimbels' was torn
down in the same year.
ATH

Addison Hutton
**Elevation of
Gimbels' building**
1890

ELEVATION to MARKET STREET.

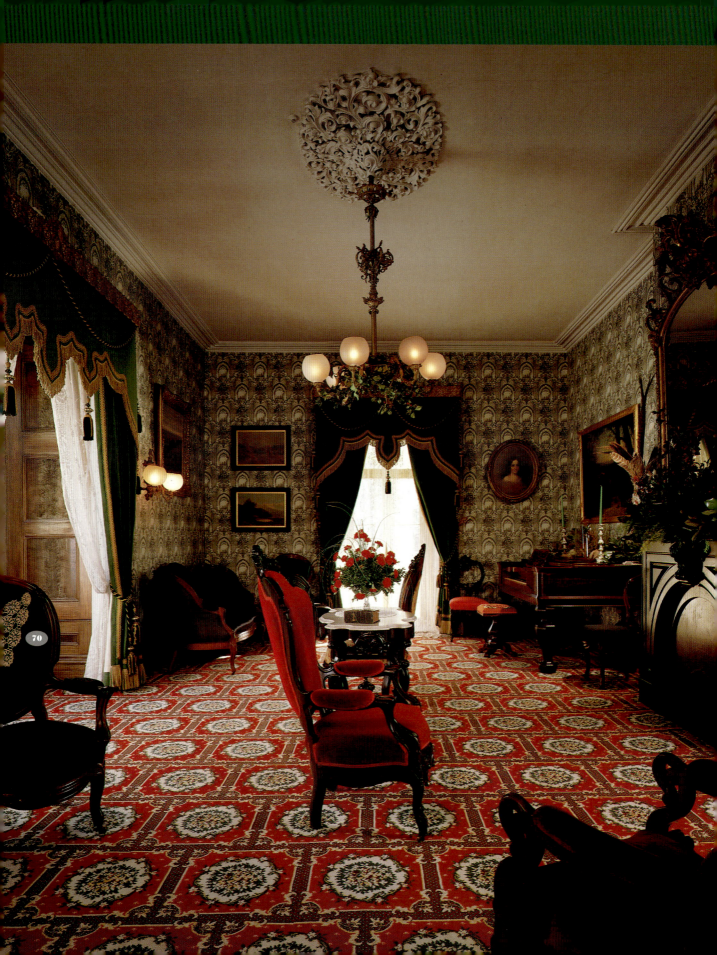

Perhaps more quintessentially Victorian than the commercial structures built in the city center was the residential construction that took place on the fringes, in new city neighborhoods and suburban districts. Philadelphia's Victorian neighborhoods expanded through large areas of Germantown, North and West Philadelphia, the Rittenhouse Square area, Chestnut Hill, and the Main Line. There, and in more isolated settings in the surrounding countryside, the wealthy built often grandiose homes to announce their arrival and express their individuality. Embellished facades—ranging from extravagant turrets to fanciful carpenter's lace—made each home the personal declaration of its owner; that fact, combined with the exuberant eclecticism of the age and the desire of architects to display their virtuosity, led to an almost regular succession of picturesque architectural styles.

Maxwell Mansion
1859
Ebenezer Maxwell, a successful textile broker, built this Germantown home in 1859 as a commuter railroad was integrating this once independent community into Philadelphia's suburban web. The design elements in this eclectic blending of Second Empire, Gothic, and Italianate styles contributed to the picturesque and emotionally expressive effect, as did the elaborate garden setting—also characteristically Victorian. At left is the parlor.

The Victorian home expressed other values as well. A refuge from the bustle, noise, dirt, and increasingly immigrant-filled streets of the industrial city, the Victorian neighborhood took its inspiration, in part, from the 19th century's romantic reconciliation with nature. An earlier terror in the face of the vast unknown had begun to give way in the 19th century to an appreciation of the sublime beauty of the wilderness. Nature, appealing directly to the emotions, was powerfully attractive to the Victorians, who regarded it as an escape from the stress of modern civilization. At the same time, a growing control over the environment domesticated nature, transforming greats tracts of it into suburbs. While few city people could afford rural estates, a growing number achieved a measure of gentry life and the pastoral idyll in these new suburban districts. The goal for the well-to-do was a home at some distance—both geographically and aesthetically—from the factories and downtown districts in which they earned their wealth. Distance from the city's commerce brought the home closer to nature, and also made it more private. The quiet streets of uniformly residential suburban neighborhoods furnished a retreat from the public world.

Samuel Sloan
Frontispiece, The Model Architect: A Series of Original Designs for Cottages, Villas, Suburban Residences, Etc.
1852
This pattern book advertised Philadelphia architect Samuel Sloan's skills to builders and potential clients; Sloan also used these images in working with patrons on the plans for their homes. Sloan designed this house for James Eastwick on the west bank of the Schuylkill River, in what was then a country district south of the city. ATH

Jasper Cropsey
Mounts Adam and Eve
1884
Jasper Cropsey's (1823–1900) idealization of the American landscape places him within the tradition of the mid-19th-century Hudson River School. This peaceful and picturesque scene—a pastoral idyll cradling human communities within the serenity of nature—is a view from Cropsey's home in Warwick, New York. CIGNA

73

[Henry B.?] Wechsler
The River Drive— Fairmount Park
1897
A family did not have to be wealthy to display Victorian sentiments. Even people of limited means could tack up on their walls the inexpensive color offset lithographs that late 19th-century newspapers distributed by the millions as part of their weekend pictorial sections. This pleasant scene appeared in the Philadelphia Inquirer's art supplement. AKM

The contrast of public and private was part of a series of opposites that defined the ideal Victorian home. This home promised husband and father safe haven from the competitive pressures of the business world; it represented refinement and higher aesthetic tastes in the midst of a culture directed increasingly toward the masses. The home also served as a shrine to religious values in a community given over to secular pursuits; it promoted moral standards and self-lessness in a society that ordinarily rewarded self-interest; it stood, as well, as a monument to consumption and display in an economy driven by the dictates of production and capital accumulation. The ideal Victorian home resonated, above all, to feminine values, and put a high premium on emotion in the middle of a masculine society that operated according to political and economic calculation. Idealized as the guardian of domestic and moral

values, the Victorian lady devoted her attention to safeguarding the respectability—and hence the social position—of her family. While an important role and one that made her a significant cultural force in her separate sphere, the role of the lady was also a severely circumscribed one. Often precluded from participating in the activity most valued by the larger world, the Victorian wife and mother was—like the home over which she presided—an ornament testifying to her husband's wealth and position.

The sense of the home as a bastion of respectability and a refuge from the industrial city was all the more apparent in the streetcar suburbs running along the less fashionable streets of North and West Philadelphia, where modestly successful Victorians bought attached but none-theless substantial brownstones from developers who filled block after block with symbols of middle class respectability. Even those enjoying only a pinched prosperity could emulate the lace-curtain propriety so important to the Victorian sensibility.

Victorian culture clearly did not embrace everyone. In the United States, this was the age of the great urban slums, of city districts teeming with immigrants by the tens of thousands, most of them poor, many of them clinging to their traditional cultures. Others were excluded as well. Native-born women working outside the home—as many had to in order to support families—also violated essential Victorian norms. That so many lived beyond the pale of respectability did little to undermine Victorian certainties. If social reformers called attention to the plight of the poor and the dispossessed, the more well-to-do could find reassurance in the widely accepted distinction between the worthy and the unworthy poor, reminding themselves that the dissolute and improvident deserved their fate.

W. T. Smedley
The Rich and the Poor
1891
Wealth, in the person of a handsome woman getting out of her carriage, commands the center of this illustration, which appeared in Harper's Weekly in 1891. But peering up from a basement apartment, and looking across and up the street, are the other, poorer faces of the city. Smedley, like the late 19th-century social reformers, was adept at turning the Victorian penchant for drawing distinctions—between good and bad, rich and poor, and the like—into a weapon for pricking the Victorian conscience. In calling attention to how the other half lived, Smedley also catered to Victorian sentimentality by focusing primarily on the children of the poor. BRM

The Victorian penchant for hierarchical distinctions played itself out on the global stage as well. The polarity of godly citizens and foreign-born slum dwellers had its counterpart in the ideology that justified exploitative relations between the industrializing West and the less economically developed peoples of Asia, the Pacific, and Africa. Queen Victoria was, after all, an empress, the most prominent representative of a century that witnessed the culmination of imperialism. While the United States was less aggressive than many European nations in 19th-century conquest, many Americans believed that they shared the western destiny to exercise a civilizing role among—as it was sometimes put—"savage and senile peoples."

Western governments and peoples acted from varied and sometimes overlapping motives in pursuing their interests in the less developed world. Urges to project national power, to tap sources of raw materials, and to secure markets for manufactured goods often figured in explaining imperialism. Some westerners traveled to remote regions seeking converts for Christianity. Other Victorians did so to indulge their fascination with the exotic, seeking out picturesque sights and collecting memories and artifacts. Many of these encounters fed a cultural imperialism through which the West came to exercise a pervasive and powerful intellectual sovereignty over the rest of the globe. By collecting art, folklore, and artifacts from abroad, westerners appropriated foreign cultures and histories, and took it upon themselves to interpret and evaluate the experience of the rest of the world.

Wealthy and prominent Philadelphians eagerly committed financial backing for the late 1880s archaeological excavations in Nippur (present-day Iraq) out of which the University Museum of Archaeology and Anthropology would emerge.

Their enthusiasm for archaeology stemmed in part from their expectation that by exploring the Near East they could confirm the biblical account of world history, an account that put Christianity at the center of humankind's experience. Their expectations for the thousands of clay tablets unearthed at Nippur—a treasure trove of the world's surviving Sumerian literature—proved well-founded, at least for a while. For more than a generation, scholars valued these tablets because they told stories of creation, the flood, the seven lean years in Egypt, and the like, which paralleled the accounts of the Old Testament—and thus could be understood as substantiating the Bible. By the later 20th century, however, some of the archaeological and ethnographic museums established in Victorian certainty were trying to understand the rest of the world in its own terms, and fostering a cultural relativism that many of the Victorians would have found incomprehensible.

Benin plaque
1550–1650
This cast bronze plaque, dating from the greatest period of the west African Benin empire (present-day Nigeria), depicts an oba— or ruler—surrounded by his retainers. The plaque is part of one of the earliest important collections of African art in the United States, and among the first in a western museum. The collection—and western knowledge of the art of the Benin kingdom—originated in the British punitive expedition that Lord Baden-Powell staged against Benin in 1897. A series of conflicts between Black Africans and European traders occasioned the raid. In defending their imperial prerogatives, the British conquered what remained of the kingdom, burned the city, and carried away as spoils of war thousands of artifacts emblematic of Benin's culture. Much of the booty passed into the collections of the British Museum. Early in the 20th century, the University Museum of Archaeology and Anthropology purchased this and the other bronzes that form the nucleus of its Benin collection from an antiquities dealer. UM

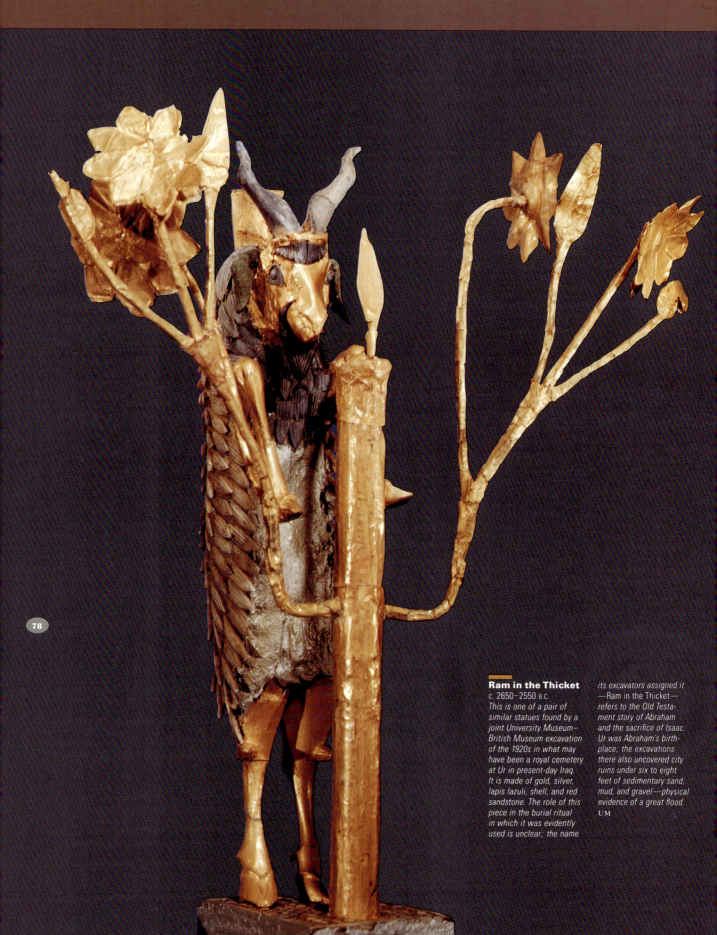

Ram in the Thicket
c. 2650–2550 B.C.
This is one of a pair of similar statues found by a joint University Museum–British Museum excavation of the 1920s in what may have been a royal cemetery at Ur in present-day Iraq. It is made of gold, silver, lapis lazuli, shell, and red sandstone. The role of this piece in the burial ritual in which it was evidently used is unclear; the name its excavators assigned it —Ram in the Thicket— refers to the Old Testament story of Abraham and the sacrifice of Isaac. Ur was Abraham's birthplace; the excavations there also uncovered city ruins under six to eight feet of sedimentary sand, mud, and gravel—physical evidence of a great flood.
UM

Victorians viewed Mesopotamia and Egypt through the prism of the biblical past in order to prove the intellectual centrality of their own world; they engaged themselves similarly in the Far East, a world entirely outside their own experience. A century of trade with China had led to a growing awareness of that land. The encounter with Japan had been shorter; naval power had forced that country to open to the West in 1853. These commercial and political conquests led to an intense, almost faddish, fascination with customs and things oriental among some upper-class Americans. The self-conscious expressiveness of much Chinese and Japanese art appealed to the exaggerated sensibility cultivated by the Victorians. And Victorians saw the Orient as, quite literally, other-worldly; its very exoticism confirmed the cultural superiority of the West.

The relationship had its more ambiguous facets as well. Some Victorians found in less industrialized civilizations—in oriental religions, for example—attractive alternatives to the highly commercialized relations of modern society. They contrasted the mystery of the Orient with the humdrum rationality of the West. Asia, they believed, spoke to the emotions and to the imagination; its superstitions addressed the fundamental questions of human existence. In the West, by contrast, modernity and secularization had stripped life of mystery and drained it of vitality.

Some Victorians were able to indulge their quest for authenticity by traveling in the Far East. Travel had once been an onerous burden, a necessary price paid by those who wanted to migrate, to do business at a distance, or to wage war or make peace. In the mid-19th century, steamships and railroads made pleasure travel possible; Victorians used their new prosperity to usher in the modern tourist era. The wealthiest—or most adventuresome—went first and farthest; others had to be content with the flood of travel books published in the second half of the 19th century. Philadelphia's Athenaeum— a subscription library—collected thousands of these volumes for its members. The "other world" became a tourist attraction; ancient Egypt and modern China—and for that matter Greece, Italy, India, Africa, and the American frontier—came to have meaning in a western-centered world, and on terms defined by Victorians.

The tourist was often a collector and sometimes a museum builder. Joseph Ryerss—descendant of an old Philadelphia mercantile family and himself a railroad investor and merchant in the China trade—ornamented Burholme, the Italianate mansion he built in northeast Philadelphia in 1859, with Chinese artifacts. His son, Robert, an enthusiastic traveler and voracious collector, continued the family tradition, seeking guidance in his travels from the many travel books he acquired; Robert's housekeeper and wife, Mary Ann, outdid them both. She journeyed—with her husband and after his death—through the Himalayas as well as in Europe, Egypt, Japan, China, India, and the American Southwest; she died on a collecting trip in Beijing in 1916. Robert and Mary Ryerss read deeply in Asian religion; they collected Buddhas and Hindu deities. The couple often dressed in Chinese robes when lecturing about Asia to local church groups and women's clubs. The Ryersses intended a public purpose for their Japanese, Chinese, and Indian collections; they bequeathed the family mansion as a museum and library to the people of Philadelphia.

G. F. Atkinson
**Indian Spices for
English Tables**
1860

*George Atkinson of the
Bengal Engineers offered
his countrymen 120 humor-
ous sketches of his travels
through India, "exhibiting
in all its phases, the peculi-
arity of life in that coun-
try." This is one of the
more than a hundred travel
books the Ryerss family
acquired.* RYS

Chinese puppet theater
Possibly 19th century
Mary Ryerss evidently acquired this papier-mâché puppet theater from Hunan Province on her last collecting trip.
RYS

Perhaps the most eccentric of Philadelphia's dilettante traveler-collectors was Maxwell Sommerville. Gem collecting evidently first brought Sommerville (1829–1904) to North Africa, the Near East, India, Burma, Siam, China, and Japan. By the last years of his life, he had refocused his attention on "effigies and other objects used by Orientals in their worship." An early catalogue of the University Museum showed Sommerville posing in the robes of a Buddhist priest in front of some of his religious relics. Though Sommerville had no formal education beyond Philadelphia's Central High School, the University of Pennsylvania appointed him Professor of Glyptology (the study of carved rare gems); he was the only holder of this title in the university's history, presumably bestowed in return for his agreeing to donate his treasures. The deal was cemented in 1899 when the University Museum installed the Buddhist temple Sommerville had assembled from a number of different sites in its just-opened building; the museum, in turn, appointed Sommerville curator for life.

Japanese Buddhist temple
Late 19th century
As currently installed, the temple is much less cluttered—and much more realistic—than the fanciful jumble its donor, Maxwell Sommerville, produced. UM

Maxwell Sommerville posing in his Buddhist temple
c. 1904
Maxwell Sommerville donated this idiosyncratic reconstruction of a Buddhist temple to the Univer-

The Victorians were the great museum builders. Their urge to organize experience and information —to collect and assemble materials according to categories and distinctions of their own devising—is readily understandable in the light of the history of the 19th century. Technological progress and economic growth expanded contact across cultures and led also to a more intense examination of the environment and nature's secrets. The sheer bulk of information the century generated, the sheer pace of scientific advance it maintained, required new organizational schemes to make sense of the flood of new data. An increasingly self-confident and prosperous society took on these challenges. Victorians mounted natural specimens in their academies and institutes; they displayed culture in the galleries of their museums; they collected and categorized living nature itself in arboreta and zoos. They organized museums to satisfy their curiosity and to instruct themselves.

Joseph Hyrtl skull collection
Assembled mid-19th century
The Mütter Museum purchased this collection of skulls in 1874 from Dr. Joseph Hyrtl, who had accumulated the material in his capacity as Professor of Anatomy at the University of Vienna. The 139 skulls came from 22 countries; Hyrtl grouped them into "racial" types and identified each with biographical data—religion, birthplace, occupation, and, where appropriate, criminal activity—to reveal what he believed to be the relationships among behavior, heredity, and ethnicity. MTR

Auditorium, Wagner Free Institute of Science
Built 1859–1865; remodeled late 1880s
Some of the greatest figures in late 19th-century American science lectured here to the audiences of ordinary men and women for whom William Wagner established the Institute that bears his name. The Institute began as an educational endeavor; the museum was meant to illustrate its lectures. Wagner shared the Victorian faith in progress and self-improvement and the conviction that popular education was a powerful instrument for bettering society.

Case of monkey and human bones
1880s
Wagner called upon naturalist Joseph Leidy to organize the Institute's exhibits. Leidy was Charles Darwin's first important American ally; this exhibit —like much that the Institute displayed—was intended to argue the case for evolution. Looking at these monkey and human bones, a visitor would first notice their similarities and then focus on the subtle variations on which Darwin's Law of Natural Selection acted. WFI

Katsura tree

This graceful 100-year-old Japanese Katsura tree, Cercidiphyllum japonicum, is a reminder of the Victorian fascination with the exotic Orient. It is a prize specimen in the Morris Arboretum, which began in 1887 as the suburban estate of John and Lydia Morris. The Morrises shared other Victorian enthusiasms as well: they were avid plant collectors in a period that was the heyday of plant exploration, and they created picturesque gardens in an age that valued landscapes appealing to the romantic temperament. They intended their arboretum to be a catalogue of nature's diverse bounty; it was, as such, an eminently Victorian endeavor. By bringing together dissimilar plants from similar climates in different parts of the globe, the Arboretum allowed the study of variation and natural selection. Like the collec-tions in the Academy of Natural Sciences and the Wagner Institute, those of the Arboretum could be understood as proving Darwin's theory of evolution, a universal theory integrating a mass of knowledge in a way that was especially congenial to the self-confident Victorian age. MOR

Entrance, Zoological Society of Philadelphia
1874

In collecting life forms for display and study, in stimulating and satisfying an appetite for the exotic, and in educating the public about the wonders of nature, the Zoological Society of Philadelphia was prototypically Victorian. Even when the zoo, which opened as the nation's first in 1874, placed as much emphasis on entertainment as on scholarship—as much on the circus as on science—it suggested the way in which naturalists were moving beyond identifying and collecting organisms to making comparisons among them and to considering how the structure and behavior of species related to their environment. ZOO

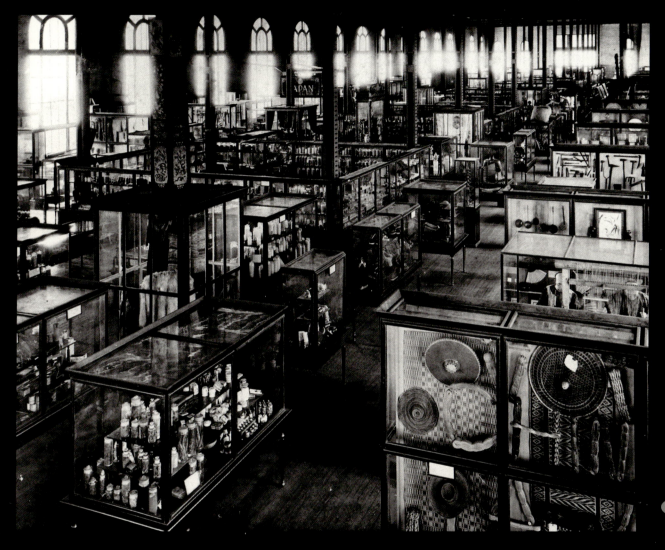

Philadelphia Commercial Museum
1926

The Philadelphia Commercial Museum began with 24 railroad freight-car loads of exhibits salvaged from the Columbian Exposition, the Chicago world's fair of 1893. The museum was intended to promote production and trade by exhibiting raw materials, handicrafts, and manufactured goods from around the world. In the process of helping American manufacturers compete more effectively in foreign markets at the turn of the 20th century, the museum acquired ethnographic and archaeological materials, photographs documenting foreign cultures, and entire exhibits from other fairs and expositions. The museum was, in effect, a permanent world's fair, conflating commerce and culture and celebrating— and promoting—western dominion over both. POH

Our own period has witnessed a revival of interest in things Victorian. We have restored in all their garish ornamentation the homes of the once nouveau riche, collected overstuffed and overelaborate furnishings that our parents discarded, and come to find camp and then to cherish the Victorian aesthetic. The attractiveness of Victoriana derives in part from their expressiveness, a trait perfectly suited to a generation recoiling from the restraint and severity of modernist functionalism. But there is more to the Victorian revival than the regular succession of styles, than the fact that its time has come.

The Victorian sensibility was not merely a matter of style. It was an expression of confidence on the part of a society that believed in the superiority of its values. Enjoying dominion over the world's resources and a growing technological competence, the Victorian majority interpreted both as progress and conflated progress with moral achievement. Unafflicted by doubt and untroubled by nuance, Victorians distinguished as readily between right and wrong or civilization and barbarism as they did between men and women or city and suburb. The expressive artifacts of Victorian culture bespeak that confidence. Even if we share the discomfort of the Victorian minority with moral absolutes and ethnocentrism, we may still look back wistfully at the Victorian era as the last time the world made perfect sense.

Victorian Christmas, Rockwood
1990
Victorian festivals—marking Christmas and other happy seasons—testify to the contemporary attraction of things Victorian. Decorated rooms are a special feature of the Christmas celebration at Rockwood, a New Castle County house-museum.

Christopher Schissler
Sundial
1578

Renaissance instrument-maker Christopher Schissler fashioned this sundial to duplicate the Old Testament miracle in which the prophet Isaiah made the sun's shadows—and time—move backward. Pouring water into the bowl—taking advantage of the way water refracts light—shifts the shadow cast by *the time-telling string. A recent reconstruction of the bowl has focused attention on the sophisticated calculations required to calibrate this timepiece. The underside of the base depicts Isaiah's miracle.* APS

Discovery and Exploration

Psalterium

c. 1260

In the centuries after the fall of Rome, western art and formal culture had primarily religious purposes. The miniatures in this mid-13th-century manuscript psalter—a prayer book—depict the life of Christ. The care taken by the anonymous artist in illustrating what he probably thought the most important of all stories might stand as a metaphor for knowledge in the medieval world: art and scholarship were expected to embellish and gild truths already established in the religious canon. **FLP**

Our culture has come to regard progress as its birthright. We take discovery and invention, exploration and innovation, for granted as we look toward a future of widening possibilities. We pride ourselves on the light regard in which we hold alike the fact and fiction of the past: the old certainties that do not withstand critical examination and the magical myths that long constrained human autonomy. We are of a mixed mind about the past, finding in it both reminders of limitations to human capacity long since left behind and monuments to achievement worthy of admiration. The art and the literature of the past, its science, and its beliefs record the explanations earlier ages found for the mysteries of the cosmos and the soul, and offer witness to distances traversed in explorations across centuries and continents. We pay homage—in much of what we formally identify and sanctify as culture in our greatest library and museum collections—to the heritage of intellect and reason that has let us master our world. We point to our history of discovery and exploration, sometimes presumptuously, to justify our power.

A shared image of distant times permeates our culture. Americans believe that for most of the world's history, human beings understood themselves to have little control over the forces that intruded powerfully on their lives. The past, our ancestors seemed clearly to understand, limited the present; tradition dictated both action and belief among peoples who found the past their best guide through a hazardous world. Human communities uncertain of their physical survival vested significant power in gods and the supernatural, and in the practices and beliefs of those—like Aristotle—who had gone before them. With the rise of Christianity, other concerns—notably that of spiritual salvation—similarly put a premium on received authority, limiting the autonomy of human communities to explore and interpret the worlds they inhabited. Over the course of the first millennium, the Bible became Europe's central text and the source of some of its most important traditions. Christians understood it to be divinely inspired and therefore the source of eternal and unchanging truth. Church and state alike derived their legitimacy from its revelations and applied their power to preserve its authority. Biblically sanctioned explanations of natural phenomena—whether they dealt with human behavior or the motions of the planets—might be codified and explicated, but they were not subject to investigation and revision. This was, by and large, a static world, one that assumed that everything knowable was known and was vouched for by authorities beyond dispute.

Challenges to these old certainties intensified from the 13th century on. In a process that eludes precise cause-and-effect explanation, an unfettering of the European imagination accompanied a series of far-reaching economic, religious, and political changes. An intellectual expansion of the world itself paralleled the growth of trade and the rise of capitalism, the Protestant Reformation, and the appearance of dynastic states. Voyages of discovery pushed the boundaries of Western knowledge outward into *terra incognita,* and astronomic observation literally expanded the heavens. Some explorers were reluctant revolutionaries, hoping to confirm what their age already knew rather than to discredit old systems of belief. Christopher Columbus, for example, did not intend to open a new world but merely hoped to confirm what many in a time of exploration already believed—that a sea route to the Indies lay to the west across the Atlantic. Others—like Copernicus, who sought in mathematics a simplified theory to account for centuries of recorded observations of planetary motion—were more conscious of the challenge they posed to received authority. Whatever their intent, the discoveries of the Renaissance were profoundly unsettling in their implications.

Christopher Columbus
Epistola . . . de Insulis Indie supra Gangem Nuper Inventis
1493

Returning from his first voyage to the New World, Christopher Columbus notified King Ferdinand and Queen Isabella that he had discovered islands above the Ganges River in the fabled Indies. This Latin translation of his letter—printed with movable type—was one of a number of publications that quickly spread across Europe the news of the successful voyage. Movable type, which could be set on a printing press with relative speed, was an innovation of the mid-15th century. FLP

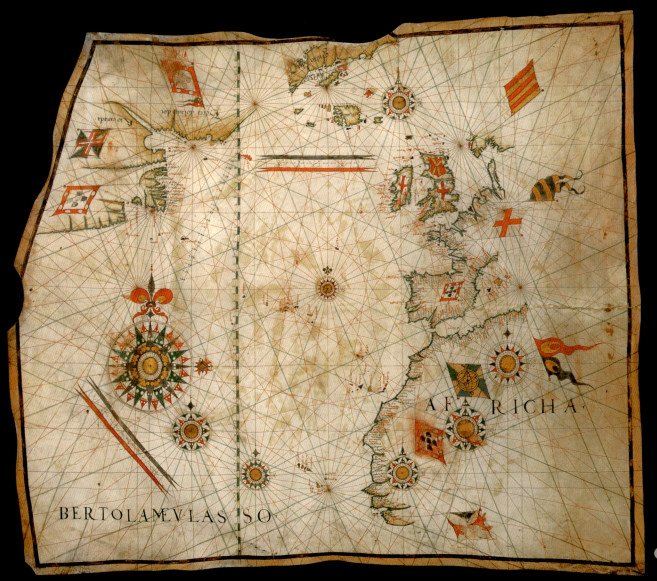

Bartolemeu Lasso
Portolan chart of the Atlantic Ocean
c. 1590

Portolan charts—navigation aids giving the locations and descriptions of coasts and seaports—date from the expansion of trade in the 14th-century western Mediterranean. This chart of the Atlantic, by the Portuguese mapmaker Bartolemeu Lasso (fl. 1564–1590), reflects that nation's preeminence in Europe's world explorations from the time of Prince Henry the Navigator (d. 1460).

Showing the coastlines of Africa, western Europe, Iceland, Greenland, Labrador, the Gulf of St. Lawrence, Newfoundland, and Nova Scotia, this very decorated parchment map suggests the increasing ambitiousness of 16th-century sea voyages. ROS

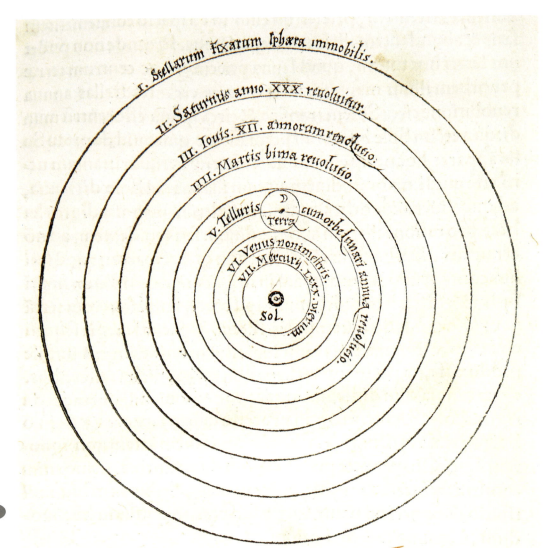

I. Stellarum Fixarum Sphæra immobilis.

II. Saturnus anno. XXX. revoluitur.

III. Iouis. XII. annorum revolutio.

IIII. Martis bima revolutio.

V. Telluris cum orbe lunari annua revolutio

VI. Venus nonimestris.

VII. Mercury. Lxxx. dierum.

Terra

Sol.

Copernicus
De Revolutionibus Orbium Coelestium
1543
Copernicus argued that the revolution of planets around the sun could better—and more simply—account for their movement across the skies than did the earth-centered universe of Judeo-Christian belief and Greek science. Also implicit in this challenge to received authority was a physically expanded universe in which the heavens no longer fitted snugly above the earth in a series of celestial spheres. Unintentionally, Copernicus prepared the way for divinity itself to recede into this deepened firmament. HCL

Copernicus, willing to break with the past, took issue with the Ptolemaic view of the universe; this assumed, like the biblical story of Creation and any commonsense look at the heavens, that the sun, the moon, and the planets revolved around the earth. The second-century Greco-Egyptian astronomer Ptolemy had preserved this traditional cosmology in the face of observable facts: the planets sometimes seemed to move backward across the night sky. Ptolemy had posited complex planetary orbits along an intricate series of circles to explain this apparent retrograde motion without challenging the received wisdom about the earth-centered universe. Ptolemy's elaborate explanation of celestial movement did conform to observation; it accurately predicted the position of the planets and thus successfully guided navigation on earth. By freeing himself from the Bible's earth-centered universe, Copernicus was able to create a more elegantly simple explanation of the motion of the planets. Moving the sun to the center of the solar system, Copernicus was able to account for the retrograde motion of the other planets by pointing out that the earth itself moved continuously. At a time when many still regarded intellectual curiosity as a dangerous and prideful heresy, Copernicus worked from the assumption that human intellect was free to impose order on the world. He called into question not just the accepted wisdom about the movement of the planets—an important enough challenge in a world that looked heavenward in prayer and to determine when to sow, when to reap, and how to navigate—but also how humankind thought about natural phenomena. In shifting the earth out of the center of the universe and setting it in motion, Copernicus emphasized movement in what had until then been a static universe.

Fels Planetarium, Franklin Institute Science Museum
This contemporary planetarium display projects an essentially Copernican view of the solar system.

The Renaissance also turned its more intense gaze into the human body, reopening the direct study of human anatomy, an area of inquiry that medieval Christianity—like religious authorities in Islam and Judaism—discouraged. The Church had long prohibited human dissection as a violation of the dead. For over a millennium, Europeans had continued to base their medicine on the Greco-Roman tradition; the Greek physician Galen would have been as comfortable with the texts of the 15th century as with the system of medical knowledge he had codified in the second. Galen's human anatomy—based almost entirely on the dissection of apes and other animals—had remained unchallenged even when contradicted by observation. Even Andreas Vesalius, the great 16th-century anatomist who received his

medical degree the same year (1537) the Church approved teaching anatomy by dissection, at first hesitated to question Galen's assertions, preferring to state rather that his findings augmented established belief. But a few years of human dissection led Vesalius, a professor at the University of Padua, to announce publicly that anatomy had to give precedence to observation rather than authority. His masterpiece, *De Humani Corporis Fabrica* (1543), broke with Galen; by the end of the century, Vesalius had become the standard for anatomical study. As important as the new knowledge the work presented— about the absence, for example, of pores in the heart through which blood trickled one drop at a time— was its approach. Vesalius presented examples to show how actual dissections had led to new knowledge; he showed readers how they might make dissections to verify or challenge the conclusions he presented.

Hans Baldung Grien
Dissection of the Scalp and Exposure of the Hemispheres of the Brain
1541
Hans Baldung Grien was one of several artists who provided images for Walter Hermann Ryff's anatomy text, Des aller furtrefflichsten . . . gschopffs aller Creaturen . . . beschreibung oder Anatomi, *which appeared in Strasbourg in 1541. These hand-colored woodcuts show the first step in dissecting the brain, and—like Vesalius's volume—indicate the instruments required. The soiling of these plates may be a result of their use in dissecting rooms.* PMA

Andreas Vesalius
De Humani Corporis Fabrica
c. 1543

Arguing that medical students had to do their own dissections to properly learn their craft, Vesalius pictured in his book the instruments needed for the procedures he recommended. The anatomical illustrations—woodcuts possibly drawn by Jan Stevensz Van Calcar, a Flemish student of Titian —were themselves scientifically important. Unlike physicians, artists were not bound by a scientific tradition that encouraged deference to established authority. CPL

In difer andern Figur der Anathomi des haupts/ sihestu ſer
die euſſerſt vnd innerſt haut/ darmit die hirnſchal bedeckt iſt/ abgezogen/
euſſerſt haut/ darauß das haar wachſer. B. Der ſelbigen haut innerhalb/ mit
ſchleym erfüllet. C. Iſt das hetirlin/ welchs nechſt der hirnſchal/ den gantzen
haſen in ſich ſchleuſſet. D. Das beyn der ſtirn. E E. Beyde wendbeyne ſter
ſcheytel. G G. Beyde beyn der ſchläff. H. Das meſſer zů dem Freyſchnit/
vorgonder Figur verzeychnet. I I. Die rund ſeg/ die hirnſchalen abzuſchneyden.

In diſer Figur ſiheſtu die ober hirnſchalen mitt der runden
zirckel ſegen/ in nechſt vorgond form mit I I verzeychnet/ abgeſchnitten. I I. ſeind
die beyden euſſerſten heüt/ ſo die hirnſchalen vmbgeben/ wie vor. E. Iſt ein harte fellin
von weiſſem gedere/ welchs die gantz hirn vmbgibt/ Dura mater gnant. D. dilin
recht ſeyt. E. Die linck ſeyt des hirns. G G. die äſt der blůt vnnd hertz aderen/
durch das hirn geſprytzet. F. Der vnderſcheyd/ der beyde theyl des hirns von eyn
ander theylet.

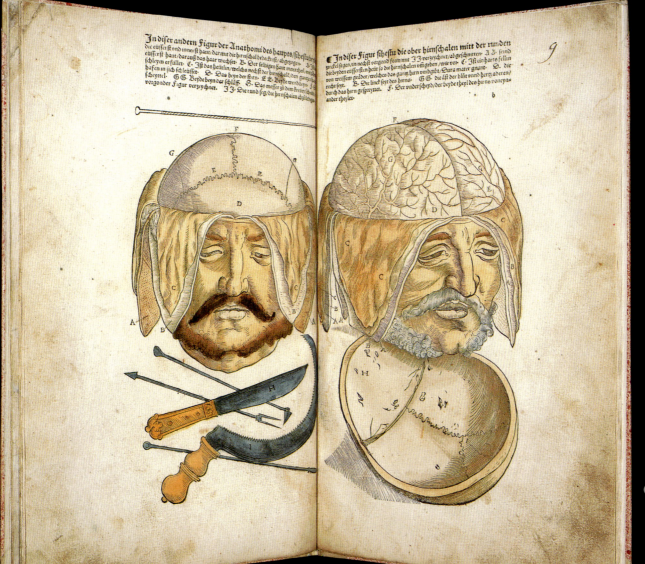

In remapping the universe and paying closer attention to the human body, science imitated art. Medieval art had often rendered its subjects flat and motionless, as fixed in time and space as they were in the God-given scheme of things generally represented on canvas. This art was highly abstract and deliberately oblivious to spatial relationships, as if in looking at the world as in gazing at the heavens, humans had tacitly agreed to subordinate their observations to larger truths: what they saw was less important than what they believed. In the 15th century, painters began to experiment with perspective, imposing their angles of vision, quite literally their points of view, on the scenes they depicted. Art now proclaimed that how the world looked depended on where one stood. By adding depth, perspective also brought movement to painting. That an artist captured a scene in a specific moment had implications far beyond the canvas, contributing an artistic voice to the swelling chorus now denying that the world was timeless or unchanging. Perspective focused attention on human experience in the world; as an artistic phenomenon, it reflected the liberation of human intellect.

Immediate follower of Giotto
The Annunciation, Nativity, and Crucifixion
c. 1310–1320
This vertical triptych by an anonymous follower of the Florentine painter Giotto presents the account of Christ's birth and crucifixion as the essential story in human history—and the most important theme that could engage an artist's attention. These images describe the core of the faith that animated medieval Europe, and suggest the importance of that faith in helping human beings make sense of their experience. PMA

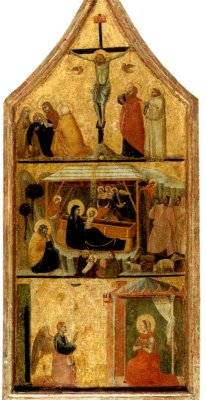

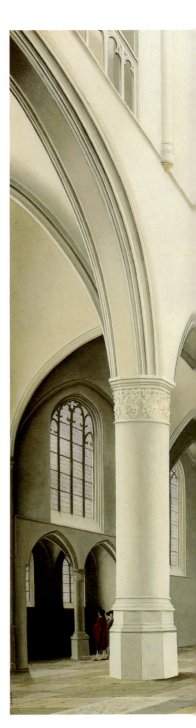

Jansz Pieter
Saint Bavo in Haarlem
1631
Perspective and movement itself are almost the subject of Jansz Pieter's Saint Bavo in Haarlem. *Pieter draws the viewer's eye inward through the church; the group in the scene is clearly in motion through an architectonic, practically mathematical, setting.* PMA

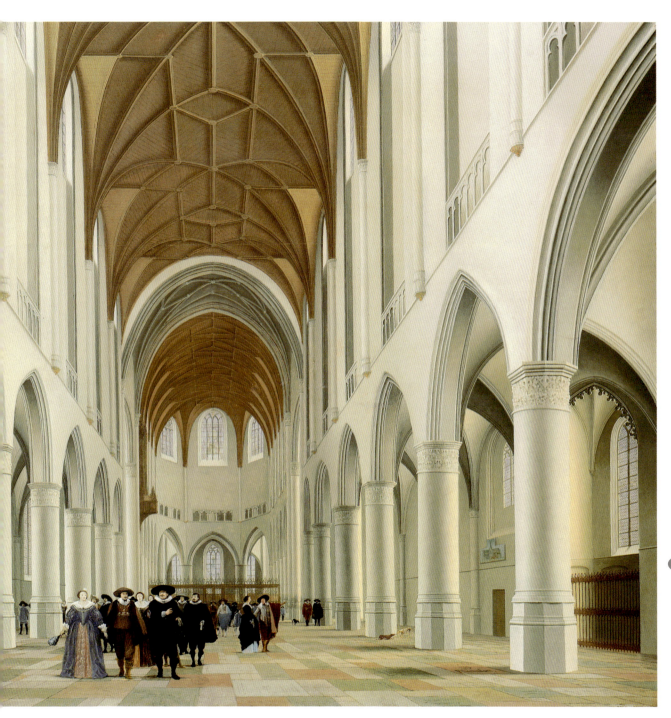

Isaac Newton
Letter to Robert Hooke
1675/6
Newton's reference to standing "on the shoulders of giants" appeared in this letter to Robert Hooke, president of the Royal Society. Newton wrote to disarm the hostility that had entered their relationship when the pair debated Newton's theory of optics.
HSP

Cambridge Feb. 5. 1675.

Sir

[margin note] Thanks for the offer of correspondence

At the reading of your letter I was exceedingly well pleased & satisfied with your generous freedom, & think you have done what becomes a true Philosophical spirit. There is nothing which I desire to avoyde in matters of Philosophy more then contention; nor any kind of contention more then one in print: & therefore I

[margin note] Contention in print to be avoyded

gladly embrace your proposal of a private correspondence. What's done before many witnesses is seldome without some further concern then that for truth: but what passes between friends in private usually deserves the name of consultation rather then contest, &

[margin note] Correspondence desired

so I hope it will prove between you & me. Your animadversions will be therefore very welcome to me: for though I was formerly tired with this subject, & have not yet nor I believe ever shall recover so much love for it as to delight in spending time about it; yet to have at once in short the strongest or

[margin note] seemes not very willing to meddle with Philosophy

most pertinent Objections that may be made, I could really desire, & know no man better able to furnish me with them then your self. In this you will oblige me. And if there be any thing els in my papers in which you apprehend I have assumed too much, or not done you right, if you please to reserve your sentiments of it for a private letter, I hope you will find also that I am not so much in love with philosophical productions but that I can make them yeild to

[margin note] If I had Hooke's Letter & to which is an answer it would render this more plain

equity & friendship. But in the meane time you defer too much to my ability for searching into this subject. What Des-Cartes did was a good step. You have added much several ways, & especially in taking the colours of thin plates into philosophical consideration. If I have seen further it is by standing on the shoulders of Giants. But I make no question but you have divers very considerable experiments besides those you have published, & some it's very probable the same with some of those in my late papers. Two at least

[margin note] R: where these two experiments of Hooke are publisht

there are which I know you have observed; the dilatation of the coloured rings by the obliquation of the eye, & the apparition of a black spot at the contact of two convex glasses & at the top of a water bubble; & it's probable there may be more, besides others which I have not made: so that I have reason to defer as much or more in this respect to you as you would do to me, especially considering how much you have been diverted by

Principles of mathematical exactness and a reliance on calculation infused artistic perspective as they did the new astronomy. Artists and scientists alike began to transform observation into measurement and found in mathematics an instrument for describing a world now alive with movement and possibility. The Englishman Isaac Newton (1642–1727) embodied this intellectual triumph. Newton's work extended from pure and applied mathematics—he was co-inventor of the calculus—through the basic principles of light and optics, to the law of universal gravitation. In creating a mathematical model of motion, he reduced the gravity observed on earth into a particular case of a natural law that explained the attraction of masses throughout the universe. Newton's mathematics and his laws of motion explained and predicted the observed phenomena of the physical world and the heavens; it was his genius to apply the same rules to all bodies in nature, deriving formulas equally useful in calculating planetary orbits, comet paths, and ocean tides. In Newton's work, the idea that laws subject to human discovery governed nature reached its clearest expression. Perhaps more than anyone else, Newton ushered in the age of faith in science. Newton's genius suggested the possibility of infinite progress. In his oft-repeated assertion that he built his intellectual monument on the "shoulders of giants," he struck a keynote in the history of Western thought: progress would henceforth beget further progress, and the past would be chiefly useful for its intimation of the future. It would be only a small leap from Newton's achievement to 18th-century Enlightenment *philosophes* who exalted the power of human reason and claimed for science the ability to analyze human behavior and to organize social and political systems that expanded human horizons.

The notion that one could master the laws controlling the physical world spread beyond the scientific elite. The new astronomy, for example, reached a broadened public through mechanical planetariums, or orreries. Their clockwork mechanisms offered quietly efficient testimony to the orderliness of the universe, the reasonableness of the world. The two that Philadelphian David Rittenhouse (1732–1796) constructed for Princeton and the University of Pennsylvania just before the American Revolution displayed with great accuracy and for a 5,000-year span the relative orbits of the six known planets and the moon. Rittenhouse, a clockmaker, self-taught astronomer, and student of Newtonian calculus (and, like Newton, director of his nation's mint), played a central role in 1769 when colonial men of science collaborated in observing the transit of Venus across the sun. The participation of Americans in this international effort to calculate the distance from the earth to the sun—thereby deriving as well the distances between the sun and the other known planets and essentially filling out the picture of the Newtonian universe—was part of an effort by the colonists to assume a fuller partnership in European science.

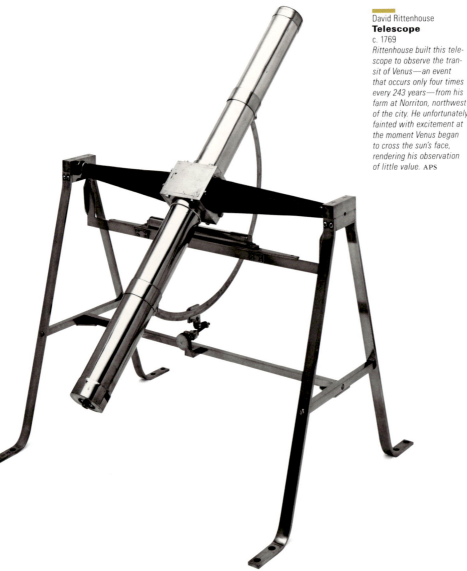

David Rittenhouse
Telescope
c. 1769
Rittenhouse built this telescope to observe the transit of Venus—an event that occurs only four times every 243 years—from his farm at Norriton, northwest of the city. He unfortunately fainted with excitement at the moment Venus began to cross the sun's face, rendering his observation of little value. APS

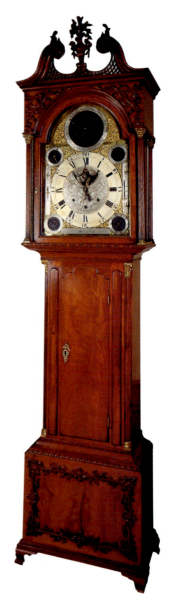

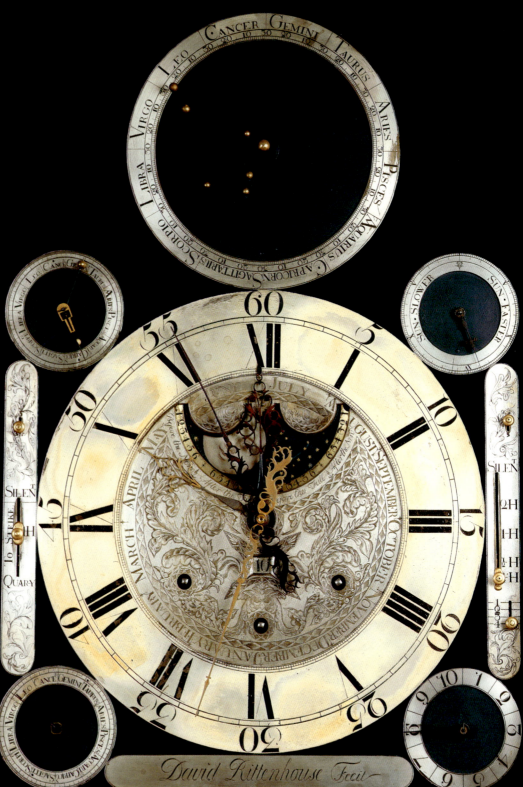

David Rittenhouse
Clock
1773

David Rittenhouse placed into a grandfather clock the features of an orrery: note the large circle at the top center that shows planetary orbits. The elaborate care obvious in its construction owes in part to the then current view of the mechanical clock as the ultimate in technology, a position of honor it began to lose only with the advent of the mature steam engine. The first scientific paper presented to the American Philosophical Society (1768) was a description of a Rittenhouse orrery. DRX

If there was an American counterpart to Isaac Newton, however, he was not David Rittenhouse but Benjamin Franklin (1706–1790). The first American conceded a place in Europe's intellectual pantheon, Franklin earned his reputation as an Enlightenment *philosophe* by the range of his intellectual activity: his work with astronomy and electricity, with the science of government and the application of intellect to myriad practical devices from bifocal lenses to heating stoves. Franklin received special praise for his studies in electricity. His experiments with static charges, conductivity, and insulators led him to identify lightning as an electrical phenomenon, to construct and carry out experiments to test his theory, and to develop the lightning rod to protect structures during electrical storms. Franklin's uniting of the disparate phenomena of lightning and electricity was not as striking in its universality as Newton's laws of mass and motion, but it offered possibilities for protecting mankind from some of the terrors of the heavens.

As a scientist, however, Franklin was clearly the exceptional colonial. The American colonies and the new nation lacked the cultural and scientific institutions—and surplus wealth, for that matter—required to nurture the more abstract fields of knowledge. These deficiencies did not embarrass Franklin. Making a virtue of what might otherwise have seemed a liability, he pointed out that he had been self-taught, that he came from an energetic people not bound by established institutions and their hierarchies into old ways of doing things, and that he practiced a science of practicality. Even though Franklin's scientific curiosity and ingenuity were in the Enlightenment mainstream—and widely appreciated on both sides of the Atlantic—he chose to depict his work as a challenge to European ways and as the birthright of a free people.

Benjamin West
Benjamin Franklin Drawing Electricity from the Sky (detail) 1805
Benjamin West (1738–1820), a native Pennsylvanian who spent his adult life in England, presented Franklin 15 years after his death as history had come to celebrate him. The subject here is not the man in his mid-forties who described and carried out an experiment with a kite to prove his theory that lightning was electricity, but an impressive elder statesman. His fearless challenge to the stormy skies —assisted by cherubs— reveals Franklin as one of mankind's heroes, a new Prometheus robbing the heavens of their fire to protect human habitations on earth. PMA

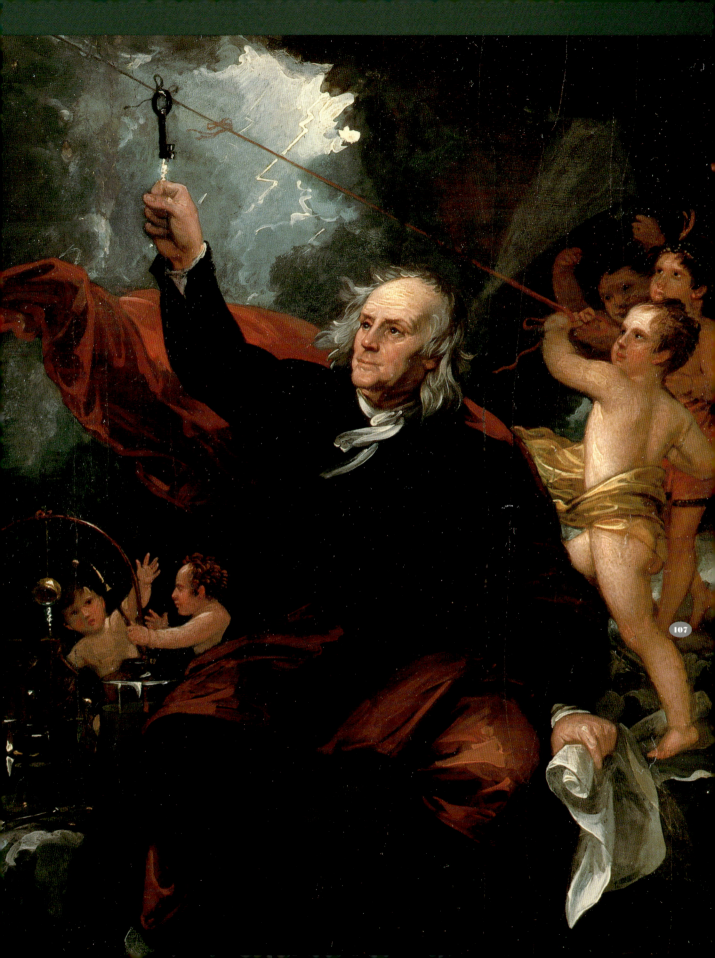

Mason Chamberlin
Benjamin Franklin
1762
*Painted in London while
Franklin was representing
the Pennsylvania Assembly
in its struggles with the
Penns, this oil shows Frank-
lin the scientist. Several
of his electrical experi-
ments are depicted. Out-
side, lightning destroys
structures unprotected by
Franklin's lightning rods*

*(one of which appears on
the intact house just out-
side the window). Two cork
balls carrying like charges
of static electricity repel
each other to the left, just
in front of a bell activated
by electricity drawn from
the storm by the outside
rod.* PMA

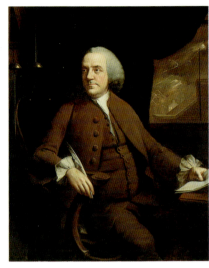

**Battery of Leyden
jars**
c. 1770
*Franklin began to use bat-
teries like these for his
experiments soon after
their discovery at mid-
century.* APS

108

In writing his autobiography Franklin fitted his science into the larger pattern of his life as an American archetype. Recounting the events through which he had lived, he identified the national character of a people less constrained by the authority of tradition than those who remained behind in the Old World. Stretching the boundaries of accepted behavior in social practice and government, Americans as individualists and republicans proved in their Revolution humankind's power to remake its social and political world. Enlightenment ideologues had enshrined progress, maintaining that the present need not defer to the past in pushing at the limits of knowledge or in recasting human institutions. But while European history and tradition had rarely cooperated with the Enlightenment imagination, Franklin was able to present his revolutionary society as a successful exercise in the discovery and exploration of human possibility.

For Franklin and the Revolutionary generation, America's social and political progress essentially fulfilled the promise of Enlightenment optimism and its belief in the unity of knowledge. Achievement in one application of human intellect meant that advances in other areas were to follow. Even as the Renaissance "rebirth" (as they saw it) of science could be taken to presage such events as the American Revolution, so too American revolutionaries could rely on that event's prediction of continued intellectual progress. Philadelphian Benjamin Rush (1746–1813)—physician and revolutionary—could mobilize fellow citizens in favor of his medical challenge to a particularly devastating yellow fever epidemic in 1793 by arguing that "the doors and windows of the temples of nature have been thrown open by the convulsions of the late American revolution." In his intellectual confidence, Rush wrapped himself in the mantle of Newton and Franklin; so too, in his determination to unite the disparate facts of medicine into a usable synthesis, he aspired to the legacy of the giants who had produced unified laws of motion or theories of electricity.

James Earle Fraser
Benjamin Franklin
c. 1938
Founded in 1834, the Franklin Institute is dedicated to honoring the memory of its namesake. The National Memorial to Franklin, which was dedicated in 1938, exhibits a large collection of Franklin memorabilia. FI

Benjamin Rush was one of medicine's great systematizers. John Brown, his teacher at Edinburgh, had reduced all diseases to specific forms of two general conditions: excessive tension and extreme relaxation. Rush went Brown one better, reducing all diseases to one—hypertension—and pronouncing all ill health treatable by the relief of vascular tension, or "depletion" as he called his regimen. This system had some benefits. For one, Rush's confidence was contagious, reassuring patients and thereby promoting health. The historical role of physicians, it should be remembered, was not merely to cure disease (for even today, much disease is not amenable to cure), but to explain it and to work with the patient as an individual whose emotions and beliefs had to be considered and mobilized in medical treatment. For another, Rush's conviction that all disease was a manifestation of the same underlying condition extended to the insane, who he believed could be returned to health. This led him to argue against their neglect and abuse. Rush's advocacy of treatment for the mentally ill would later earn him recognition as the father of American psychiatry. But with these important exceptions, Rush's medicine and his confidence led down a dead end, making his medical career an object lesson in how quickly the progress embraced by one generation can be rejected by the next.

Rush understood the interrelationship of emotion and vascular tension; anxiety, fear, grief, happiness, and the like figured importantly in whether someone fell ill or recovered. In this regard, his medicine has a distinctly contemporary air. As befitted an incautious revolutionary, however, he placed heroic physiological interventions at the heart of his therapeutics. Rush trusted bleeding and purging above all other treatment to deplete excessive tension in the blood vessels. Bleeding—taking as much as 60 to 80 ounces of blood—and purging with such poisons as calomel, a salt of mercury, were as likely to induce physiological catastrophe as the return of health. But no evidence of untoward results could subvert Rush's faith in his system. For one thing, none of his contemporaries possessed more than anecdotal knowledge of the results of various treatments. And, for another, physicians advocating competing systems argued their merits in the manner of medieval scholastic disputations, more as philosophers than as scientists concerned with experiment or evidence.

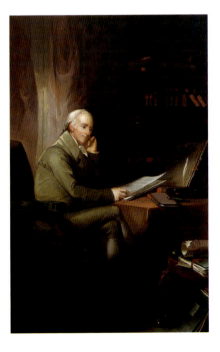

Thomas Sully
Benjamin Rush
1813
Benjamin Rush, a signer of the Declaration of Independence, remained politically active throughout his career as one of the nation's leading physicians. He practiced at Pennsylvania Hospital, where this portrait—executed after his death—hangs. PAH

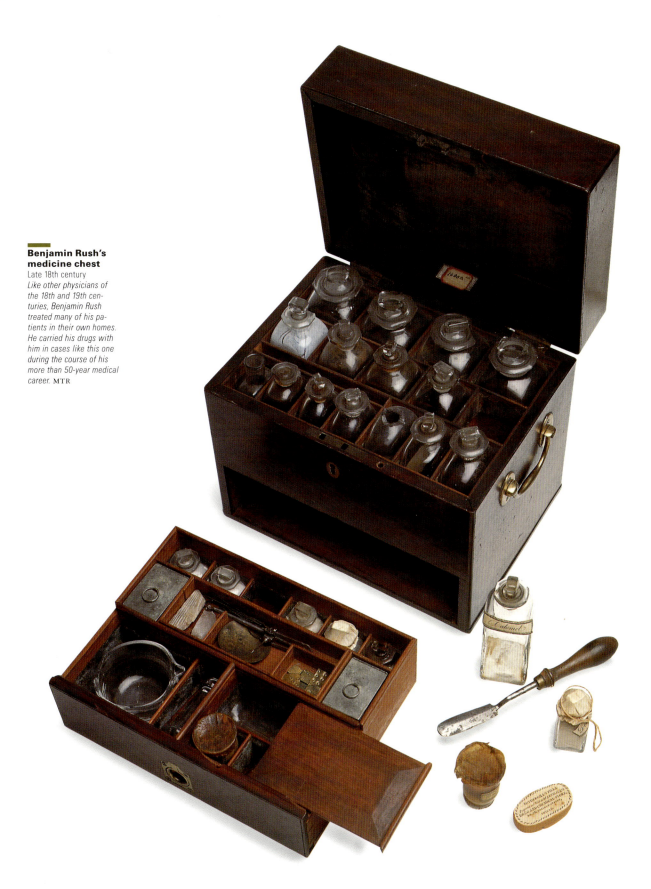

Benjamin Rush's medicine chest

Late 18th century
Like other physicians of the 18th and 19th centuries, Benjamin Rush treated many of his patients in their own homes. He carried his drugs with him in cases like this one during the course of his more than 50-year medical career. MTR

Thomas Sydenham
Medical Observations
1809
Benjamin Rush edited this first American edition of Thomas Sydenham's Medi-cal Observations. Syden-ham is particularly noted for elaborating the symp-toms and courses of measles, dysentery, gout, and syphilis. CPL

112

William Wood Gerhard
Journal medical
1834
Philadelphia's William Wood Gerhard (1809–1872) was the first American phy-sician to make a major contribution to the new scientific medicine. After study in France, Gerhard pursued the clinical inves-tigation of epidemic fevers at Pennsylvania Hospital and at Blockley (the munici-pal almshouse hospital, later called Philadelphia General Hospital). In 1837

he was able to establish distinct pathologies for typhus and typhoid, thereby differentiating them for the first time as separate diseases. Three autopsies at Pennsylvania Hospital— dated 10 April 1834—are described in the first Ameri-can entries he made in the journal medical that he began to keep while studying in France. CPL

Ancienne Maison Jolliot.

2 18

Hôpital de Pennsylvanie

[handwritten French clinical notes, largely illegible]

Coming after two centuries of intellectual triumph, 18th-century medicine suggests intellectual failure. It was a failure born, ironically, of success. A growing reliance on observation had generated information in medicine no less than in the physical sciences. The great English clinician Thomas Sydenham (1624–1689) was only the most notable of a number of physicians who turned in the 17th century to establishing the symptoms of dozens of discrete diseases and describing their natural histories; Rush actually edited American editions of Sydenham's *Medical Observations*. The accumulation of facts overwhelmed practitioners; it put a premium on systems that could organize disparate data and make them useful. The elegant mathematical systems appearing in the physical sciences further stimulated systematic thought in medicine. Rush—no less than Franklin—believed himself the inheritor of Newton's legacy.

The modernization of medical knowledge came only after medicine reoriented itself around hospitals in the 19th century. Physicians practicing on large numbers of generally poor patients in these institutions would learn to regard their charges as clinical material rather than as full human beings, as biological mechanisms uncomplicated by emotions and other mysteries not open to full scrutiny. In these circumstances, practitioners focused on disease itself rather than on patients and were, in many instances, able to associate symptoms observed in living patients with results found after death, at autopsy. Over a large number of cases, such observations yielded statistical correlations between visible symptoms on the one hand and underlying pathologies and physiological processes on the other, bringing medicine into the realm of modern science. While Benjamin Franklin was not particularly interested in a setting for scientific medicine when he helped organize Pennsylvania Hospital, America's first, in 1751, it is fitting that he played a role in creating the institutional arrangements that would allow European scientific medicine to take root in the United States. That began to happen soon after his death. Young doctors returned from training in France with the statistical medicine then being developed in hospitals freed from religious auspices by the French Revolution and brought under the control of scientifically oriented physicians.

T. C. Wild [?]
South East View of the Pennsylvania Hospital
c. 1800
The East Building (at right), built in 1755, was the first structure erected for Pennsylvania Hospital. The building is still in use; it houses—along with medical services—a small museum open to the public. The adjoining Center Building displays a 19th-century operating amphitheater and medical library. PAH

The new medicine was but one aspect of the 19th century's embrace of a materialistic culture that divested itself of spiritual emphasis. The new doctor was a modern personage, handling the body as a piece of physiological machinery and achieving personal recognition through mastery of a changing and growing craft. In the art of Philadelphia painter Thomas Eakins (1844–1916), the physician fully assumed the mantle of a modern icon. Eakins's epic portrait of Dr. Samuel D. Gross operating at Thomas Jefferson Hospital shows the surgeon's power over life. Here, as in much of his work, Eakins obeyed the realist injunction to celebrate heroism in modern life. Gross's bloodied hand and scalpel dominate the composition. The setting is clearly modern; anesthesia —then still relatively new—allows Gross to operate slowly, to carefully cut out dead thigh bone instead of amputating the leg, as the surgeon of a generation before might have done in similar circumstances, and to interrupt the operation to lecture about the surgical procedure. The patient's mother, the only figure to turn away and cover her face, emphasizes the scientific impersonality of the amphitheater of medical students and colleagues, all closely following Gross. As is true of artistic realism in general, Eakins's work is suggestive of the orientation toward factual knowledge inspired by the expanding science of his day. Eakins himself had been attracted to scientific inquiry. He knew Gross through his own study of anatomy at Jefferson; he had also dissected at French hospitals as part of his artistic training.

Thomas Eakins
The Gross Clinic
1875
Now widely celebrated as one of the greatest 19th-century American paintings, Eakins's The Gross Clinic originally generated a mixed response. The painting's uncompromising realism—the patient reduced to his buttocks, the copious blood—troubled viewers who expected art to explore themes more traditional and refined than bloody surgical operations. The art jury for Philadelphia's Centennial Exposition rejected the canvas, and it hung instead in the Centennial's medical exhibit. JMC

116

Eadweard Muybridge
Animal Locomotion, human series
1887
The men Muybridge photographed were mostly University of Pennsylvania research staff, and the women were evidently paid artists' models. AKM

Eakins also worked briefly on a scientific project at the University of Pennsylvania in the mid-1880s, helping Eadweard Muybridge (1830–1904) develop methods of photographing animal and human motion. Each of the 781 plates of *Animal Locomotion* (1887)—Muybridge's masterpiece—depicts a time-motion sequence. It was Muybridge's goal to break motion down into its simplest component processes. He photographed animals walking and running at different speeds and under various conditions; humans walked, ran, sat, kneeled, crawled, carried various loads, watered plants, swept, danced, and smoked cigarettes. Muybridge had evidently begun this work at the behest of horse breeders; his photographs of humans proved useful to industrialists embracing the new scientific management of the turn of the 20th century. By the time he did his work, the notion that human beings might be usefully regarded as machines was no longer foreign. Nor was it particularly troubling to view humans as a special case of animal life.

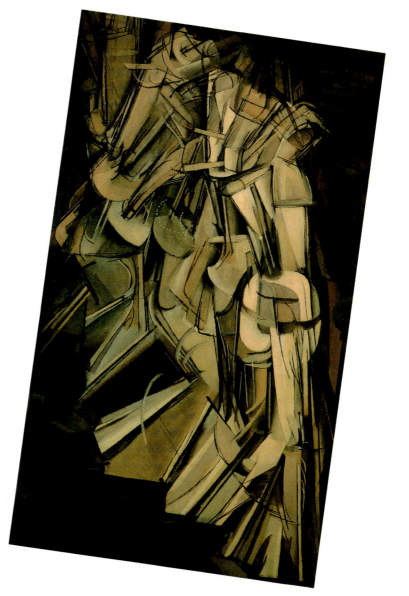

Marcel Duchamp
Nude Descending a Staircase, No. 2
1912
The inspiration of photographic studies of motion is obvious in Marcel Duchamp's abstract figure reduced to its mechanical essentials. PMA

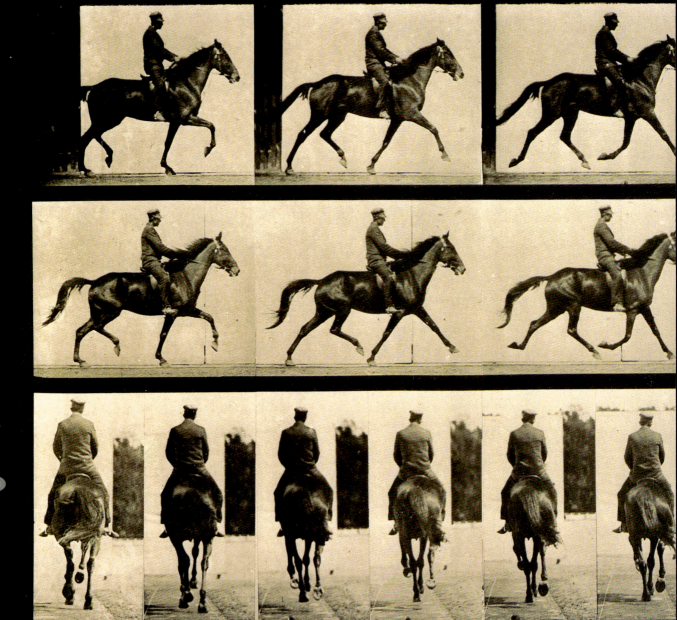

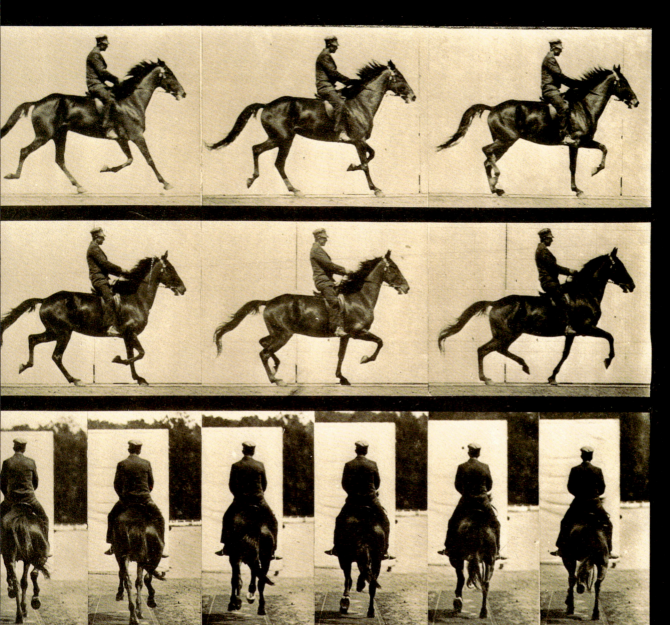

Eadweard Muybridge
Animal Locomotion, horse series
1887

One of Eadweard Muybridge's first questions was whether a galloping horse ever has its four feet off the ground at the same time; it does. The project employed horses from a local stable and wild animals and birds from the Philadelphia Zoo. AKM

Charles Darwin (1809–1882) had anticipated parallels between human and animal life and done considerably more. In demonstrating the common ancestry of living organisms in *On the Origin of Species* (1859), Darwin had challenged the scriptural account of creation and effected the biological counterpart of the 16th- and 17th-century revolution in the physical sciences. By marshaling evidence that the world's life forms (like its land mass and its environments) had evolved, Darwin argued convincingly against the broadly held notion of the immutability of species and therefore against the reliability of inherited knowledge. Like Copernicus, Darwin created a more dynamic universe than had hitherto been imagined. Even as Darwin diminished humankind's role in the center of divine creation,

he—like Copernicus—expanded human intellectual horizons. Despite criticism that Darwin had presented a brute, mechanical, and soulless universe, his explanation of evolution achieved wide acceptance within a generation; the fact of human presence on earth was no longer so mysterious that it required supernatural intervention or other myths to account for it. Evolution explained the biological world just as surely as Newton's law of universal gravitation governed the physical universe. Humans could understand—indeed, they had discovered—both.

Darwin had not been the first student of natural history to suggest evolution, but his systematic and overpowering statement of the case transformed the science of biology. Darwin spent most of the 20 years after his five-year (1831–1836) survey of South American coasts on the *HMS Beagle* developing his analysis and

publishing monographs on coral reefs, earthworms, fossils, volcanic islands, earthquakes, and the like. *On the Origin of Species* presented careful observations of the fossil record, information drawn from embryology and morphology, data about the geographic distribution of plants and animals, and common knowledge about how plant and animal breeders improved their stocks through artificial selection. At the core of Darwin's analysis was his theory of natural selection. Noting that natural populations regularly overproduced offspring and that the tremendous variation within (and among) species advantaged some individuals (and species) over others in the ensuing and unending struggle for survival, Darwin concluded that favorable variations would come to predominate.

Charles Darwin
**Draft title page,
On the Origin of
Species**
1859
*Darwin included this draft
title page in a letter of 28
March 1859 to his col-
league, geologist Charles
Lyell, who had encouraged
him to publish his argument
on evolution in book form.
Lyell had arranged in 1858
for the first public state-
ment of Darwin's theory, a
joint presentation before
the Linnean Society in Lon-
don by Darwin and Alfred
Russel Wallace. Wallace
had independently devel-
oped and argued, in a short
paper, the idea of evolu-
tion by natural selection.*
APS

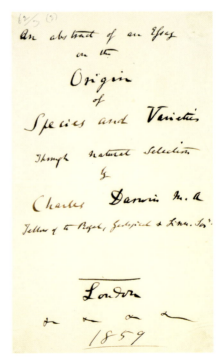

Charles Darwin
**Drawing of
geological strata**
1849
*Darwin used this sketch
to illustrate an 1849 letter
to Lyell in which he shared
his thoughts about how
islands formed through
volcanic activity.* APS

**Joseph Leidy
with thigh bone of
dinosaur**
c. 1858
*In this stereopticon view,
Joseph Leidy sits with the
thigh bone of Hadrosaurus
foulkii after it was ex-
humed in Haddonfield,
New Jersey, in 1858. Leidy
was the first to identify a
dinosaur as such. Erected
at the Academy of Natural
Sciences' original building
at Broad and Sansom in
1868, this was the first
dinosaur to be exhibited
in a public museum. From
studying this and other
specimens of life forms no
longer extant, Leidy came
to believe more strongly
in Darwin's theory of evolu-
tion. Leidy used his role in
a number of Philadelphia
cultural institutions—the
Academy, the Wagner Insti-
tute, the Zoo, and the Uni-
versity of Pennsylvania—
to advance Darwinism.*
ANS

Like Copernicus and Newton before him, Darwin erected a monument to the power of human rationality. More than the work of his predecessors, his contribution came very quickly to play a role in more mundane realms of human power. The scientific breakthrough associated with Darwin was very quickly appropriated to justify economic, social, and political authority.

To be sure, those who had created the 16th- and 17th-century revolution in the physical sciences had not worked in isolation. The Catholic Church had quite clearly understood the challenge posed by Copernicus and Galileo; they, with Newton and like others, had—in a way that is clear only in retrospect—intellectually legitimated the great transformations of their age: the Protestant Reformation, the age of exploration, the capitalist displacement of feudal economic, political, and social systems. In time, many of the books, manuscripts, and artifacts of the new physical science found their way into the hands of individuals and institutions whose positions had been enhanced by these broader transformations. The fact that tangible symbols of intellectual achievement could help legitimate new wealth and new power helps explain the preservation of these 16th- and 17th-century materials and their appearance in contemporary collections. Darwin materials would be put to similar use.

But Darwin was different. At the time of the revolution in the physical sciences, traditional authorities still held sway. By the mid-19th century, science had begun to displace religion and tradition as a source of authority. The proliferation of knowledge from Copernicus through Darwin paralleled economic transformations in contributing to a secularized society. Religious constraints on human possibility continued to give way; notions of mutual obligation and community responsibility were undermined as well. The new economics created wealth beyond reckoning; the new science of evolution seemed to promise those who applied it to human life that unchecked competition and struggle brought progress. This doctrine acquired the name Social Darwinism. Through it, Darwinism—more than any previous science—was put in the service of an ideology; those who seized upon it in the second half of the 19th century used it to justify the nastiest and most brutal exploitation of man by man short of war. Its disciples invoked Social Darwinism to excuse imperialism abroad, and child labor, starvation wages, and racism at home.

We have unraveled many of the old mysteries; indeed, we know answers to questions our forebears never thought to ask. Our culture insists that there is no limit to the power of the human gaze. The heavens and the earth reveal their secrets; our bodies and our beliefs as well come under the scrutiny of human intellect. None of this is to say that the explorers who preceded us fully embraced the prospect of such complete revelation. Newton may have spent as much time in mysticism and alchemy as he did in what we recognize as science. And Darwin remained a committed Christian.

American Eugenics Society album
1923

The American Eugenics Society organized in 1916 to propound its own version of Darwinism: the message that "better" races should breed more prolifically and "inferior" races should limit their reproduction. The organization flourished until the horrors of Nazism undermined public support for its racist agenda. The Society campaigned for compulsory sterilization and eugenic marriage laws; it also pursued its aims through a program of public education that included "fitter family contests." These were especially popular at midwestern fairs in the 1920s. The winners—like this family selected for honorable mention at a Kansas fair in 1923—personified the "Nordic" racial ideal. The American Philosophical Society holds perhaps the largest collection of archival material on the eugenics movement in the United States. APS

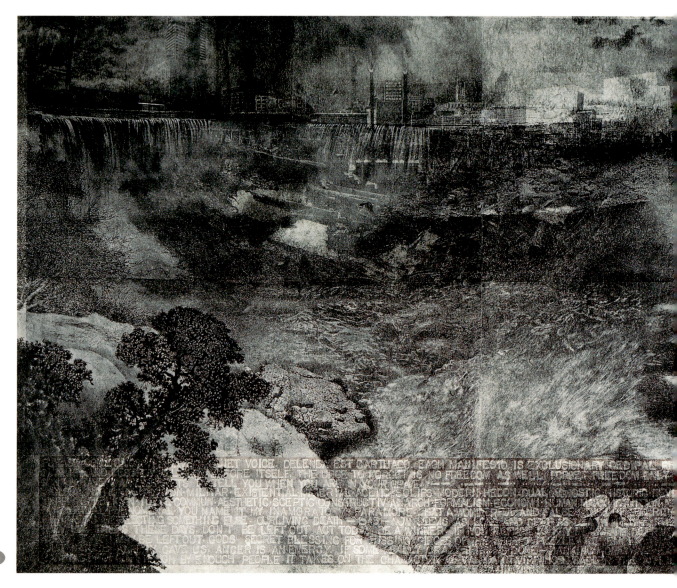

Anthony Petr Gorny
Centers of Power
1982–1986

This contemporary print by Anthony Petr Gorny (1950–) suggests the discomfort some feel with the way we have recreated the world. An idyllic land-scape of Niagara Falls— along with Christ's head —graces the front of this print. Held up to the light, the reverse image shows though these traditional icons, revealing the mod-ern skyline of Philadelphia, an enormous construction pit, and a Bethlehem steel plant. The lower edge of the reverse image juxta-poses words and phrases suggesting older values as well as contemporary

hopes and anxieties—the artist's reminder that, for many, the dream has failed. The modern collections of the Pennsylvania Academy of the Fine Arts—like its holdings in 19th-century American art—reflect the institution's continuing role as both museum and school. Since its founding in 1805, the Academy has actively collected and dis-played the art of the day, using this art to help train students for roles as the artists of their day. PAFA

This century has realized much of the promise of half a millennium of exploration and discovery. Our age, more than any other, has capitalized on humankind's intellectual mastery. We hold secrets to make life longer and more comfortable; our reach extends into the very heavens where once the greatest of secrets held dominion. But the history of our own time gives us pause as we survey the progress we take as our birthright. The devastation contemporary humankind has inflicted on itself demonstrates that knowledge can give rise to tyrannies no less horrible than those rooted in what we dismiss as ignorance.

Hana Geber
O the Chimneys
(detail)
1984
This image of the Holocaust by Hana Geber (1910–) represents an artistic effort—40 years after the fact—to come to terms with the horror of which the modern world is capable. NMAJH

As even more of the universe is engaged by human rationality—as the atom and the gene reveal their secrets to our intensified gaze—it remains clear that not all phenomena yield equally to the authority of intellect. There is, to be sure, no want of explanation for the processes of our own minds, but judicious reflection argues for intellectual modesty in efforts to subject creativity, emotion, and faith, good and evil, to the scrutiny of reason. Some voyages of discovery lead only to *terra incognita,* to the reminder that we sometimes experience what we cannot fully understand. Children and adults alike embarking on Maurice Sendak's voyage of psychological exploration in *Where the Wild Things Are* are reminded that fears accompany them on these journeys of discovery.

These fears are personal. But this artistic vision is at the same time powerfully symbolic of the terror that goes along with the responsibilities we have assumed in creating a world that is not altogether within our control.

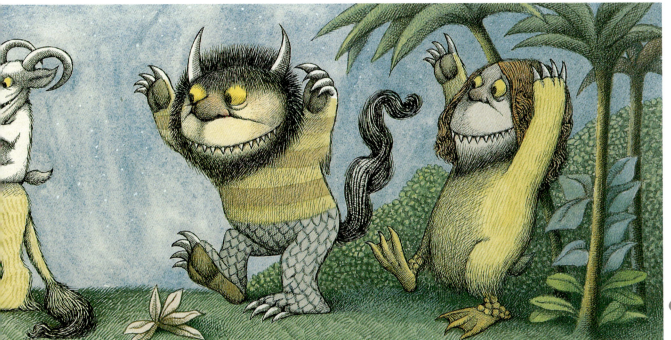

Maurice Sendak
**Where the Wild
Things Are**
1963
*Maurice Sendak's draw-
ings for* Where the Wild
Things Are *(1963)—and
for 79 of his other books—
are at the Rosenbach Mu-
seum and Library.* ROS

La Bible historiale
2nd half of 15th century
This manuscript Bible has miniatures illustrating various sections. Here, God rests after the six days of Creation. FLP

The World We Have Lost

**Enmerkar and the
Lord of Aratta**
c. 1750 B.C.
The Sumerian epic Enmer-
kar and the Lord of Aratta
*includes an account of a
time when neither danger-
ous animals nor calamities
threatened mankind, and
when all human beings
spoke the same language,
obeyed divine laws, and
were ruled by a benevo-
lent deity.* UM

Memory is the heart of culture. Human communities look to art and literature, myth and belief, to preserve the experience of the past as a foundation for the present and future. By nature imperfect and selective, cultural memory is determined as much by how a group sees itself as by what it has lived through.

Few memories pervade culture more powerfully than those recalling a golden age, a remote time so implausibly perfect that its details—in many cases its very existence—are as likely to be invented as real. An acute regret for the loss of a cherished perfection is as old as human memory. Equally ancient is the principle shaping the content of such memories: the specifics of a lost age speak to the present, offering reassurance in the face of adversity and renewing hope in the face of despair. Societies animated by mythic golden ages rely on them to explain and compose experience in their own time. Such myths operate most compellingly in traditional communities, where culture is essentially spiritual and concerned with fundamental questions about the meaning of life and the role of humankind in the cosmos. Yet mythic golden ages survive in our more secular culture, sometimes embedded in sacred observance and dogma, sometimes abstracted of meaning—cultural relics or hollow reminders of once vital beliefs.

Almost every people has its Eden, its memory of a perfect time in a distant age. Whether the Judeo-Christian Garden of Eden, the Sumerian Enki's Spell, or Roman myths about the reign of Saturn, these utopias were places of peace, harmony, and simplicity, lands of plenty blessed by comfort, joy, and pleasure; many were peopled by carefree individuals giving themselves over to a sensuous hedonism. A blissful security—a sense of order and innocence—infused these Edenic visions. No dangers or anxieties intruded; no predators lurked; no famine threatened. Strikingly similar in their qualities, these different golden ages suggest that disparate cultures shared common longings for a world less difficult than the one in which humankind has spent most of its history—in privation and under threat, with life likely to be solitary, poor, nasty, brutish, and short.

Stele
8th century
This 8th-century stele— or commemorative tablet —from the Classic Maya period shows a young ruler on his throne with his mother beside him. It represents a time that the Mayas later regarded as a golden age and invoked with particular force as first the Aztecs and then the Spanish overran their civilization in the Yucatan peninsula of present-day Mexico. They explained, for example, that they rose in rebellion and destroyed the great city of Mayapan in the mid-15th century because they were no longer governed by the just kings of their ancient past. Their rulers had become tyrants, even hiring Aztec soldiers to oppress them. This stele was found at Piedras Negras in Guatemala. UM

Echoing creation stories are equally pervasive myths of return and redemption. Banished from paradise for some failing and condemned to suffer in an imperfect and corrupt world, humankind is offered hope of a renewed golden age. This utopia may come at the end of days, or with reentry into a promised homeland at the end of an exile; in the form of Heaven or Nirvana, it follows a good life or a righteous death; it may also appear as universal salvation after the advent of a righteous leader or savior. Life after the return parallels life after creation: humans live once again close to their deity; peace and harmony are restored; and the most onerous burdens of life in the everyday world are lifted. The prophet Isaiah promised that nations would beat their swords into plowshares and their spears into pruning hooks. Some of the legends concerning Maitreya, a Buddhist tradition that peaked in the early 6th century A.D., contain a roughly similar prophecy. Its followers expected that the Buddha of the Future—Maitreya—would be born 5,000 years after the death of the historical Buddha, ushering in an age of compassion and grace. Some messianic cults believed Maitreya might appear whenever the world was especially threatened. More specific in its redemptive terms was the late 19th-century Native American religious movement centered on the Ghost Dance. Its adherents—primarily Native Americans newly forced onto reservations—were promised that if they observed its rituals, a new age would dawn, the dead would return to life, game animals would once more be abundant, and the white man would disappear.

Book of Isaiah, Gutenberg Bible facsimile
1913
One of the earliest Judeo-Christian return myths appears in the book of Isaiah. This version is from the Gutenberg Bible (c. 1455). This was the first book printed with movable type. Though this represented an important technological advance, Gutenberg's typeface resembled the calligraphy of the period; the hand-colored decorative motifs similarly duplicated illuminated manuscripts of the time. FLP

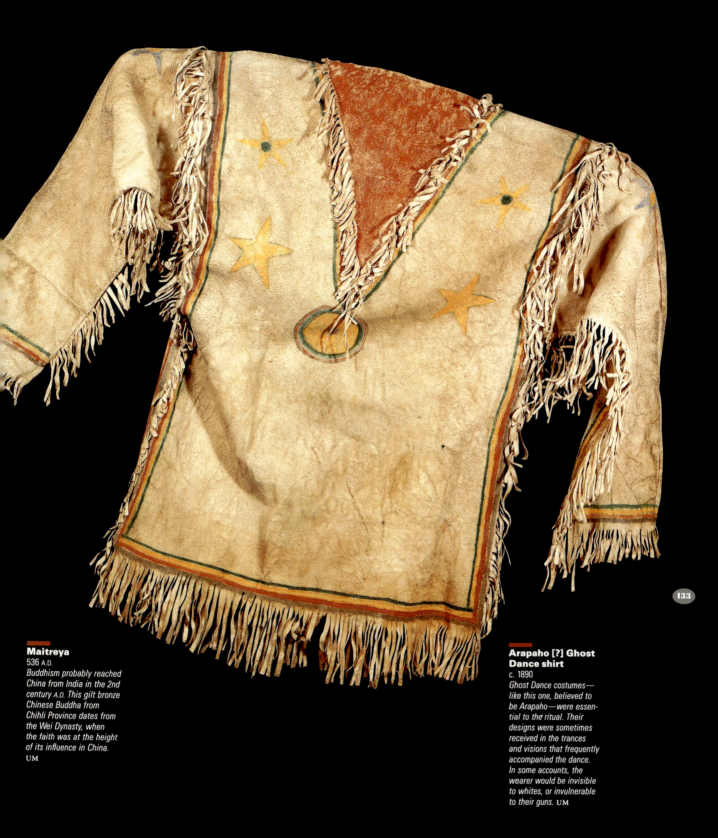

133

Maitreya

536 A.D.
*Buddhism probably reached
China from India in the 2nd
century A.D. This gilt bronze
Chinese Buddha from
Chihli Province dates from
the Wei Dynasty, when
the faith was at the height
of its influence in China.*
UM

**Arapaho [?] Ghost
Dance shirt**

c. 1890
*Ghost Dance costumes—
like this one, believed to
be Arapaho—were essen-
tial to the ritual. Their
designs were sometimes
received in the trances
and visions that frequently
accompanied the dance.
In some accounts, the
wearer would be invisible
to whites, or invulnerable
to their guns.* UM

Because they arise from the most basic human needs for reassurance and hope, origin myths and return themes reverberate through many cultures, with parallels in communities separated by dozens of centuries and thousands of miles. They dominate many of our religious traditions; even secular cultures honor these elemental utopias through repeated reference, often recreating them to meet the particular needs of their own time and place.

Pennsylvania's early Quaker settlers believed they were creating a community based closely on God's laws even as they proceeded to establish a prosperous settlement in the American wilderness. The colony conducted its early relations with the Indians according to an almost Edenic vision. The general themes of peace, harmony, simplicity, and the relative equality of all men similarly recalled biblical ideals, but this was not meant to be a utopia abstracted from the commerce of everyday life. Over time, material success eroded some of the spiritual intensity of the Society of Friends. Some early 19th-century Quakers seeking a return to the values animating their forebears precipitated a schism that would divide the faith for a century and a half. Seeking to resurrect the ideals of simplicity and equality, these schismatics drew easily on the classical statement of the theme of return in the Judeo-Christian tradition—the prophecy of Isaiah. Sometime Quaker minister, schismatic, farmer, and signpainter Edward Hicks (1780–1849) presented this theme visually in *The Peaceable Kingdom,* a painting he produced many times in several variations over a quarter of a century.

Hicks evidently modeled his first Peaceable Kingdom in 1825 after a contemporary English engraving that reproduced and illustrated the lines from Isaiah 11:6 about the wolf and the lamb, the leopard and the kid, the young lion, the fatling, and the little child. Hicks set his scene—in this and other versions of the painting—against a backdrop of America's natural scenery. He often placed in the background Quakers and Indians negotiating under the Treaty Elm in Shackamaxon. To make inescapable his many-leveled references to the biblical ideals of early Quaker settlement and the hope that these values might be reestablished in the midst of the schismatic contention of his own time, Hicks paraphrased Isaiah around the borders of the painting.

134

Edward Hicks
The Peaceable Kingdom
c. 1827–1832
The ebb and flow of public regard for Hicks's Peaceable Kingdom paintings ironically restates the return theme. Long out of favor, Hicks's primitivism began to return to fashion when the politics and culture of the Great Depression and the American folk art revival of the 1930s focused attention on the life and art of the common man. SC

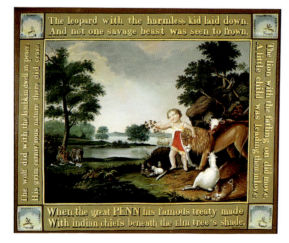

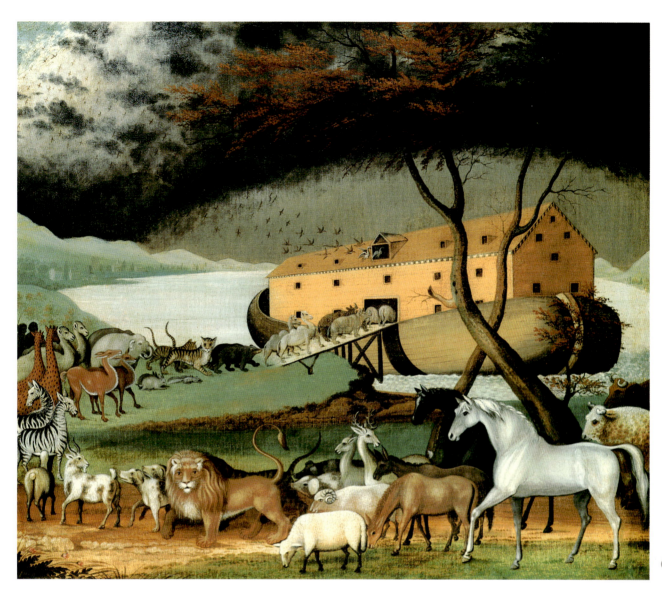

135

Wampum belt
1682
This wampum belt of oyster shells and leather reportedly presented to William Penn by the Lenni Lenape at the 1682 Treaty of Shackamaxon has, more than any other single artifact, been taken to symbolize early Pennsylvania's honorable treatment of the Native Americans of the Delaware Valley. Penn had written the local chiefs of his intentions toward them before he arrived in the colony: "The king of the country where I live hath given me a great province, but I desire to enjoy it with your love and consent, that we may always live together as neighbors and friends." The slight, small figure is an Indian; the bulky figure a Quaker. HSP

Edward Hicks
Noah's Ark
1846
Noah's Ark let Hicks restate his theme with a slightly altered subject matter. PMA

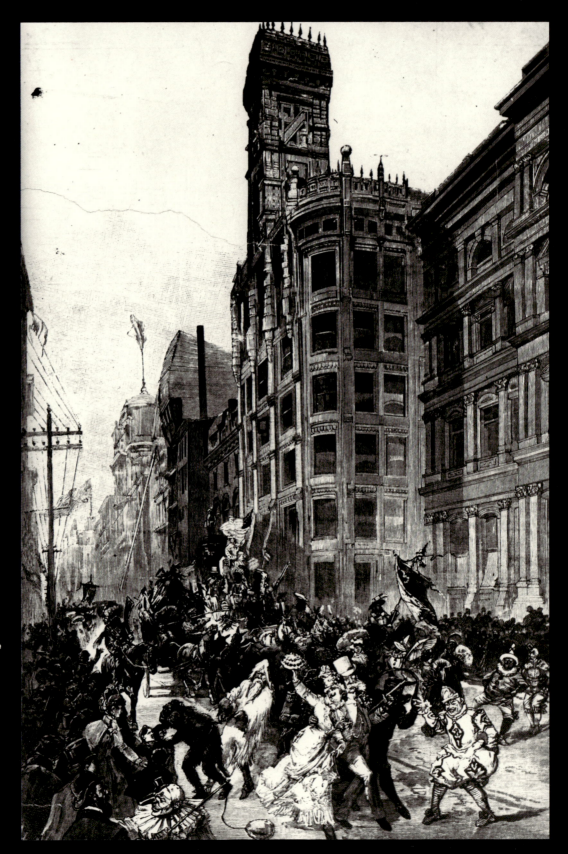

Harper's Weekly
**Philadelphia
Mummers' Parade**
14 January 1888

This same blend of sacred and secular, of multiple pasts and simultaneous presents, marks the Mummers' Parade, another cultural manifestation of origin and return myths intimately associated with Philadelphia. Rooted in a pagan view of the universe that early Christianity easily absorbed, mummery is on one level a resurrection fantasy. We can imagine the despair of primitive European peoples as autumn and winter brought ever less daylight, ever colder temperatures, fewer nuts and berries to gather, and fewer animals to hunt. Seemingly abandoned by their protecting deities, communities looked for promises that the earth itself would not die. Evergreen trees, their still-laden branches offering some reassurance of continuing life on even the darkest days, came to occupy mid-winter positions of honor among pagans and their Christian descendants alike. Similarly, mummery— in its reenactment of human death and rebirth—celebrated the return of longer days and with them a renewal of the earth's fertility after the winter solstice.

But mummery is more unabashedly pagan in the Edenic vision it offers. By dressing up in the skins of animals and the feathers of birds, men express their longing for that golden age in which they were undifferentiated from nature. Dressing as women in the same way signals a desire for (or a memory of) that prehistory before there were two separate sexes, before woman—as the story has it—introduced man to knowledge and precipitated the expulsion from paradise. Eden, as celebrated by the Mummers' Parade, is a condition of preconsciousness when humankind was not burdened by knowledge, particularly by the knowledge of its own mortality.

Contemporary participants in the Mummers' Parade are unlikely to be animated by these essential impulses. Indeed, the parade as we know it has been so institutionalized that much of its historical meaning has evaporated. Also lost to public memory are the reasons late 19th-century Philadelphians came to organize the parade in its current form— with ordinary citizens taking one day off from their regular routines each year to mock the pretensions of their presumed betters and to put on airs of their own. This was a moment of historic change, as an emerging urban industrial society began to demand ever greater sacrifices of spontaneity and individual autonomy in the name of the discipline necessary for a smoothly functioning interdependent community. The parade offered a fantasy message of license and social equality, a temporary escape from order and discipline, a momentary return to the bliss and hedonism of a lost golden age.

Though strikingly different in theme and appearance—one a quietly reflective rural idyll, the other a raucous urban scene sanctioning abandon—the Peaceable Kingdom and mummery similarly evoke chimerical golden ages. But dreams of lost worlds are not animated by timeless myths alone. More historically authentic experiences have come to be idealized, particularly as modernization has accelerated the pace of change in recent centuries. Rapid social transformation has forced the regular rejection of apparently outmoded practice and belief, and their almost as regular rediscovery and rescue. What one generation discards in the name of progress, a later one recovers and reveres as emblematic of its ideals. The very pace of change has transformed history into myth.

138

Seymour Mednick
Mummer
1985

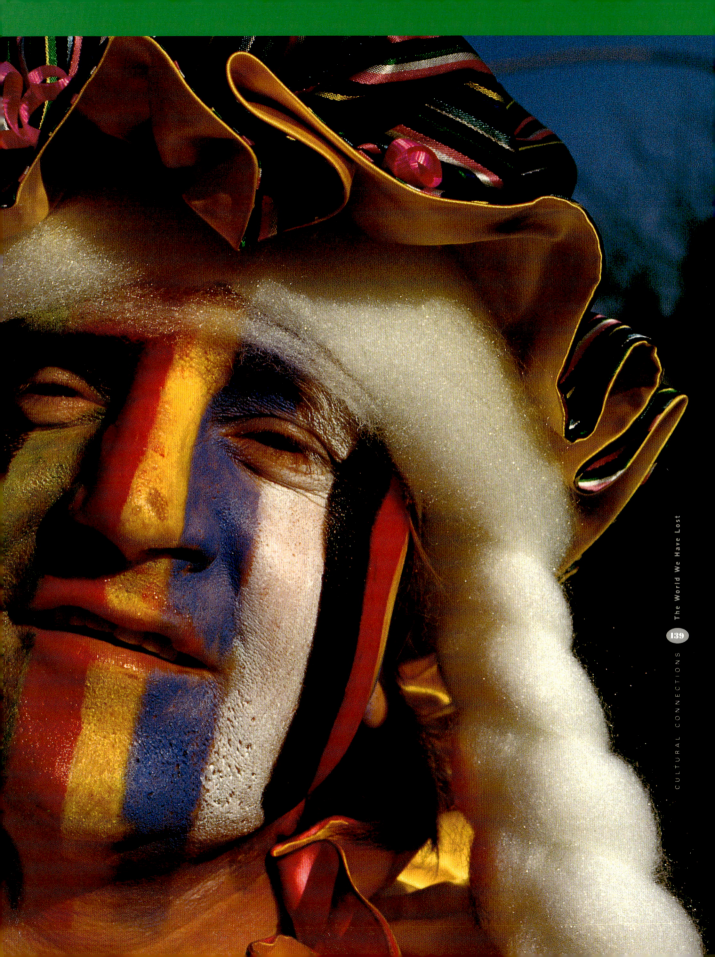

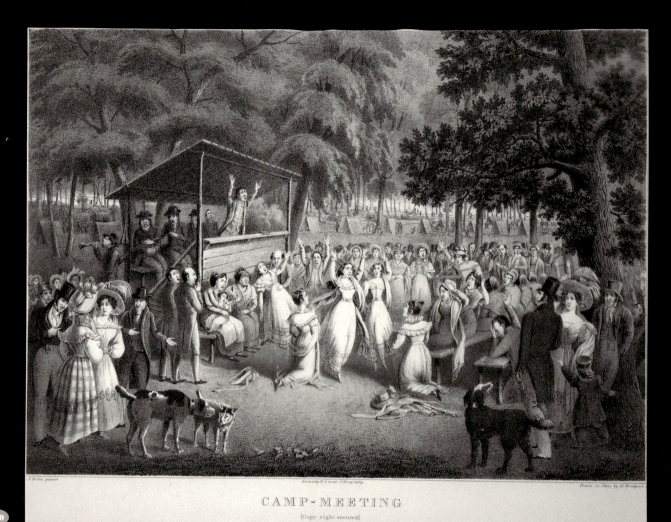

CAMP-MEETING

[Copy-right secured]

Alexander Rider
Camp Meeting
1830
Alexander Rider, a German immigrant painter, captured this Philadelphia-area revival with the sensibility of a distanced observer, almost caricaturing the camp meeting to offer a commentary on an important social phenomenon. Rider called attention to the different ways in which Americans regarded

revivalism. The fashionable and well-dressed —perhaps those least troubled by material success—hover on the fringes, while the homespun listen in devout attention; the drunken-looking man suggests the difficulty of reaching those most in need of the revivalist's message. That women— some in religious frenzy— dominate the "anxious seat" in front of the preacher is a reminder that American churches were becoming feminized.

Women—who were less active in the public economy—assumed ever greater responsibility for moral and religious concerns and for much of the direction of the nation's Protestant churches. The Philadelphia lithographic printing company of Kennedy and Lucas published this print. LCP

This is particularly the case in the United States, where those who abandoned the Old World for the New never fully succeeded in recreating a stable society governed by fixed rules and enduring traditions. Buffeted by permanent economic, political, social, and cultural revolutions, Americans transformed the mundane details of their national experience into a succession of golden ages, utopian interludes recalling—and promising—permanence and security.

As befits origin myths, America's starts with memories of its earliest European settlers. But a people self-confidently exploiting a continent and building a nation had little time to pause and reflect on its origins. The 17th and 18th centuries only began to emerge from the complicated messiness of real life and into the clear light of myth during the course of the 19th century. By the 1820s and 1830s, many Americans had come to fear that the geographic expansion, growing cities, and increasingly powerful market economy bringing their nation material success simultaneously undermined its traditional communities and its way of life. The dominant values of the age applauded economic growth and the environment of unprecedented competition that was an unintended legacy of the American Revolution. Some quieter voices questioned less attractive manifestations of the unrestrained individualism that paralleled the flowering of the American economy. Particularly worrisome were the rapacious greed with which many of their countrymen set to their tasks, the straining of the social fabric as Americans pursued their own interests with ever less respect for the concerns of others, and the insecurity and loneliness that beset a society characterized by competitive individualism. The past came to hold ever more answers—some of them mutually contradictory—for people fearful of the present.

Many found their answers in the Great Revival of Protestant Christianity, one of the most important features of early 19th-century American life. Revivals spread across the landscape, engulfing town after town as itinerant preachers brought their message of old-time religion to camp meetings and organized churches alike. Clashing with the increasingly secularized values that accompanied economic growth, the Great Revival promised that a return to the faith of Puritan forebears would restore the sense of community weakened by predatory individualism and material prosperity, thereby rebuilding the godly commonwealth.

A newly emerging myth of the frontier attracted others. In celebrating rugged individualism and in creating an American hero in the often solo guide, hunter, trapper, or Indian fighter, the frontier myth was inconsistent with the religious revival in some of its aspects. Westward movement frayed the bonds of community—and many Americans feared where an untrammeled individualism might lead. But in raising the frontier experience to the level of myth, Americans transformed the economic exploitation of the western wilderness into a reprise of the heroism of the early colonists. The frontier represented authenticity, and honest experience and feeling uncorrupted by civilization's disingenuous refinement and materialistic pleasures. Frontier heroes subjugating the West for their own economic benefit could be understood as acting selflessly on behalf of the nation and in tune with its highest values. The frontier became a reminder of the real America even as the individualism it fostered undermined such fundamental American values as republican community and civic virtue.

Nathan Wheeler
Andrew Jackson
1815–1816
This oil painting by Nathan Wheeler is the earliest known surviving likeness of Andrew Jackson, the nation's first genuine western hero. Jackson first came to national attention as an Indian fighter, leading the Tennessee and Kentucky militias in the Creek Campaign of 1814. Wheeler painted Jackson in New Orleans in 1815 or 1816, soon after the General had successfully defended the country's leading western port in the nation's most dramatic success against the British during the War of 1812. The crudeness of this image was perfectly appropriate for Jackson, who counterpoised his western roughness against eastern sophistication in a political career that made him the first westerner to occupy the White House. HSP

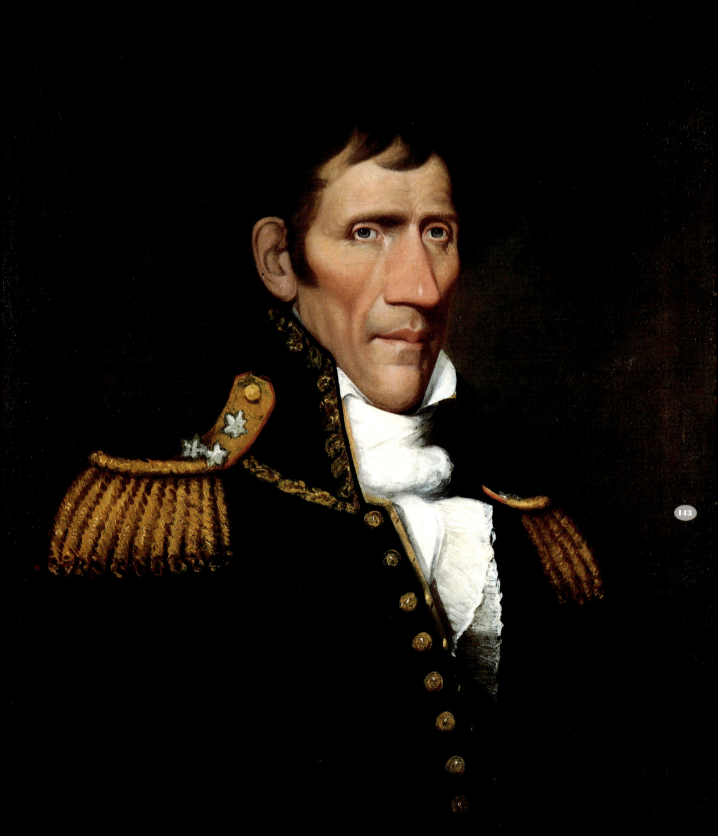

How dear to this heart are the scenes of my childhood,
When fond recollection presents them to view!
The orchard, the meadow, the deep-tangled wild-wood,
And every loved spot which my infancy knew!
The wide-spreading pond and the mill that stood by it,
The bridge and the rock where the cataract fell,
The cot of my father, the dairy house nigh it,
And e'en the rude bucket that stood by the well —
The old oaken bucket, the iron-bound bucket,
The moss-covered bucket which hung in the well.

Stephen Foster
Old Black Joe
1860
*The songs of Stephen Foster
—among them "Swanee"
and "My Old Kentucky
Home"—helped create
the antebellum image of a
South steeped in tradition
and deeply committed to
a community life based on
mutual obligation. Foster
was a northerner; born in
present-day Pittsburgh in
1826, he turned full time
to songwriting to support
himself after the success
of "Oh! Susannah" in 1848.
He wrote a number of Civil
War songs in support of
the North before dying
penniless in New York's
Bellevue Hospital in 1864.*
FLP

The vague nostalgia expressed in early 19th-century rural idylls presented a domestic version of the frontier myth in its reminder of bucolic country life during an era of explosive urbanization and economic development. Songs—like "The Old Oaken Bucket," "The Old Folks at Home," and "Home, Sweet Home"— as well as broadsides, lithographs, and other popular culture forms harked longingly back to childhood scenes, to the simple joys of everyday life, and to quiet, unrushed times populated by caring, embracing families. Idealized memories of family life assumed great significance; ties among parents and children, brothers and sisters, offered an obvious antidote to the risks of isolation and anonymity. To know that one was the product of a time, a place, and the people who gave one life and among whom one lived was to know that one was not completely on one's own. Knowing your place—literally— meant that you did not need to create your identity from whole cloth. It eased the crushing burden of responsibility imposed by an economic and social system that established individual achievement as its touchstone of personal worth. Home and family have always symbolized continuity and rootedness, but they assumed exaggerated importance as great numbers of Americans forsook both in their cityward and westward rush for material success.

The South offered the most completely developed alternative to the chaos of an individualistic age. Frightened by the economic and social transformation clearly visible around them, southerners idealized an already vanishing way of life and clung to it as an accurate representation of the South. They argued that their plantations were organic, cohesive communities, providing the security and stability of roots sunk deep in the past and the tight embrace of emotional bonds linking young and old, black and white, in the present. They presented the plantation not as a business but as a family, governed by sentiment and a code of honor rather than by calculation and greed, and presided over by an aristocracy that valued tradition above all else. Slavery itself was as much a communal living arrangement as a system of enforced labor. Everyone had a place in this idealized vision, and everyone had the comfort of being connected with everyone else. It was slaveowners and their apologists, of course, not slaves, who found something attractive in the very lack of freedom—in the horror— that slavery represented. The southern ideal resurrected feudalism as the ultimate haven in a heartless, grasping America.

Revival religion and frontier freedom, domestic nostalgia and the southern plantation—all offered reassurance and refuge in a modernizing nation that many feared had abandoned its values and lost its way. Americans drew on both past and present in building each of these alternatives; they selected, distorted, and glorified memories of times and places in their history that were, they presumed, more richly imbued with community feeling. They looked backward both to express their doubts about the present and to highlight features of contemporary life they believed particularly worthy. One theme ran consistently through these competing and complementary mythic ages: they were more authentic—that is, less corrupted and more personally fulfilling—than the present. Offering reassurance in times of social turmoil, these myths outlasted the pre–Civil War decades in which they originated. Powerful images drawn from them would enrich the vocabulary to which Americans regularly turned—and continue to turn even in the present—to define themselves and their values.

But if growing numbers of Americans had begun to long for a less troubling past in the decades before the Civil War, they came to do so with a heightened intensity after that conflict escalated into bloodshed. Threatening as it did the nation's very survival, the war required Americans to focus on their experience as a people in order to determine what, if anything, united them and what they might cling to. What were their core beliefs, their essential characteristics? Answers to these questions were essentially historical, drawing on past experience and building myths about the nation's origins and the golden age in which its fundamental values were beyond dispute. Americans transformed aspects of their colonial history into a series of icons meant to define who they were in the late 19th century. Thus was born the colonial revival, which reconstructed the past as a way of reshaping the present.

The present peered longingly into the past through the windows of the "olde tyme" New England kitchens featured in expositions and fairs from the 1860s and 1870s on. These kitchens were central features of the wartime North's historic reenactments, part of the pageantry of the great fairs organized to build civilian morale during the Civil War the admissions fees the kitchens charged helped women's groups support medical and social services for Union soldiers. For the Civil War generation, the colonial kitchen—as women's sphere—presented an important argument about the republic's origins and its durability. Individuals had not created the nation; it had originated in a process as magical as human birth. The nation was not merely a set of social or political arrangements subject to casual alteration, but a living organism whose disruption might cause its death. The nation would survive the war; change—when and if it came—would always have to respect deeply rooted traditions. Like much in the colonial revival that followed these early kitchen reconstructions, this argued implicitly for a fundamentally conservative ideology.

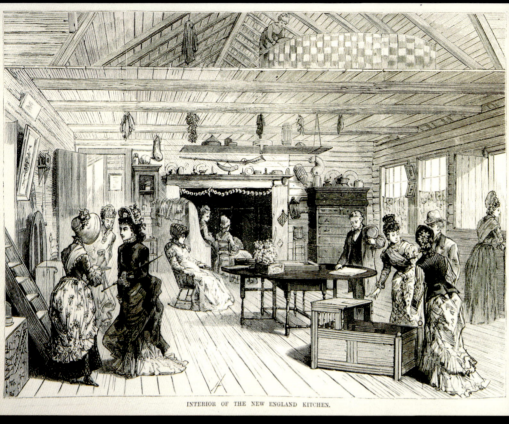

INTERIOR OF THE NEW ENGLAND KITCHEN.

Frank Leslie's Historical Register of the United States Centennial Exposition, 1876

The New England Kitchen

1877

The kitchen captured the essence of domesticity. As the core of the home and the presumed center of womanly life, the kitchen represented—for the 19th century—a safe haven from the manly world of turmoil and threat that lurked outside its walls. The bloodshed of war also focused attention, as it often does, on the crucial roles women played in procreation and nurture. Set back in the colonial era, the kitchen spoke of a more peaceful time as well as of a separate sphere of women's activity. This image is of a later and better-known example of these reconstructions, "The New England Kitchen" at Philadelphia's 1876 Centennial Exposition. This particular kitchen has generally been considered an important precursor of the colonial revival. FLP

147

Colonial Pennsylvania Plantation

Volunteers staff the Colonial Pennsylvania Plantation of the Bishop's Mill Historical Institute, a working farm museum that originated in a mid-1970s Bicentennial project. Unlike most expressions of the colonial revival in the century after the Centennial, the Colonial Pennsylvania Plantation displays how ordinary people lived in the era of the American Revolution.

The message of social and political conservatism embodied in the colonial revival found a welcoming audience in the years after Appomattox. The war had been an object lesson in how little held the American people together; the blood it spilled had offered terrible proof of how profoundly the centrifugal forces of individualism, democracy, and capitalism had disrupted the American nation. In the view of many, matters continued to deteriorate in the latter decades of the century. New social and economic strains accompanied the growing power of corporations, the ascendance of industry, and the rise of cities, as new ways of living and working continued to undermine traditional communities.

By century's end the very nature of the American people was in question, adding to the growing unease and the need for reassurance. The flood of immigration brought ever greater numbers of ever less familiar faces, voices, and manners from eastern and southern Europe to the United States. As if in response, longer-settled white Americans retreated into patriotic and hereditary organizations—the Daughters of the American Revolution, the Sons of the American Revolution, the Mayflower Descendants General Society, the National Society of Colonial Dames, and others—joining together to revere the colonial (and near-colonial) past. These organizations limited membership to individuals who could trace their ancestry to the Revolution, the colonial period, or similar events—to times, in other words, when the nation's bloodlines had been more pure and its unity more obvious. These new patriotic organizations were part and parcel of the colonial revival; both manifested the growing importance ascribed to the nation's origins as its future grew ever more uncertain.

D'Ascenzo Studios
Stained glass window
c. 1920–1928
The Daughters of the American Revolution underwrote the chapel built in the early 20th century to memorialize George Washington's Revolutionary War encampment at Valley Forge; the DAR seal graces the stained glass window in what is now the Valley Forge Historical Society Museum. VFHS

The colonial revival infused many areas of American life in the late 19th and early 20th centuries, but it manifested itself most clearly and materially in the cultural institutions established to proclaim its message. The preeminent example is Colonial Williamsburg, the site of Virginia's early capital, whose restoration John D. Rockefeller, Jr., began to underwrite in the late 1920s. Rockefeller had lavished nearly $80 million on the project by the mid-1930s, creating a scrupulously accurate reconstruction of the town's pre-1790 buildings. Rockefeller was not unique among the wealthy beneficiaries of America's industrial expansion in marking his family's achievement by paying his respects to the nation's heritage. Historic preservation allowed the newly rich to bask in the reflected glory of America's historic elite—in the case of Williamsburg, George Washington, Thomas Jefferson, Patrick Henry, and their like. The reconstructed town actually distorted the past in its overemphasis on the orderly patrician culture created by the planter class and in its almost total inattention to the lives of the great majority of the real Williamsburg's residents.

A simplified past would be the hallmark of the colonial revival, one less complicated and less troublesome in every way than the original. Slavery, the essential feature of Virginia's colonial economy and social system, did not intrude in Colonial Williamsburg. The same absence of social or political conflict or any other messiness would also prevail at Greenfield Village, which Henry Ford began to assemble outside Detroit in the late 1920s. Ford homogenized the past in his collections and reconstructions; his buildings and artifacts covered the colonial period but extended the idealized past all the way to Thomas Edison's New Jersey laboratory. (Edison noted that Ford's reconstructed laboratory was neater and cleaner than the original.) Williamsburg and Greenfield Village were parallel American Edens, nearly perfect in their expression of complementary origin myths. The former enshrined the earliest surviving British settlement in what became the United States; the latter was meant as a monument to the genius, self-reliance, and pioneer virtues on which the nation had depended from the outset and on which its achievement was built.

Port Royal hall
1762
The Port Royal hall came from a Philadelphia house built in 1762. By the time Henry Francis du Pont established the Winterthur Corporation to operate his home as a museum in 1951, Winterthur displayed about 100 American period rooms covering the years from 1640 to 1840. WTR

The Philadelphia area boasts some of the strongest institutional representations of the colonial revival. The most ambitious, Henry Francis du Pont's Winterthur, traces its origins—like Colonial Williamsburg and Greenfield Village—to the late 1920s. Du Pont, scion of one of the nation's greatest industrial fortunes, collected entire rooms of paneling and architectural details—as well as individual antiques—at his estate in Winterthur, Delaware. Like many practitioners of the colonial revival, he preserved the past selectively, presenting in his period rooms primarily the upper-class life of the 13 original colonies and the early Republic. Ironically, du Pont sometimes destroyed the houses from which he removed rooms, adding a particular finality to his decisions about which parts of history were worthy of preservation.

The colonial revival also preserved structures standing in the midst of functioning communities. Indeed, the many important and elegant historic houses now punctuating the local landscape remind us of the success of the colonial revival as well as of the region's rich colonial history. Even as 20th-century economic development and urban growth endangered many older buildings, some—particularly the homes of the colonial elite and houses associated with important patriots or other historic personages—became suitable objects of the preservation impulse. The National Society of the Colonial Dames of America, an ancestral organization, saved Germantown's Stenton from potential demolition in the face of an encroaching city in 1901. The Colonial Dames restored and furnished the house—built by James Logan, William Penn's colonial administrator and later both chief justice and governor of Pennsylvania —in the style of the period from 1730 to 1830.

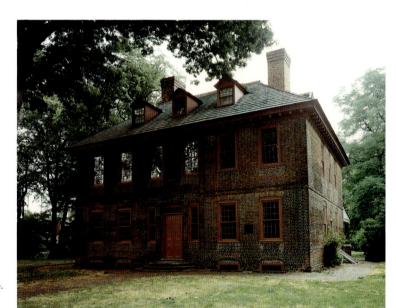

Stenton
1720s
James Logan (1674–1751), one of colonial Pennsylvania's most powerful, best-educated, and wealthiest citizens, built this brick plantation house in the 1720s in the style of English country houses of the period.

Overleaf:
Cliveden
1760s
Benjamin Chew (1722–1810) built Cliveden in the mid-1760s as his country home in Germantown. With the exception of a few years during and after the Revolution (Chew, discomfited by having taken the wrong side in the Revolution, sold the house and then repurchased it), Cliveden stayed in the family until it was acquired by the National Trust for Historic Preservation in 1972.

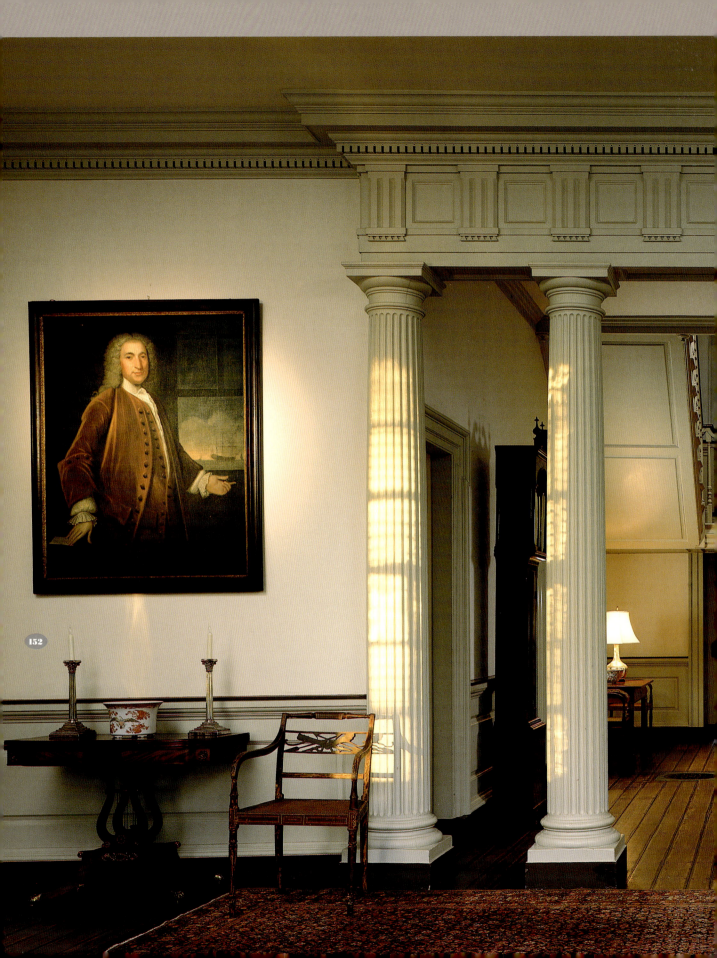

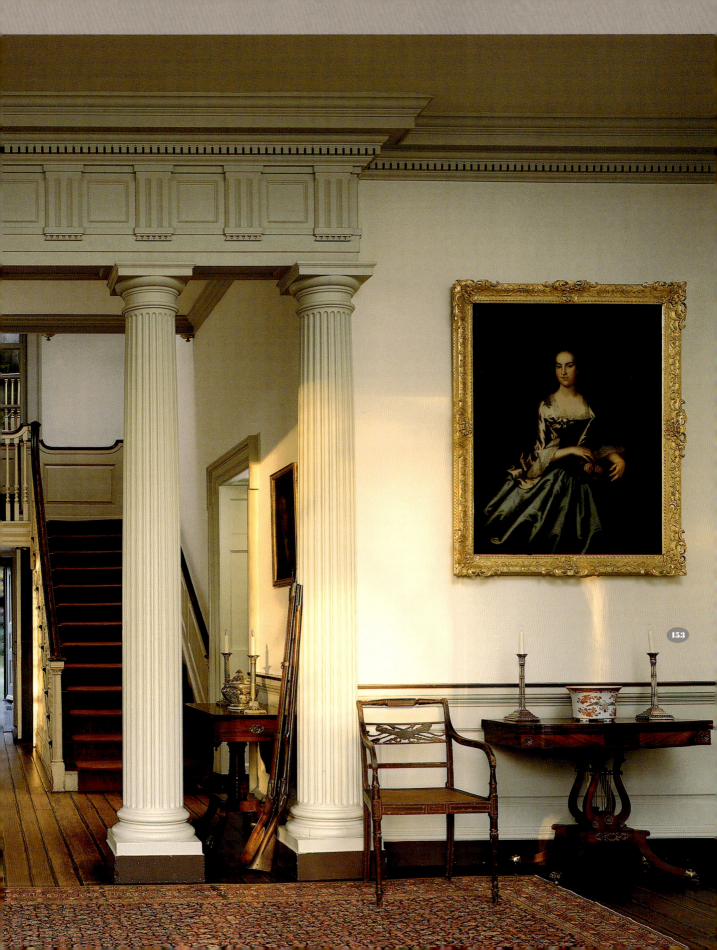

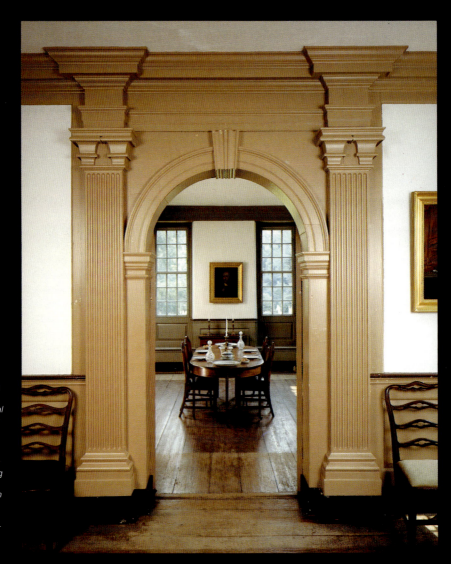

Hope Lodge

Built 1743–1748; restored 1920s–1930s

In the spirit of the colonial revival, William and Alice Degn emphasized Hope Lodge's relationship with George Washington's Whitemarsh Encampment of 1777, when the building was the headquarters of Continental Army Surgeon General John Cochran. The Pennsylvania Historical and Museum Commission now administers the house as a museum of both the colonial period and the colonial revival, showing how the rooms the Degns decorated with colonial artifacts differ from those they furnished in colonial revival style with 19th-century antiques.

Hope Lodge has an essentially parallel story. William and Alice Degn acquired the house in 1922 from a firm that had recently purchased the Fort Washington site in order to quarry stone. Built as an elegant Georgian mansion in the 1740s by Samuel Morris, a prosperous Quaker miller, the house was virtually intact—it had been a farmhouse for 90 years—when the Degns entered the scene as preservationists. William Degn was a wealthy Philadelphia meat packer; he and his wife were avid antique collectors and history buffs. They respected the historical integrity of the house in their restoration, but furnished it with 19th- as well as 18th-century antiques, rented some of its lands to tenant farmers, and left the estate to the public as a museum on Mrs. Degn's death in 1953.

While practitioners of the colonial revival generally presented a one-dimensional history, some took more liberties with the past than others. Two local sites—Pennypacker Mills and Pennsbury Manor—suggest the casual disregard for the facts of the past that sometimes marked the colonial revival's historical idealizations. Samuel Pennypacker actually gutted an authentic colonial farmhouse at the turn of the 20th century to create Pennypacker Mills, a fanciful rendition of an elegant Georgian-style colonial mansion. Pennypacker, who served as governor of Pennsylvania from 1903 to 1907, wanted an imposing home that would establish his credentials as a country gentleman and reflect his conservative political and cultural values. Though only a modest stucco-over-stone German farmhouse, the structure he purchased perfectly suited his purposes. It dated back to the 1730s;

Pennypackers had owned it as early as 1747; and George Washington had used the house as his headquarters in 1777 while preparing for the Battle of Germantown. Pennypacker ripped out almost every original feature—down to the floorboards—and replaced them with mass-produced architectural details meant to appear colonial while providing modern comforts. He framed some pieces of Washington's correspondence as evidence of the home's association with the nation's origins and cluttered the summer kitchen with a spinning wheel and other reminders of the hard work of colonial forebears.

Pennypacker Mills
Built c. 1730; remodeled and reconstructed 1901–1902
Montgomery County purchased the 125-acre Pennypacker Mills site in 1981, in part to keep land open along the Perkiomen Creek near Schwenksville. The county's Department of History and Cultural Arts has preserved the home and its grounds as an example of the colonial revival.

1926
The adulation of things colonial and Revolutionary blended at times into out-and-out Anglophilia, a worship of English roots that seems on its face unfaithful to the intent of the American Revolution. It was in this confused spirit that Philadelphia's Sesquicentennial Celebration of 1926 exhibited a replica of Sulgrave Manor, an ancient English home connected with George Washington's ancestral family—though a home he evidently never heard of during his life. When the Sesquicentennial ended, the structure was moved from the fair site in far South Philadelphia to Chestnut Hill, where it has stood at 200 West Willow Grove Avenue since 1927.

Pennypacker Mills was a private effort; Pennsbury Manor—where William Penn had built a riverfront estate worthy of an English nobleman in the 1680s—was a public project from the outset. The Commonwealth of Pennsylvania launched its most ambitious historical preservation project here after acquiring the site in 1929. Penn's home had collapsed before 1800; the Pennsylvania Historical and Museum Commission used the flimsiest standards of historical authentication in constructing a completely new building over some surviving basement fragments. Various political considerations—including a desire to promote tourism as well as a wish to raise a shrine honoring the Commonwealth's founder—supported construction even in the face of widespread condemnations of the new manor house as a fake.

The colonial revival idealized a golden age; its basic theme was the moral superiority of the colonial past to the late 19th- or 20th-century present. Indeed, the revival was premised on a wide-ranging critique of contemporary life. It assumed that people in the past worked harder and displayed greater craftsmanship, that they were more patriotic and pious, and that they behaved and lived more genteelly. These positive qualities seemed scarce commodities in a present overrun by immigrants, transformed by industry, and overshadowed by urbanization. The aggressive forces of the present threatened surviving remnants of the past; these required preservation. The private possession of antiques and colonial houses allowed the privileged to identify with the more virtuous past and served as statements of gracious living in an age that had fallen from grace. Their public presentation—in museums, historical societies, and houses opened for display—was a political declaration, demanding that the uncouth, noisy, insubordinate, and assertive denizens of contemporary cities recognize and defer to the superior virtue of the orderly and disciplined past.

Contemporary social change animated the colonial revival, causing descendants of an older elite who wanted to exploit the memory of earlier family glories to join forces with the newly rich who could purchase legitimacy by association with the past. But with the broad success of the colonial revival as an origin myth, it transcended its own origins. The colonial revival achieved everyday banality as part of the nation's design vocabulary, influencing the appearance of both suburb and city. It found natural expression in the colonial design elements that graced many new suburban homes beginning in the late 19th century. And it reached significantly into cities with government support of urban renewal preservation and restoration efforts—like Philadelphia's Society Hill—in the 1950s and 1960s and (through tax benefits) 1970s. The colonial revival provided a sense of history and an illusion of permanence in a country that needed both.

Pennsbury

Reconstruction, 1938–1939
In the first significant federal commitment to historic preservation, New Deal public employment projects funded Pennsbury and other colonial revival reconstructions during the Great Depression of the 1930s. It seems ironic that the liberal presidency of

Franklin Delano Roosevelt, committed as it was to an inclusive vision of an American citizenship open to individuals of diverse backgrounds, should underwrite the colonial revival's pinched and restrictive vision of national history. The New Deal generally

premised its cultural and historical job relief projects on the notion that they would make Americans—many of whom were alienated by hard times—feel that they had a stake in their country. In part because of the growing professionalization of historic preservation and museum curatorship in recent years, the state now interprets Pennsbury

to the public as a colonial revival structure, an example of how the 1930s imagined the 1680s.

So too did the arts and crafts movement, an originally British cultural phenomenon that sank deep roots in the turn-of-the-century United States. The movement rejected many features of industrial society and the market economy in its resurrection of more authentic traditions of labor and artistic expression. Paralleling the colonial revival in their critique of modernity, proponents of the arts and crafts movement disputed the widely accepted notion that the ongoing industrial revolution had brought with it human progress; they argued rather that the factory system and the pervasive introduction of machine technology had produced human misery and degradation. Honesty, piety, creativity, social harmony, and other essential human values had suffered in the transition from country-side to factory. They saw mankind enslaved to the machine, and the destruction of human values reflected

in crowded and impoverished city slums, depopulated and dying rural villages, grim factories—and the cheap and shoddy goods that poured out of them.

Like other return myths, the arts and crafts doctrine offered human-kind a way to secure its redemption by recommitting itself to qualities characteristic of earlier times. The movement's basic premise was that humans needed to live close to the soil, working at traditional crafts in relatively primitive communities, in order to live authentically. Factories and the complex urban economy had submerged individuality by requiring standardization; simple communities would by contrast allow—as they had in the past—for individual self-expression. Believing that a return to historical methods of production would restore the superior values of traditional communities, the move-ment called for a renewal of handicraft techniques in textiles, furniture, metalware, ceramics, glass, architec-ture, printing, and bookbinding. Its ideologues and craftsmen found inspiration in the tools and produc-tion techniques still in use among

traditional peoples. They developed as well a recognizable style, emulating nature in using a multiplicity of forms and colors and basing their design solutions on the nature of the materials with which they worked and the function of the objects they produced. They exalted utility and functional simplicity as design values and idealized imperfections as proof that products were handmade and unique. At the movement's core was a belief that work, creativity, spirituality, and fulfillment were intertwined: work could and should be creative and expressive; every worker could and should be a craftsman or -woman and therefore an artist; craftwork reintegrated life and art, bringing spiritual fulfillment and authenticity to producer and consumer alike.

Strap hinge
Early 19th century

Dr. Albert Barnes (1872–1951) amassed one of the world's great art collections in the early decades of the 20th century. He fell out with Philadelphia's cultural community in a celebrated dispute that still limits public access to the Barnes Foundation's galleries. Barnes spurned formal academic judgments of his art treasures, and his style and purposes clashed with the expectations of the city's aesthetic elite. Although he collected some important works of high-culture art —notably the paintings of French impressionists— his philosophy of art showed the influence of the arts and crafts movement. He repeatedly argued that art should be part of everyone's life, not just a rarefied taste cultivated by an elite. He meant his Foundation to be a school opening the appreciation of art to a broad public, not a museum presenting art to an already initiated minority. He believed that anyone was capable of a personal response to art and—in the tradition of the arts and crafts movement— argued that art could be found in the everyday world. There was beauty in artisanship, in the well-made, in the products of spiritually fulfilled craftsmen as well as in the work of acknowledged artists. Barnes snubbed formal categories in arranging art on his walls, interspersing the products of traditional craftsmen— primarily Pennsylvania Dutch metalworkers and woodworkers—with priceless Renoirs and Cézannes. This simple, symmetrical wrought iron strap hinge is the work of a anonymous craftsman, probably Pennsylvania Dutch, judging from the hearts cut into it. It was likely made for a barn door in the early 19th century. BRN

Henry Chapman Mercer
Spinning Wool
c. 1903
Henry Mercer's interest in
preindustrial crafts led
him beyond accumulating
the relics of a bygone era
to preserving old produc-
tion techniques. Distressed
that "so beautiful an art
as that of the old Pennsyl-
vania German potter should
perish before our eyes,"
Mercer (1856–1930)
served a traditional appren-
ticeship in order to learn
the craft. Subsequent ex-
periments in tile making
led him to organize the
Moravian Pottery and Tile
Works in Doylestown in
1910. Here he used tradi-
tional processes to craft
tiles and mosaics depict-
ing a wide range of picto-
rial subjects at the core of
the arts and crafts move-
ment. The pagan zodiac,
the Bible, the lore of primi-
tive peoples and early
American history, pre-
industrial crafts, and native
plants and animals all fur-
nished images expressing
the themes of nature, sim-
plicity, and tradition. The
Moravian Tile Works—
reactivated by the Bucks
County Department of Parks
and Recreation in 1974—
adheres to Henry Mercer's
designs and techniques in
producing tiles and mosaics
like this one, which de-
picts wool spinning. MRV

160

G. Bush
Clock wheel–cutting engine
c. 1812–1837

Henry Chapman Mercer began his collection of American tools and craft-produced artifacts when he found a pile of discarded spinning wheels, rope machines, and salt boxes in 1897. His interest in rescuing remnants of a world disappearing under the onslaught of industrialism made him an active collector of tools and artifacts documenting the ingenuity and accomplishments of Americans who lived before the machine age. Mercer began to build his museum in 1913; he interpreted the holdings and added to them until his death in 1930. This clock wheel–cutting engine is part of the museum's collection of clock-making tools, one of the more than 60 craft and production processes the Mercer Museum documents. A skilled craftsman would use this hand-cranked engine to cut the teeth in gear wheels. The engine illustrated here is an early 19th-century American version of a tool that dates back to the late 17th century. Mercer's records indicate that G. Bush of Easton, Pennsylvania, made this tool in the years between 1812 and 1837.
MER

The arts and crafts movement promised to humanize the social, economic, and moral order. But its ambitious agenda was little more than whimsy in the face of the profound transformation wrought by the industrial revolution. The movement—particularly in the United States—avoided politics, offering instead personal solutions to massive economic and social dislocations; those solutions expressed individual eccentricity rather than a systematic strategy for far-reaching reform. The arts and crafts craving for antique simplicity was most completely realized as a design statement, and in the personal tastes of an affluent and appreciative elite. Wealthy backers opened a handful of model factories and craft villages, including Rose Valley in Moylan, Pennsylvania; individuals like Henry Chapman Mercer drew on their personal wealth to subsidize craft production. But for all its elegant legacy, the movement serves as a reminder that not all return myths have been equally effective in mobilizing public response.

Nicola D'Ascenzo
Presentation sketch for stained glass window
c. 1920
Philadelphia stained glass artist Nicola D'Ascenzo (1871–1954) designed these windows about 1920 for a Horn and Hardart restaurant at 3636 North Broad Street in Philadelphia. D'Ascenzo executed drawings on paper for presentation purposes. ATH

Woven cloth
1940
The now widespread practice of occupational therapy grew directly out of arts and crafts ideology. A number of well-to-do women brought their interest in the movement—then current among the genteel classes—to their roles as volunteers in early 20th-century mental hospitals. They introduced weaving, basketry, wood carving, carpentry, bookbinding, blacksmithing, and jewelry making into the hospitals, not merely to occupy patients in busy work but to engage them in the traditional crafts valued by proponents of the movement. This craftwork was a reminder that art was once part of life, that the pace of life was once less hectic, and that individuals in past times presumably enjoyed a fuller measure of emotional health. By emphasizing activities associated with the simple life, and by promising to restore psychologically troubled patients to health by helping them reintegrate work and life, occupational therapy represented a complete personalization of the return myth. An occupational therapist at the Institute of the Pennsylvania Hospital wove this on a small loom in 1940. PAH

MARINERS—PRIDE

John LaFarge
Art, Education and Music
1907
John LaFarge (1835–1910) is credited with helping rekindle American interest in stained glass. He began to experiment with the medium after his European studies introduced him to the revival of medieval and Gothic stained glass techniques. LaFarge developed opalescent glass, fusing several colors together to create an irregular texture suggesting gradations in density and shade; he received a patent for the process in 1880. This window is part of a set of six LaFarge did for the Edward Bok house in 1907. Bok (1863–1910), as editor of the Ladies' Home Journal, was one of the most forceful American advocates of the aesthetic simplicity and design integrity that the arts and crafts movement preached. The Willett Studio—an important participant in the movement in Philadelphia—created the leaded glass border that allowed the window to fit a preexisting opening at the Fleisher Art Memorial when Mary Louise Curtis Bok presented this piece to the Fleisher in 1955. FAM

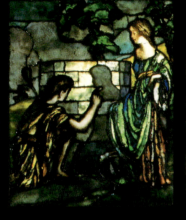

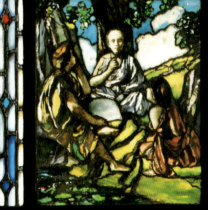

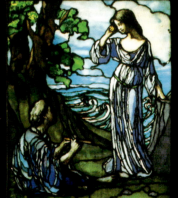

163

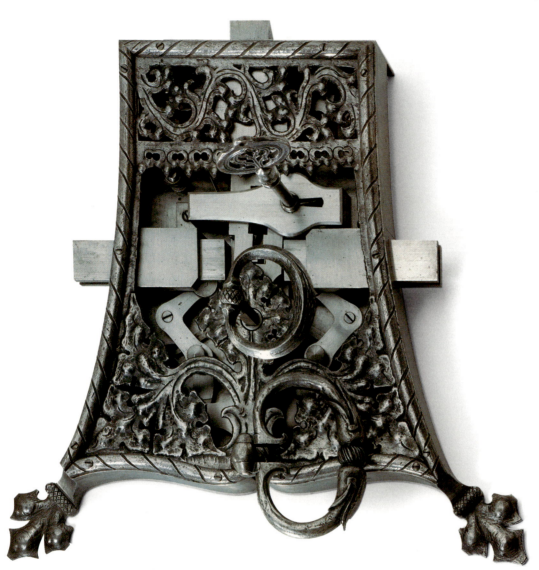

Samuel Yellin and
Richard Geite
Wrought iron lock
1911
*Born in Poland, Samuel
Yellin (1885–1940) learned
blacksmithing in Germany,
Belgium, and England be-
fore immigrating to Phila-
delphia in 1906. Yellin
established his own iron-
working shop in 1909,
where—assisted by highly
skilled immigrant workmen
—he worked with hammer
and anvil within the old
guild tradition. Yellin col-
lected medieval ironwork;
his work, which can be
found throughout the east-
ern United States, exem-
plifies the arts and crafts
revival of earlier craft tra-
ditions. With Richard
Geite, one of his workmen,
Yellin crafted this copy of
a German Gothic crab lock
in 1911 as an experimental
test piece.* **PMA**

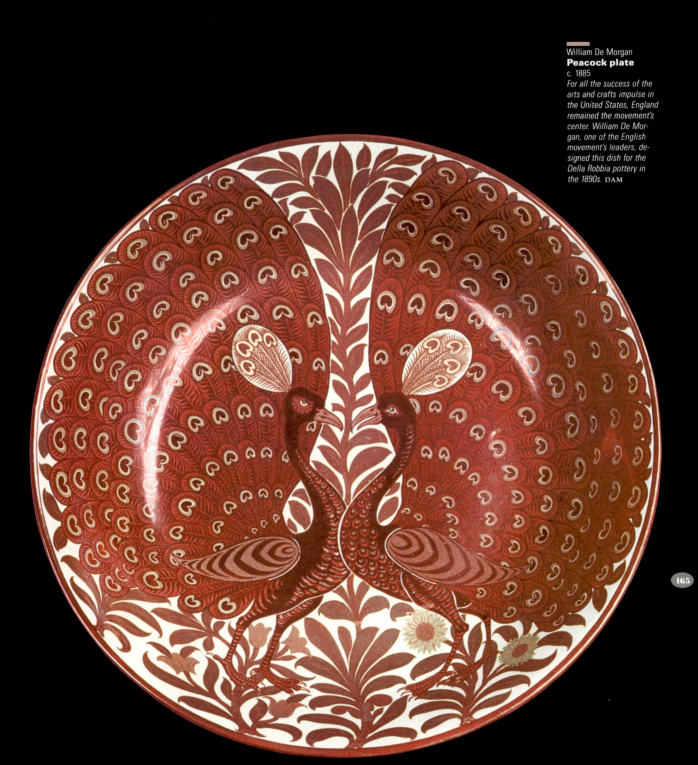

165

Indeed, the recent past has witnessed a succession of golden ages and redemption myths; few have enjoyed the universality of the religious myths that animated and reassured earlier cultures. And because our secular culture is little bound by time-honored values and historical precedents, we are relatively free to pick our own. Mindful that images drawn from the past are helpful in describing what we value in the present, we have turned in the 20th century to history. But we have done so as fad- and fashion-conscious consumers, selecting first one and then another of our multiple pasts in a dizzying sequence, longing for what we have lost and, if need be, inventing it. Little more than a generation now separates what we reject from what we rediscover.

In the last several years, we have even begun to apotheosize the very industrial revolution from which generations of our forebears recoiled and against which the colonial revival and the arts and crafts movement militated. The present is growing nostalgic for machinery, steam engines, even power-driven looms—the noisy, incessant, inhumane, and dangerous demons once thought to haunt dark factories and mills. We are transforming memories of industrial labor, with all its repetitive drudgery and risk, into authentic human experience—a not altogether surprising turn as more and more of us work in a pastel and plastic service economy. Preservationists now argue that we ought to save, adapt, and reuse urban loft buildings and factories. And we visit museums of industrial production along with farm museums and gracious colonial homes.

The Chocolate Works

Built 1902–1920;
reconstructed 1984

*The real estate develop-
ment firm of Historic Land-
marks for Living converted
20 structures in Philadel-
phia's oldest neighbor-
hoods to modern uses as
apartment buildings in the
decade after 1978. In nam-
ing this Old City structure
on 3rd Street north of
Race The Chocolate Works,
the developers sought to
emphasize the building's
earlier use as a confection-
ery factory.*

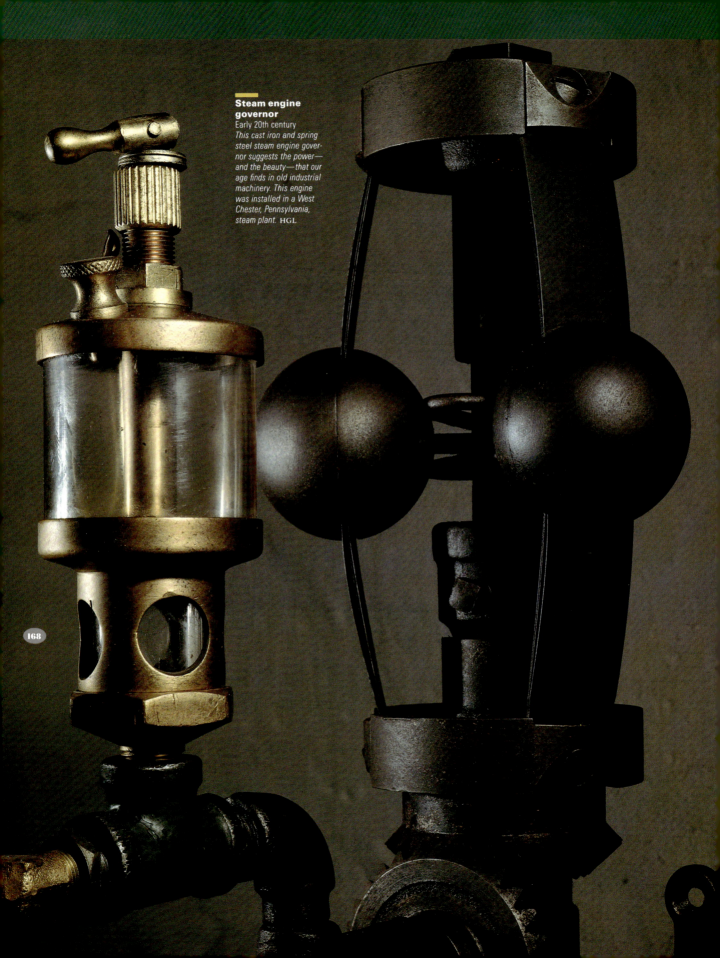

Steam engine governor
Early 20th century
This cast iron and spring steel steam engine governor suggests the power—and the beauty—that our age finds in old industrial machinery. This engine was installed in a West Chester, Pennsylvania, steam plant. HGL

168

Wilmington's Hagley Museum is among the earliest of the nation's industrial preservations, and one of its most ambitious. The museum's roots go back to Henry Francis du Pont's interest in the colonial revival and his request that his sister preserve the remnants of old powder mills along the Brandywine River after production ceased there in 1921. The museum itself grew directly out of the 1952 celebration of the 150th anniversary of the start of the du Pont industrial empire along the Brandywine; its opening in 1957 precociously suggested the industrial romanticism of our own time. The preservationist approach to the site harmonized industry and nature. Picturesque iron and stone work improve on the natural beauty of a creek flowing through a rustic scene. The historical preservation of this setting realized the original intent of the founders of the nation's industrial economy, if not their original achievement. Many early 19th-century manufacturers opened production facilities in pristine rural settings in order to escape the presumed vices of an urbanized workplace and a landless proletariat. The rural mills and factories in many cases deteriorated toward worker insecurity and oppressive working conditions. But in recounting the nation's industrial progress, we are free to imagine its origins in picturesque and pleasant surroundings, its industrious workers stalwart republicans and models of civic virtue.

Nostalgia for a simple time and the conviction that life was more authentic and meaningful in a past golden age is not, of course, a uniquely American phenomenon. The American arts and crafts movement built on its English precursor; the colonial revival had roots in the English country life movement. Indeed, the 19th-century modernization of Europe led collectors to search for, recover, and even invent peasant customs, folk tales, and traditional music. A heightened sensitivity to the past in the period when industrialization and urbanization were transforming European society even helped guarantee the acceptance of such altogether new phenomena as the distinctive and "historic" plaids created for Scottish clans in the 19th century. Did the ongoing quest for diverse golden ages infuse American more than European life? Probably—ours is a society with comparatively shallow roots. We regularly ransack and reinterpret our origins and even reconstruct memories of the more recent past in order to redefine ourselves.

Hagley
As captured in this contemporary photograph, the du Pont black powder works on the Brandywine River seem sylvan and tranquil. It takes some effort to imagine the dangers of manufacturing explosives—and to evoke the lives of 19th-century laborers—in the park-like setting of this historic site.

One theme recurs regularly in this search for the worlds we have lost: the present does not hold all aspects of the past in equally high regard. The relics of a past age may resonate more powerfully in one period than in another, and for one group than for another. We can and do change how we choose to present ourselves; we can and do change what we regard as worthy of historical attention. The past has an inexhaustible capacity for presenting different faces to succeeding generations.

Many of the artifacts we now treat reverentially—colonial homes, Revolutionary icons, simple craft goods, old manufacturing sites— barely survived into the present. Changing fashions jeopardized some; economic development imperiled others; the wear and tear of time and a general pattern of neglect exacted their toll. But we in the United States have been relatively fortunate. Little of our cultural patrimony—the national treasures through which we define ourselves as a people—has left American shores for other lands. Our nation's power, its relatively short history, and its geographic isolation have by and large minimized the intrusion of foreign nations into our historical legacy. It is difficult, for example, to imagine the signed draft of the Declaration of Independence in a British or Japanese museum. When we have reversed ourselves and decided to venerate something long thought trivial—as Americans did with the Liberty Bell after more than a century of relative inattention— we have generally been able to restore the object, if it survived, to a position of esteem.

Liberty Bell
1752

Now the most revered of American icons and Phila-delphia's most visited at-traction, the Liberty Bell has not always commanded such respect. We tell our children—correctly—that the bell cracked several times after its original casting in 1752, but we are on less firm ground in citing the bell's role in an-nouncing the Declaration of Independence or in hav-ing it crack in tolling the deaths of Chief Justice John Marshall or George Washington. The bell actu-ally had very little to do with the important events of our early history. Its de-fective sound condemned it to relative inactivity in the State House tower; the fact that it ultimately became the Liberty Bell owes to the circumstances of its origin in the 1750s and of its rediscovery in the decades before the Civil War. The bell carries a verse from Leviticus— "Proclaim liberty through-out all the land unto all the inhabitants thereof"— because it was cast to commemorate the 50th anniversary of William Penn's 1701 grant of a Charter of Privileges conferring a measure of self-government on the inhabitants of his colony.

The verse—which refers to the biblical custom of the Jubilee, the 50th year when servants automati-cally recovered their free-dom and land reverted to its original owner—caught the eye of abolitionists campaigning to end slav-ery in the United States. They adopted the bell as a symbol of their cause, named it the Liberty Bell, and even carted it around to abolitionist meetings. The public did not begin to associate the bell with the Revolution until the 1840s and 1850s—after, that is, the abolitionists identified it with their own cause. The story that the bell rang out when Congress voted for Independence evidently first appeared in the 1840s in the fictional works of George Lippard (1822–1854). The bell barely survived until Amer-icans began to rewrite the history of their Revolution; it was in 1828, for exam-ple, given as scrap metal to the contractor casting a new bell. Only the fact that it would have cost too much to haul it away saved it. INHP

Other cultures have been less favored. Colonial conquest expropriated cultural treasures along with more worldly spoils from Asia, Africa, South America, and the Pacific. Archaeological and anthropological expeditions—mostly legitimate by the standards of their day—put other art and antiquities into European and American hands in the 19th and early 20th centuries. Wealthy collectors willingly purchased objects procured through outright theft in less wealthy lands. These transfers of culture met, for the most part, with minimal resistance. But the relationship between the powerful imperial West and the less developed world was hardly one of bargains fairly made; this was not a relationship of equals, but one exploitative by its very nature. That some of these appropriated artifacts were little treasured in their lands of origin until the recent past is perhaps a mitigating circumstance. We may be more horrified by the Nazi plunder of Europe's libraries and museums in World War II than by archaeological excavations and the international commerce in looted antiquities, but all shared similar consequences. Peoples were dispossessed of their past. The great museums of Europe and the United States are literally cluttered with the cultural patrimony of less developed nations.

Their independence achieved in recent decades, Third World peoples are now rewriting their histories. In the wake of nationalistic revolutions, many now choose to emphasize the eras of self-determination that preceded European domination; they tend also to idealize the traditional cultures rooted in those earlier periods. Yet more than a century of traffic in culture has deprived them of many objects now essential to their identities as they choose to present them. The governments of Mexico, Egypt, Greece, and Native American tribes have requested the return of antiquities taken from their lands. While efforts to repatriate these treasures threaten the collections and missions of Western museums currently holding them, a 1970 UNESCO declaration on cultural patrimony— a document originally drafted at Philadelphia's University Museum— grants broad recognition to the legitimacy of such claims. For now, arguments against repatriation continue to hold sway in much of the Western museum community. But there can be no denying that in pressing for the return of cultural property, Third World cultures are acting much as we do when we determine what to emphasize about our own past as a way of defining what we believe in and who we are in the present.

Iron-age pottery
c. 500 B.C.
The University Museum's mid-1970s excavation at Ban Chiang, Thailand, adhered to the principles of the UNESCO declaration on cultural patrimony. This joint enterprise of the Thai government and the University of Pennsylvania was designed from the outset to serve the interests of both partners. University archaeologists were able to pursue ethnographic studies of the objects uncovered at Ban Chiang within the context of the site as a whole. The artifacts themselves were understood to belong to Thailand. Pieces came to Philadelphia only if they required specialized study not possible in Thailand. Some remained here for temporary exhibit before their return to Thailand; a small number are still on loan to the University Museum. The Thai government has built a museum in Ban Chiang where the bulk of the collection is now displayed. Before this excavation, the documented history of what is now Thailand effectively began about 1000 A.D., when peoples from the Indian subcontinent arrived in the area. This new archaeological evidence of a technologically sophisticated metal-working culture dating back to 4000 B.C. has added about 5,000 years to Thailand's history. The inset shows an excavation of broken Middle Period pottery. UM

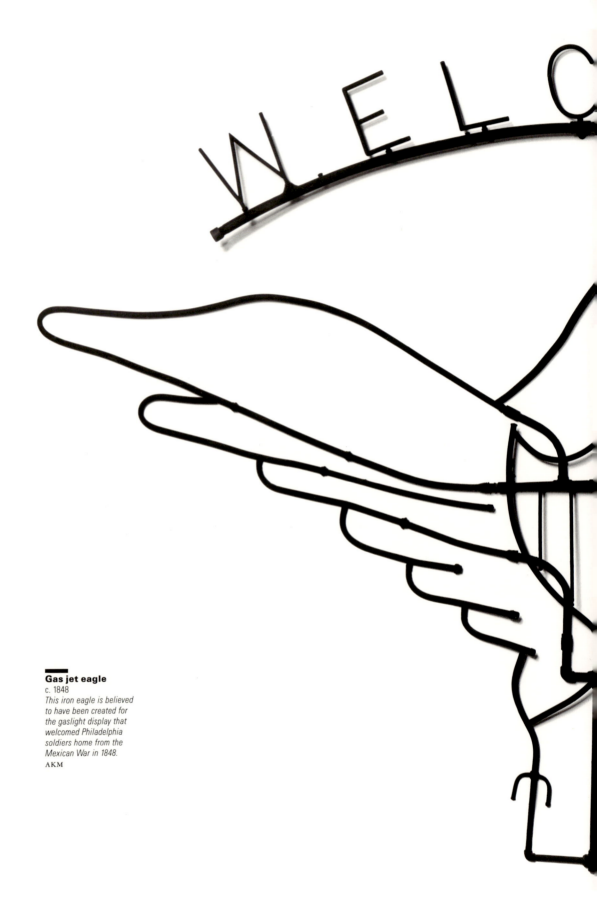

Gas jet eagle
c. 1848
*This iron eagle is believed
to have been created for
the gaslight display that
welcomed Philadelphia
soldiers home from the
Mexican War in 1848.*
AKM

The Institutions

Academy of Natural Sciences

19th Street and Benjamin Franklin Parkway
Philadelphia, PA 19103
Telephone 215 **299 1000**

Afro-American Historical and Cultural Museum

7th and Arch Streets
Philadelphia, PA 19106
Telephone 215 **574 0380**

Serengeti waterhole diorama

Dinosaurs are a major attraction of the Academy of Natural Sciences museum. The first dinosaur skeleton ever mounted for display was unveiled at the Academy in 1868. A current exhibit, "Discovering Dinosaurs," features this historic specimen as well as a towering *Tyrannosaurus rex* and interactive displays on dinosaur behavior, structure, and ecology, on dinosaurs in popular culture, and on the scientific debate over their extinction.

Other features include spectacular displays of gems and minerals, mummies, and wildlife dioramas illustrating African, Asian, and North American habitats. A stream exhibit demonstrates recent findings of Academy scientists involved in estuarine and wetland investigations. Outside-In, a museum-within-the-museum, allows children to explore the world of nature through hands-on and sensory activities. Demonstrations and activities feature live animals, crafts, storytelling, and music.

Founded in 1812, the Academy is the oldest natural history institution in the western hemisphere. Its historically and scientifically important collections contain more than 20 million specimens, gathered by such notable naturalists as Captain James Cook, Lewis and Clark, Thomas Jefferson, and John James Audubon.

The library is the repository of the Academy's archives and manuscripts as well as 155,000 printed volumes ranging from the 15th century to the present. Treasures include field notes, correspondence and diaries, photographs and original illustrations. On display in the Reading Room, beneath portraits by Charles Willson Peale and others, is Audubon's *Birds of America,* one of the few "elephant folio" copies in the hands of the original subscriber.

The Afro-American Historical and Cultural Museum was founded during the Bicentennial year on the site of a historic black community near Independence Hall. Its mission is to collect, preserve, and present evidence of the struggles and contributions of African-Americans throughout Pennsylvania and the Delaware Valley. Through well-documented exhibits, the museum places that story within the context of the African diaspora and demonstrates how African-Americans have made and continue to make their own history while enriching the growth and development of the American Republic.

The museum has hosted concerts by jazz legends Max Roach and Betty Carter, and readings by James Baldwin and Gwendolyn Brooks. Educational programs reach young and old. More than 90,000 children attend programs annually; "Teas for Two," for senior citizens, is one of hundreds of other offerings. The museum also has a growing collection of art works by prominent African-American artists, including Henry Ossawa Tanner.

The "Sharing the Heritage" program solicits artifacts, docu-

American Philosophical Society

5th and Chestnut Streets
on Independence Square
Philadelphia, PA 19106
Telephone 215 **440 3400**

Above
Romare Bearden
**Captivity and
Resistance**
1976

Right
**Wedgwood
antislavery
medallion**
1788

ments, and photographs of historical value from individuals and families. Donors help chronicle history by recording events from a personal perspective.

Over 40 years of Black Philadelphia's cultural, social, and political life is recorded in the collection donated by *Philadelphia Tribune* photojournalist Jack Franklin. Other collections document Negro League baseball, the growth of Mercy Douglass Hospital, and the careers of Rep. Robert N. C. Nix, Sr., and Anna Russell Jones, the first African-American woman from Eastern Pennsylvania to enlist in the Army during World War II.

Founded by Benjamin Franklin in 1743, the American Philosophical Society is the oldest learned society in the United States. Its collections are both a historic repository and a record of current scientific investigations. Philosophical Hall (open to the public by appointment) contains David Rittenhouse's telescope, a model of John Fitch's steamboat, and portraits and busts of early Society members.

The Library, which stands across 5th Street from Philosophical Hall, holds nearly 200,000 volumes and six million manuscripts. This rich source for historians of American science includes first editions of Newton's *Principia,* Franklin's *Experiments and Observations on Air,* and Henry D. Smyth's *Atomic Energy for Military Purposes.* Manuscripts include Lewis and Clark's field notes, Benjamin Smith Barton on botany, J. Peter Lesley on geology, Franz Boas on anthropology, and Herman H. Goldstine on the early development of computers. Changing exhibits in the Library lobby are open daily to the public. Exhibits in Benjamin Franklin Hall (427 Chestnut St.) are open by appointment.

Originally the Society's interests were as broad as those of the Founding Fathers, most of whom were members, seeing freedom and learning as interdependent. In the 20th century, accessions have focused on the history of science, including geography, genetics, American technology to 1860, quantum physics, biomedical science, anthropology, and linguistics. The Library has been named the repository for professional organizations in many of these fields. It is open to serious investigators, though books do not circulate.

American Swedish Historical Museum

1900 Pattison Avenue
Philadelphia, PA 19145
Telephone 215 **389 1776**

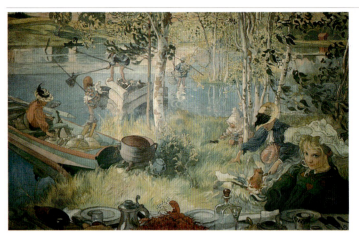

Carl Larsson
**Kräftfisket
(Crayfishing)**
(detail)
1898

A translation of the writings of Martin Luther into the Lenape language is the rarest of several 17th-century books in the American Swedish Historical Museum. It symbolizes the intention of the area's first European settlers to move peacefully among their neighbors, setting a precedent for William Penn. This theme is developed in "Before Penn: Swedish Colonists in the Land of the Lenape," a major exhibit.

The contributions of Swedes and Finns to American government, industry, science, religion, naval technology, and the arts are celebrated in a series of galleries. The John Ericsson Room honors the Swedish-born designer of the *Monitor,* which defeated the Confederate *Merrimac* in the Civil War. A mural depicting his life and work covers one wall; models and drawings of his many inventions are displayed.

Middle-class Swedish life at the turn of the 20th century is depicted in a watercolor and a tapestry cartoon in oil by the Swedish painter Carl Larsson. Other notable works in the fine arts collection are landscapes by the Swedish-American artists Carl Oscar Borg, Birger Sandzén, and Carl Sprinchorn, and a sculpture honoring Swedish immigrants by Charles Oscar Haag.

The historic rooms designed in the 1930s and 1940s are excellent examples of Art Deco interior design. The Pioneer Room reproduces a 19th-century Swedish farmhouse interior. The Fredrika Bremer Room displays manuscripts and belongings of the 19th-century novelist and feminist. The Jenny Lind Room holds mementos and sheet music from the Swedish Nightingale's 1850–52 American tour.

Athenaeum of Philadelphia

219 South 6th Street
Philadelphia, PA 19106
Telephone 215 **925 2688**

Original drawings of the U.S. Capitol and early drawings of Independence Hall are possibly the best-known items in the Athenaeum's extensive architectural collection. Its comprehensive documentation of 550 American architects working prior to 1945 attracts scholars from around the world. Though primarily a library, the Athenaeum was one of the first institutions to take an active interest in American neoclassical decorative arts. Its fine and decorative arts collections can be seen against a handsome architectural background. The building that houses the Athenaeum, designed by John Notman, was the first major example in America of the Italianate Revival Style and one of the first buildings in Philadelphia to be made of brownstone.

As the only library collection in the nation that specifically focuses on the Victorian era in the United States and the only one that specializes in 19th-century American architectural history, the Athenaeum combines scholarly esoterica with nuts-and-bolts restoration data. Its photographic archives and holdings of trade catalogues and wallpaper samples make it a practical resource for architects, designers, and owners of historic houses.

Founded in 1814 as a reference library for members and a

Atwater Kent Museum

15 South 7th Street
Philadelphia, PA 19106
Telephone 215 **922 3031**

Above
Members' reading room

Below right
Porringer (Thomas Frye imprint)
1753–1758
Excavated at Head House Square, Philadelphia, 1963–1964

depository of rare books and periodicals, the Athenaeum is a progressive institution that keeps its members abreast of events through publications and lectures.

Serious investigators may use the library by appointment. Members have access to the library and to lectures, tours, and concerts. The Victorian Society of America has its national headquarters here.

Atwater Kent radios, Baldwin locomotives, Disston saws, Quaker lace, Schoenhut toys, and Stetson hats are just a few of the Philadelphia-made products on view at the Atwater Kent Museum—the History Museum of Philadelphia. With over 40,000 objects in its historical collections and 500,000 in the City Archaeological Collection, the Atwater Kent Museum is one of the largest and most diverse repositories of Philadelphia's cultural patrimony. The collections span the city's 300-year history, with the greatest emphasis on the 19th and 20th centuries. Extensive holdings document the material culture and expressive traditions of daily urban life.

Through exhibits and displays, educational and public programs, publications, and media presentations, AKM uses its historical and archaeological collections to tell the rich and fascinating story of Philadelphia's social history and popular culture, setting that story within the broad context of the evolution of America's cities. Exhibits and programs provide a historical perspective on such contemporary issues as housing, the decline of our industrial economy, city planning, and social justice. While thematically rooted in the past, programs suggest ways to improve the quality of life in neighborhoods and the city at large. AKM's "object-oriented" approach to learning—neither dogmatic nor moralistic—is designed to stimulate young and old alike to consider how life was different, and how it was similar, for past generations. Visitors acquire a basis for evaluating the material culture and the traditions of their home, neighborhood, city, and nation.

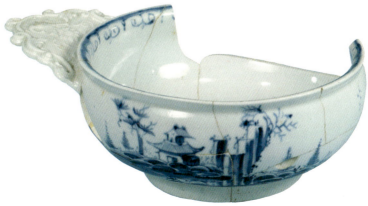

THE INSTITUTIONS

CULTURAL CONNECTIONS

Awbury Arboretum

Balch Institute for Ethnic Studies

Francis Cope House
Entrance: Chew Avenue west of Haines Street
Philadelphia, PA 19138
Telephone 215 **849 2855**

18 South 7th Street
Philadelphia, PA 19106
Telephone 215 **925 8090**

Below
The Awbury pond and wetland

In the heart of Germantown, 57 acres have been set aside for families to picnic, sled, bird-watch, and participate in nature programs amid some of the oldest and finest specimen trees in the state. A 250-year-old black oak, *Quercus velutina,* and a 120-year-old river birch, *Betula nigra,* are among the historic trees in the Awbury Arboretum.

In addition to native plants, Awbury has some of North America's oldest introduced species. In 1784, horticulturist William Hamilton imported America's first "tree of heaven," *Ailanthus glandulosa,* and its first "white mist" tree, *Ginkgo biloba.*

At the top of the hill near the main entrance, the Francis Cope House, with park offices and classroom, overlooks a gently rolling terrain designed by William Saunders. The long vistas of his English Romantic design encompass a variety of ecosystems rare in any city: pond, wetlands, meadows, upland woods, thickets, and wildflower gardens.

The Arboretum began in 1852, when the shipping magnate Henry Cope acquired land for a country estate and named it after his ancestral home in Avebury, England. Six successive generations of Copes formed a community here in homes that are Quaker interpretations of Victorian Gothic design.

Since 1985, the Awbury Arboretum Association has restored the grounds and the exterior of the Francis Cope House, and promoted Awbury as an educational resource for adults and schoolchildren. The Awbury Community Garden enables 40 local families to farm their own vegetable plots.

Ethnic heritage and the immigrant experience are the focus of research, exhibition, and education at the Balch Institute for Ethnic Studies. More than 80 ethnic groups are represented in the museum and library collections, which are interpreted through such exhibits as "Ethnic Images in Toys and Games" and "Something Old, Something New: Ethnic Weddings in America."

A major exhibit on display until 1992, "Freedom's Doors," celebrates the centennial of Ellis Island by describing the role that seven other ports of entry have played in immigration up to the present. The exhibit displays a selection from the 4,000 items in the museum's collection of paintings, drawings, posters, traditional clothing, household utensils, crafts, and devotional items. Many of these everyday objects entered the United States in the baggage of immigrants, treasured reminders of home in the turmoil of movement. Others testify to the specifics of ethnic experience in this country. One such holding consists of artifacts created by Japanese-Americans interned in relocation camps during World War II.

The Institute's research library is the largest multi-ethnic collection in the country, with approximately 60,000

Barnes Foundation

300 North Latches Lane
Merion Station, PA 19066
Telephone 215 **667 0290**

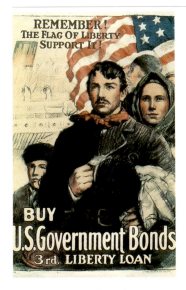

Left
**U.S. government
World War I poster**

Below right
Pierre Auguste Renoir
The Artist's Family
1896

Albert C. Barnes gathered one of the world's leading collections of French impressionist and post-impressionist paintings in a building housing 23 galleries. Barnes collected—in many cultural traditions—to demonstrate the evolution of artistic traditions and the methods employed by artists to create works expressive of their individuality, time, and milieu.

A walk through the galleries is an incredible experience. One can savor 180 Renoirs, 69 Cézannes, 7 van Goghs, 60 Matisses, and 45 Picassos in one afternoon. In addition, there are works by Manet, Degas, Seurat, Rousseau, Soutine, Modigliani, Pascin, Demuth, Glackens, Charles and Maurice Prendergast, Pippin, Klee, Miró, Rouault, and many other modern painters. The visitor can review and compare paintings by such old masters as Giorgione, Titian, Tintoretto, Paolo Veronese, El Greco, Claude Lorrain, Chardin, Daumier, Delacroix, Courbet, and Corot. There are also works by Dutch artists, Italian, French, Spanish, German, and Flemish primitives, African sculpture, Pennsylvania Dutch folk art, and representative examples of Chinese, Persian, Greek, Egyptian, and Indian art.

Barnes was at heart an educator and founded The Barnes Foundation in 1922 because he believed that the appreciation of works of art required organized effort and systematic study. For many years his collections were seen primarily by those participating in the courses he established.

The Arboretum School offers courses on horticulture, botany, and landscape architecture. Twelve acres of rare and specimen plants surround the galleries.

volumes, 2,700 feet of manuscripts and archival records, 6,000 reels of microfilm, and 12,000 photographs, as well as other graphics, audio recordings, and ephemera.

The library also houses and administers the Philadelphia Jewish Archives Center and the Scotch Irish Foundation Library and Archives. The Education Department offers student programs, lectures, reading and discussion groups, performances, films, a travel program, and an ethnic dinner series.

Bartram's Garden

54th Street and Lindbergh Boulevard
Philadelphia, PA 19143
Telephone 215 **729 5281**

John Bartram's solitary devotion to nature is ironically symbolized by the isolation of his 18th-century house and garden in industrialized Southwest Philadelphia. Lying along the banks of the Schuylkill River, the 44-acre site offers natural habitats, such as meadows and wetlands, as well as plants that Bartram and his son William discovered on their travels through the American wilderness.

Bartram's Garden was one of the first botanical gardens in the United States, and John Bartram (1699–1777) is credited with having established the science of botany in North America. At his Philadelphia farm, Bartram packaged seeds and roots for customers in England and received specimens from abroad—a way station between the Old World and the New. A ginkgo, pawpaws, persimmons, oaks, magnolias, and a yellowwood that the Bartrams planted can still be seen here, as can examples of Franklinia, the Bartrams' most famous discovery. Many specimens are labeled.

Maple sugaring, cider pressing, and candle- and butter-making are demonstrated in the stone stable or beneath the grape arbor. The 18th-century stone farmhouse contains period furnishings. Bartram himself made additions between 1728 and 1770, cutting and setting the local fieldstone. His skill as a stone cutter is evident in the pillared porch, horse trough, and cider mill.

Picnicking is allowed, and a shop offers books and small gifts. Group tours of the house and garden can be arranged. Programs are offered to adults and school groups on the environment, botany, and colonial life.

Left
A botanist's study, c. 1770 addition to Bartram House

Below
Farmhouse at Colonial Pennsylvania Plantation

Bishop's Mill Historical Institute

Colonial Pennsylvania Plantation
Ridley Creek State Park
Media, PA 19063
Telephone 215 **566 1725**

This living history museum illustrates the life of a plantation family during the late 18th century. Interpreters wear clothing hand sewn from fibers grown in nearby fields. They prepare meals from the plants and animals they tend, harvest, and preserve, using tools typical of the period from 1760 to 1790.

Work follows the natural cycle of the seasons, and visitors are encouraged to ask questions. The Bishop's Mill Historical Institute administers the plantation as a research and learning center, providing visitors with a realistic view of 18th-century life and generating research data otherwise unavailable from archaeological or historical resources. Researchers experience how conditions, technology, and

Brandywine River Museum

US 1 and PA 100
Chadds Ford, PA 19317
Telephone 215 **459 1900**

customs affected people's lives—for instance, the comfort or lack of it that women's clothing provided. Other research has concentrated on problems of construction and the physical layout of the farm, the acquisition and breeding of animals, and the cultivation of 18th-century crops.

Five farm buildings are in use, along with fields, gardens, and pastures. The farmhouse dates to 1705, and period furnishings and reproductions fill the rooms. Many were made by Chester County craftsmen, who are also represented in the pottery, porcelain, and utensils.

Group tours, workshops, and special events are held throughout the year, among them Kids' Day, a craft show, a Civil War reenactment, a December Wassail Tour, a harvest weekend, and a photography contest. A shop provides books and souvenirs. The library is open by appointment.

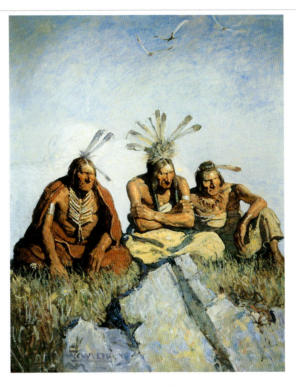

N. C. Wyeth
**Nothing Would
Escape Their
Black, Jewel-Like,
Inscrutable Eyes
(The Guardians)**
1911

The Brandywine River Museum celebrates nearly two hundred years of art, much of it influenced by the Brandywine Valley. The Valley itself is depicted in a number of landscape paintings by such artists as Thomas Birch, Jasper Cropsey, and William Trost Richards.

The museum has an extensive collection of art by members of the Wyeth family of Chadds Ford. N. C. Wyeth attended Howard Pyle's school of art in the early 20th century; he soon became one of the greatest American illustrators, capturing the spirit of classic adventure stories like *Treasure Island* and *Kidnapped.* The elder Wyeth passed his talent to three of his children. Their work, along with that of other Wyeth family members, is on exhibit here. A gallery added in 1984 is devoted entirely to the work of N. C. Wyeth's son, Andrew Wyeth.

The history of American illustration can be traced through the museum's collection. A selection of works by 19th- and 20th-century illustrators is always on view, including drawings by Howard Pyle and other artists of the golden age of illustration and many recent works as well.

Concerts, lectures, films, and guided tours are offered. Native wildflowers surround the museum, which is housed in a grist mill dating from 1864. Contemporary glass towers keep visitors visually in touch with the river and the rural landscape. Special annual activities include unique Christmas exhibits, crafts events, and a Memorial Day weekend antiques show and sale.

Camden County Historical Society

Campbell Museum

Park Boulevard and Euclid Avenue
Camden, NJ 08103
Telephone 609 **964 3333**

Campbell Place
Camden, NJ 08101
Telephone 609 **342 6440**

The 18th-century home of a prominent Quaker family, and a museum that illustrates the material culture, ethnic heritage, and social history of the region, enable the Camden County Historical Society to interpret family, work, and community life from 1600 to the present.

In 1726 Joseph Cooper, Jr., built Pomona Hall in the style of a Philadelphia townhouse. This three-story brick structure, one room wide and two rooms deep, stood in the middle of a working farm of 412 acres. Rooms that represent the Joseph Cooper family reflect a warm, quiet elegance. Highly polished furniture of maple, walnut, and cherry illustrates the quality of local craftsmanship.

Sixty years after Joseph Cooper built Pomona Hall, his nephew Marmaduke expanded the house and refurbished the exterior in the balanced proportions of Georgian architecture. The central hallway, staircase, dining room, kitchen, and bedrooms are now restored to the 1788 period. In 1897 a Cooper descendant, John

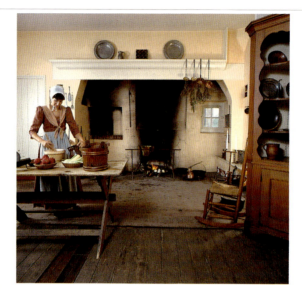

Colonial kitchen, Pomona Hall

Whitall, added more rooms. A late 19th-century parlor represents this period.

The museum contains "stalls" of equipment from blacksmith, cooper, shoemaker, and harness shops, as well as construction, surveyors', farm, candlemaking, shipbuilding, and glassblowing tools. The local shipbuilding industry can be followed from the construction of the *Dollar* (1899) to the *Camden* (1960). Other industries are represented by Victor Talking Machine victrolas and Esterbrook pens. Other exhibits feature the Delaware River, a 19th-century schoolhouse, toys and miniatures, Civil War uniforms and weapons, and firefighting equipment.

From the unglazed red clay bowls of 500 B.C. to the highly ornamented tureens of the Age of Elegance, the collections of the Campbell Museum demonstrate how a close look at the dining table can provide new insights into the decorative arts.

A large soup tureen in the form of a turkey cock records a landmark of decorative development. In Europe and the colonies before 1745, glazing colors were generally harsh and dull because bright colors could not withstand the high firing temperatures required to harden clay. Beginning about 1740, experiments with a second firing at a lower temperature achieved the softer, pastel tones visible in the turkey's head and wattle. Wealth, technical advances, and cultural interactions soon freed craftsmen from functional limitations while inspiring elaborate and imaginative designs.

The rococo style of the 18th century is exemplified by the work of Johann Joachim Kaendler, who used his sculptural skill to animate soup service.

Carpenters' Hall

320 Chestnut Street
Philadelphia, PA 19106
Telephone 215 **925 0167**

A swan tureen executed at the Meissen factory in Saxony is a fine expression of his art. The museum has a wide variety of soup tureens in the shape of boar's and cow's heads, rabbits, and fish, as well as cabbages, cauliflowers, and other vegetables.

Several objects reflect the expansion of trade between Europe and China. A rice bowl decorated with a stylized Chinese landscape was produced about 1754 in Worcester, England, while a tin-enameled earthenware tureen of classical Western design was produced in Canton about 1780.

The museum offers lectures and a film program.

Below
Soup tureen
c. 1755

Right
Carpenters' Hall

Carpenters' Hall, built by the Carpenters' Company as its meeting hall (1770–1774), served as the site of the First Continental Congress. Later, 72 local institutions either met or were formed in the Hall, including the First City Troop and the Philadelphia College of Pharmacy and Science. Established in 1724, the Carpenters' Company is the oldest trade organization in the country, and its 115 members still meet regularly in the Hall.

Standing in a courtyard at the end of a narrow lane, the Hall looks today much as the delegates to the First Continental Congress saw it in 1774. Six Windsor chairs used by the delegates are on display. Other collections include 18th- and 19th-century carpentry tools, photographs, and portraits attributed to Charles Willson Peale and his son Raphael. Also on view is the blue and white banner, with compass, rule, and rising sun, carried by the Carpenters' Company in the 1788 parade celebrating the ratification of the Constitution. The centerpiece of the exhibits is a scale model of the Hall under construction, complete with workmen.

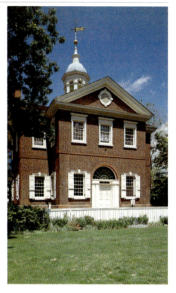

The 5,500-volume library began in the 1730s as a collection of architectural pattern books. In the 19th century it expanded into a members' lending library, offering books on a variety of topics, particularly travel and science. The second-floor room in which it is housed is typically Victorian, with mahogany and glass bookcases and dark, oversized furniture, a contrast to the clean, light lines of the building.

Chester County
Historical Society

CIGNA Museum

225 North High Street
West Chester, PA 19380
Telephone 215 **692 4800**

Two Liberty Place
1601 Chestnut Street
Philadelphia, PA 19192
Telephone 215 **761 1000**

Located in the heart of historic West Chester, the Chester County Historical Society documents three centuries of life in southeastern Pennsylvania. It operates a museum, library, and educational programs at its headquarters building and a county archive at a site nearby.

Fine Chester County and Philadelphia furniture as well as locally made decorative arts are exhibited in architectural settings in the large permanent exhibition area. In the remaining galleries, changing thematic exhibitions interpret life in the Delaware Valley. Over 50,000 objects in the museum's collection share a common history of use, manufacture, and ownership in Chester County, revealing the area's rich material culture. The collections reflect many aspects of county life and include needlework and clothing, agricultural tools and equipment, toys and dolls, paintings and drawings, glass, silver, pewter, ceramics, industrial and mechanical objects, and political memorabilia.

The archive houses one of the finest and most complete collections of historic county records in the nation. Coupled with the library's vast collection of personal papers, business and church records, photographs, maps, broadsides, newspapers and audio-visual materials, the research facilities have the depth to serve visitors ranging from amateur genealogists to historians and scholars.

Lectures, courses, workshops, and special public events are regularly scheduled throughout the year.

Below
High chest of drawers
1695–1740

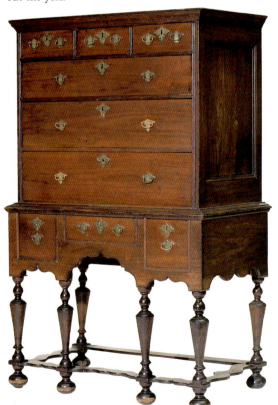

Until steam engines revolutionized firefighting in America, volunteers hauled their own equipment to fires. The CIGNA Museum displays 18th-century leather buckets, one of the first steam fire engines, and 20th-century motorized pump and ladder combinations. Founded in 1792 at Independence Hall as the Insurance Company of North America, CIGNA was one of the first companies to enter the fire insurance business, and its collection of artifacts, paintings, and documents follows the company's—and the country's—development. These holdings are now divided among CIGNA's offices at One and Two Liberty Place and the lobby at 1650 Arch St.

"The Pioneer," the oldest existing steam fire engine, is the centerpiece of nine full-sized pieces of equipment on display. The ornate metalwork of the Frazier hose carriage of 1853 is another fine example of Philadelphia craftsmanship. An 1850 portrait of Benjamin Franklin (shown, anachronistically, as a young man) commemorates his founding of the Union Fire Company, the country's first. Nathaniel Currier (of Currier & Ives) drew upon his experiences as a firefighter in New York for several series of prints. All major 19th-century cities except Philadelphia are shown being

186

Civil War Library and Museum

1805 Pine Street
Philadelphia, PA 19103
Telephone 215 **735 8196**

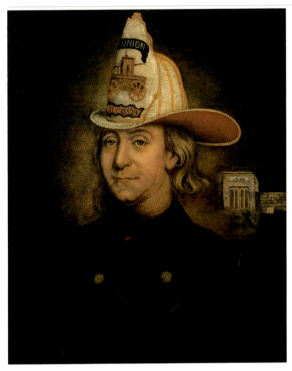

Above
Charles Washington Wright
Benjamin Franklin, the Fireman
c. 1850

Right
Thomas Hicks
Meade at Gettysburg
1876

The Civil War Library and Museum was founded in 1888 by the Military Order of the Loyal Legion of the United States. Rutherford B. Hayes was its first president.

The collection includes Ulysses S. Grant's dress uniform, presentation sword, and death mask; Jefferson Davis's dressing gown; General Meade's frock coat, slouch hat, and swords, as well as the flags from his headquarters; General Sherman's frock coat; and General Reynold's saddle, sash, and the sword belt worn at Gettysburg.

The weapons collection contains rare handguns, swords, muskets, rifles used by Union and Confederate forces, and a pike brought by John Brown to Harpers Ferry. Other artifacts include flags, musical instruments, medals, knapsacks, and items from camp and field. The Lincoln Room contains mementos and portraits of the 16th president, along with lifemasks, a cast of his hands, and documents connected with his assassination.

The library has 15,000 volumes and manuscripts, personal letters and documents, and the largest collection of military escutcheons in the country. There are numerous oil paintings and watercolors of Civil War leaders and scenes.

devastated by flames. Thanks in part to William Penn's planning, this city never had a major fire disaster.

CIGNA collects cityscapes and other artistic representations of the cities in which it does business. Other collections reflect CIGNA's maritime interests: ship models, seascapes, and the wheel from the *Hesperus*. Rembrandt Peale is represented by *View of the Wissahickon*.

There are four temporary shows annually. Reference materials can be studied in the research library by appointment.

Cliveden

6401 Germantown Avenue
Philadelphia, PA 19144
Telephone 215 **848 1777**

One of America's best collections of Chippendale furniture is housed in Cliveden, the elegant colonial home of Benjamin Chew and the site of the annual restaging of the Battle of Germantown. Every October, local living history troops take up their muskets to reenact that day in 1777 when General Washington attempted to dislodge the occupying army from Cliveden. Though bullet damage is still visible, its stone walls proved impenetrable. Washington moved his troops on toward Whitemarsh.

Benjamin Chew (1722–1810), Chief Justice of Pennsylvania, designed his mid-Georgian house as a summer retreat from the heat of Philadelphia. Its clean lines and restrained ornamentation reflect Chew's Quaker heritage. It stands today little altered, inside or out, from his time, though six generations of Chews occupied the house continuously until 1972, when it became the property of the National Trust for Historic Preservation.

Cliveden's decorative arts collections span 200 years. Furnishings came from the workshops of some of the best-known artisans in Philadelphia: mahogany Chippendale furniture created by Thomas Affleck, Jonathan Gostelowe, and others, and looking glasses and girandoles attributed to James Reynolds. Paintings include a portrait of Chew himself and E. L. Henry's depiction of the Battle of Germantown.

The lives and belongings of Chew and his heirs are documented in 200,000 manuscript pages. The library, which also houses collections on historic preservation, cookbooks, and historic Germantown, is open by appointment. Educational programs stress conservation, the environment, and Germantown history. A shop offers period mementos.

Left
Entrance hall

Delaware Art Museum

2301 Kentmere Parkway
Wilmington, DE 19806
Telephone 302 **571 9590**

The Delaware Art Museum has major collections of American 19th- and 20th-century art, including a nationally recognized collection of original illustrations. In addition, it is the primary American repository of works from the English Pre-Raphaelite movement.

The Samuel and Mary R. Bancroft Collection of English Pre-Raphaelite art is on permanent display. All the major artists, including Dante Gabriel Rossetti, Edward Burne-Jones, and William Holman Hunt, are represented; the collection also includes decorative arts, jewelry, and archival material.

The museum's range includes American fine art from 1840 to the present—paintings by Winslow Homer, Thomas Eakins, John Sloan, Edward Hopper, and Andrew Wyeth, prints and drawings, sculpture, photographs, and crafts. Contemporary art is strongly represented in all media.

Howard Pyle, the Wilmington artist/illustrator and inaugurator of the golden age of American book and magazine illustration, is represented by more than 500 works. The

188

Elfreth's Alley

Off 2nd Street between Race and
Arch Streets
Philadelphia, PA 19106
Telephone 215 **574 0560**

Above
John Sloan
Spring Rain
1912

Below right
Elfreth's Alley

museum also houses major works by Pyle's students and followers—N. C. Wyeth, Frank Schoonover, Maxfield Parrish, Stanley Arthurs, and Violet Oakley, among others.

Changing exhibits bring art from other institutions and showcase various aspects of the permanent collection. "Pega-foamasaurus" is a permanent participatory gallery for children.

The library contains 35,000 volumes for reference and research. The Museum Shop offers reproductions, art books, jewelry, sculptures, posters, prints, and stationery, and there is a sales and rental gallery.

Possibly the oldest residential street in the nation, Elfreth's Alley is a unique collection of colonial and Federal-era buildings. All but one are still privately occupied; the exception, the Museum House (126 Elfreth's Alley), is open throughout the summer and fall. Built by blacksmith Jeremiah Elfreth around 1740, it documents the lives of Alley residents through restored rooms and research into the architectural and human lineage of each house.

This narrow street reflects the changing patterns of life in Philadelphia. Before the Revolution, most Alley residents drew their livelihood from the nearby Delaware River. The men were shipwrights, blacksmiths, river pilots, and sea captains. When the Revolution disrupted life on the waterfront, craftsworkers and tradespeople moved into the Alley: cabinet-makers, potters, barbers, hatters,

dressmakers, and small shopkeepers. As the century drew to a close, a number of French immigrants appeared, and waterfront activity resumed, bringing several sea captains back to the Alley.

Preservation of the street was initiated in 1934 when residents formed the Elfreth's Alley Association and began to open their historic homes to the public one day a year (a practice that continues in the June Fete Days). Battling to keep the houses intact and fend off developers, the Association eventually won Historical Landmark status. Since 1957, it has supported research into the lives of approximately 500 individuals who lived or worked in the Alley, and has tracked down some of the articles that they made. Examples are displayed in the Museum House.

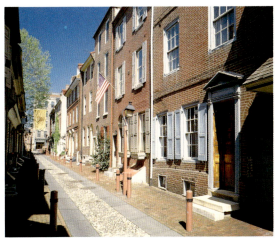

THE INSTITUTIONS

CULTURAL CONNECTIONS

189

Wharton Esherick Museum

Horseshoe Trail
Paoli, PA 19301
Telephone 215 **644 5822**

Fairmount Park Council for Historic Sites

Fairmount Park
Philadelphia, PA 19131
Telephone 215 **685 0045**

The Wharton Esherick Museum, which was the sculptor's home and studio, is an intensely personal fusion of fine craftsmanship with wild flights of the imagination. Esherick carved, forged, and constructed everything from kitchen utensils to staircases. Even the floorboards express his sense of rhythm and design.

On exhibit are more than 200 pieces produced between 1920 and 1970: paintings, woodcuts, prints; sculpture in wood, stone, and ceramic; furniture and utensils. They reveal the artist's progression from organic forms through the sharp prismatic angles of cubism,

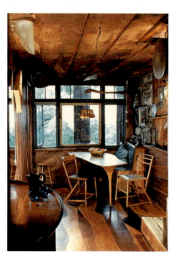

eventually evolving into swirling, lyrical forms. Esherick has been described as a stubborn survivor of the American arts and crafts movement who nevertheless kept pace with changing concepts of modernism.

Though he began as a painter, having learned his craft at the Philadelphia Museum School of Industrial Arts and the Pennsylvania Academy of the Fine Arts, Esherick is best known for his sculptural furniture and furnishings. He has been called the dean of American craftsmen.

Whether a cubist-style desk of "interpenetrating geometric planes" or a "free-form" couch, Esherick's work incorporates the principle of organic architecture: the idea that an object should harmonize with and grow from its environment. The rooms he designed are a continuous sculpture of warm wood textures and related forms. Guided tours are available; reservations are required.

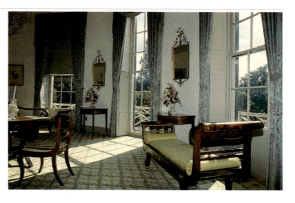

Below left
Dining room

Above
Oval drawing room, Lemon Hill

Visitors to some of Fairmount Park's historic sites can walk through Philadelphia's past and see the city's future in the skyline beyond the trees. Colonial days are recalled in Rittenhouse Town, site of North America's first papermill; in the handsome interior paneling of Bellaire; and in the Quaker simplicity of Cedar Grove. Georgian elegance is typified by Mount Pleasant, Laurel Hill, and Woodford, built "out in the country" as summer retreats away from the city's heat and yellow fever.

Four buildings of classic Federal design are Lemon Hill, with its series of three oval rooms; Sweetbriar, with its pure geometric lines; Strawberry Mansion, made far more grand than originally intended by 19th-century additions; and Loudoun, an elegant Greek

Aquarium Drive below
Philadelphia Museum of Art
Philadelphia, PA 19101
Telephone 215 **592 4908**

Revival package for the furnishings, decorative objects, and papers of the Logans who lived there from 1804 to 1939.

In the mid-19th century, when the city purchased land along the Schuylkill River as a watershed for its new waterworks, it acquired a number of historic estates. As the Park grew from its first parcel of 5 acres to its present 8,700 acres, other sites have been added, both in the Park and in many Philadelphia neighborhoods, providing a three-century perspective on the city's architecture and history, its residential and commercial life.

The Fairmount Park Council, a consortium of 24 historic sites, aims to "preserve, restore and increase public awareness" of these architectural and historic treasures through tours and special programs. Over the years, many of these sites have been adapted for residential, commercial, and recreational uses. Those marked with a dot are house-museums. Sites not mentioned above are:

East Fairmount Park
Fairmount Water Works (1812)
Historic Boat House Row
 (12 sites, mid-19th c.)

Ormiston (1798)—Royal
 Heritage Society
Rockland (1811)—American
 Rowing Historical Society
West Fairmount Park
Belmont Mansion• (1745–1760)
Chamounix Mansion (1800)—
 American Youth Hostels
Japanese House and Garden•
 (reconstruction of 17th-c.
 building)
Memorial Hall (1876)
Ohio House (1876)—Fairmount
 Park Ranger Corps
Germantown
Canoe Club (18th-c. mill site)
Southwest Philadelphia
American Swedish Historical
 Museum (1926)
Bartram's Garden (1728, 1770)
Blue Bell Inn (1766)
Northeast Philadelphia
Glen Foerd on the Delaware
 (1820, 1889)

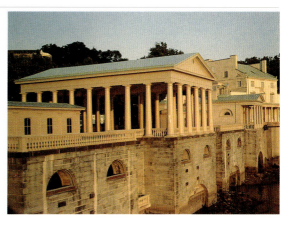

Fairmount Water Works

The Fairmount Water Works was the nation's first large-scale municipal waterworks. This ensemble of buildings, constructed over a 60-year period beginning in 1812, is one of the finest examples of neoclassical architecture in the United States. Frederick Graff, and later his son, designed, engineered, and modified the structures and their machinery over the nearly one hundred years the site supplied Philadelphia's drinking water.

With the Fairmount Water Works, Philadelphia built a temple to industry that was a public attraction from the beginning and became the genesis of the extensive Fairmount Park system. Through interactive

Fireman's Hall

2nd and Quarry Streets
Philadelphia, PA 19106
Telephone 215 **923 1438**

exhibits and programs, the Interpretive Center focuses on the site's pivotal role in the history of the region. Working models, historical images, and a surviving 1851 turbine and pump bring this history to life.

The Water Works' location on the banks of the Schuylkill River, at the gateway to the central business district, makes it an ideal place to explore the fragile relationship of a city to its environment. Visitors can, for example, test the quality of water obtained from tap, river, and sewer sources to measure the impact of human activities on the aquatic environment.

The Fairmount Water Works Interpretive Center holds archaeological collections obtained during the ongoing restoration of the site and a photographic archive. It is developing a research library and archive. The Center will be open to the public in the fall of 1992. In the meantime, group tours, programs, and exhibits are offered periodically.

Hand- and horse-drawn apparatus
c. 1820–1907

This 1902 firehouse-turned-museum covers the story of firefighting in America from volunteer brigades to the municipal workers of the early 20th century. Here are a wooden hand pump of 1731, believed to have been used by Benjamin Franklin, a replica of a fireboat wheelhouse, and a stained-glass window depicting a dramatic rescue.

Shiny red pumps, wagons, and hand-drawn, horse-drawn, and steam-powered engines of all sizes fill the first floor hall. A case contains meticulously accurate models of local 20th-century fire engines made by John Digeisi. Other displays demonstrate the skill and bravery of early volunteer firefighters. A life-sized graphic shows an 18th-century bucket brigade. Collections of firemarks, helmets, clothing, and badges are supplemented with paintings and other depictions of firemen in action.

On the second floor the story of professional firefighting is told. A film describes the days when the neighborhood fire station housed eight or ten men, two pieces of apparatus, and teams of horses to pull them. The original living room of the firehouse has been restored to show how the men spent their leisure time. Beyond the chief's office, the visitor steps to the wheel of a fireboat. The teachers' room also serves as a memorial honoring the fallen.

A state-of-the-art display of the "Jaws of Life" conveys another aspect of the firefighter's job. The curator conducts classes in firefighting history and fire safety for school and adult groups upon request.

Samuel S. Fleisher
Art Memorial

709–721 Catharine Street
Philadelphia, PA 19147
Telephone 215 **922 3456**

If contemporary art seems a strange complement to the medieval and Gothic religious works exhibited at the Fleisher Art Memorial, the connection is to be found in the tastes and social commitments of its founder, Samuel S. Fleisher.

In 1898 Fleisher started the first free art school in the nation —"for the world to come and learn art"—and gathered both famous and emerging talents. Stained glass windows by John La Farge, wrought iron gates by

Samuel Yellin, murals by Nicola D'Ascenzo and Robert Henri, and an altarpiece by Violet Oakley can be seen here.

Contemporary art can be viewed in the Fleisher art gallery throughout the year. Challenge Exhibitions display the works of local artists and are interspersed with faculty and student shows.

Fleisher formed his Graphic Sketch Club at a time when the arts and crafts movement was dominant. Artists of the movement drew historical references from medieval and Gothic themes and often used Byzantine and Egyptian iconography. Fleisher's personal collection reflected these interests. When he purchased the Romanesque Revival basilica next to his school to save it from demolition, he installed his medieval collection along with Russian icons and Oriental rugs belonging to his brother. He renamed the church "The Sanctuary." In 1945, when the Philadelphia Museum of Art assumed administrative control over the Memorial, the Sanctuary collections were enriched with 15th- and 16th-century European paintings and sculpture.

Concerts, exhibitions, art history lectures, and low-cost art classes are open to the public.

Below left
Pau Vergos
St. Accursius
Before 1495

Right
Wilbraham bookcase
1870s

Frankford Historical
Society

1507 Orthodox Street
Philadelphia, PA 19124
Telephone 215 **743 6030**

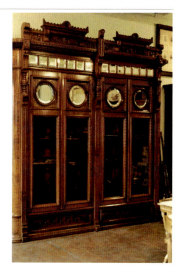

The Frankford Historical Society was formed in 1905 by a small group of local residents to preserve the history of Frankford and Northeast Philadelphia and collect related historical data and artifacts. The Society is housed in a Georgian Revival building designed for it in 1930 by Frank Rushmore Watson. In addition, the Society preserves architectural elements from two 18th-century estates. The original entrance of Allengrove Mansion is incorporated into the garden facade, and two mantels

193

CULTURAL CONNECTIONS THE INSTITUTIONS

Franklin Institute
Science Museum

20th Street and Benjamin Franklin Parkway
Philadelphia, PA 19103
Telephone 215 **448 1200**

from Waln Grove are in the office and boardroom. The building houses a meeting room, museum, and library.

The research library has extensive holdings on Frankford and Northeast Philadelphia: newspapers, deeds, books, journals, genealogies, maps, atlases, newspaper clippings, Bibles, letters, and scrapbooks, as well as photographs, glass slides, and stereographic images of Frankford, Bustleton, Holmesburg, Tacony, Bridesburg, Pennypack, and other areas from 1860 to 1920.

Objects of local historical interest include Indian artifacts, ceramics, stoneware, costumes, textiles, portraits, furniture, watercolors and prints, household objects, industrial artifacts, decorative objects, and weapons. The Lodge Collection contains works on Abraham Lincoln and the Civil War and artifacts from that war.

The Frankford Historical Society is open to the public several days a year. It is open to researchers by appointment.

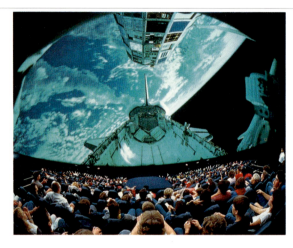

**Tuttleman
Omniverse Theater**

The Franklin Institute, one of the first hands-on science museums in America, is dedicated to making science accessible. Exhibits move from the history of scientific exploration and discovery to the future of science and technology.

Exhibits in the Science Center focus on the physical sciences and technology, using artifacts from the Institute's collections to place contemporary science in its historical context. Highlights include the 350-ton Philadelphia-made Baldwin 60,000 locomotive, the giant walk-through human heart, and an original Wright model B biplane. The Science Center is also home to the Fels Planetarium.

The stately Franklin Hall has as its centerpiece a monumental marble statue of Benjamin Franklin. Its fine collection of Franklin artifacts includes the original glass armonica.

The new Mandell Futures Center looks forward to the science and technology that are shaping the future. Visitors can walk under a waterfall and enter a rain forest in FutureEarth, examine the human body from the inside out in FutureHealth, experience life aboard a 37-foot model of a space station in FutureSpace, and create synthesized symphonies and explore a smart house in FutureComputers. Issues of the future are explored in the Musser Choices Forum, in which visitors can vote on science-related concerns.

In the Tuttleman Omniverse Theater, state-of-the-art film technology surrounds the audience with sight and sound, transporting them into space, the Grand Canyon, the depths of a live volcano, or the body of a world-class athlete.

194

Free Library of Philadelphia

19th and Vine Streets on Logan Square
Philadelphia, PA 19103
Telephone 215 **686 5322**

The Central Library of the Free Library of Philadelphia houses many special collections. Unique holdings include clay tablets more than 4,000 years old, a first edition of Poe's *Murders in the Rue Morgue,* and Dickens' desk and stuffed raven, Grip. These treasures are in the Rare Book Department, which also contains the city's largest repository of illuminated manuscripts and an extensive collection of Fraktur, a Pennsylvania German folk art.

The Print and Picture Department offers nearly one million pictures, most of which circulate. Some ten thousand pictures, prints, and photographs constitute a pictorial history of the city of Philadelphia from William Penn's day. The Theatre Collection covers all aspects of the theater as well as film, television, the circus, and popular entertainment. The Edwin A. Fleisher Collection of Orchestral Music

houses more than 13,000 compositions, each with a conductor's score and a complete set of instrumental parts.

The Special Children's Collection contains original art, a complete set of Children's Book Week posters, and the state resource collection of folklore and children's literature. Other special collections for public use include a large automotive collection and the extensive Map Collection. The latter contains the country's most comprehensive collection of real estate atlases for Philadelphia and its suburbs.

Changing exhibits and a variety of programs are regularly scheduled, and there is a gift shop run by the Friends of the Library. Books on all topics, recordings, and videotapes may be borrowed from the Central Lending Library and the Children's Department.

Below
Ethiopian accordion book
c. 17th century

Friends Historical Library of Swarthmore College

500 College Avenue
Swarthmore, PA 19081
Telephone 215 **328 8496**

Friends Historical Library was established in 1871, when Anson Lapham donated to Swarthmore College 150 volumes of Quaker books for a small library "exclusively for matters pertaining to Friends." Since then the Library has collected books, serials, manuscripts, pictures, and memorabilia related to Quaker history, from the mid-17th-century beginnings of the Religious Society of Friends to the present.

The Friends Historical Library's collections include materials on Quaker history and doctrine; Indian rights; women's rights; the abolition of slavery; and Quaker activity in literature, science, business, education, and government. Closely related is the Swarthmore College Peace Collection, established in 1930, which encompasses the history of the peace movement, conscientious objection, nonviolence, internationalism, and civil disobedience. Special collections in the Swarthmore College Library are the Bathe Collection on the history of technology; materials on William Wordsworth and W. H. Auden; accounts of British travelers in the United States; and miscellaneous rare, illustrated, and decorated books.

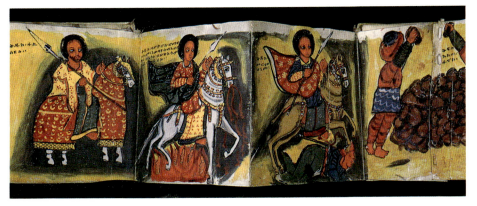

German Society of Pennsylvania

611 Spring Garden Street
Philadelphia, PA 19123
Telephone 215 **627 2332**

The German Society of Pennsylvania is the oldest German organization in America. Founded in 1764 to protect German immigrants from unscrupulous shipping agents and unfair treatment, the Society now concentrates on preserving the German cultural heritage in Pennsylvania.

The wood-paneled library contains polished mahogany bookcases surmounted by portraits and busts of German poets, philosophers, and musicians. Within the glass cases is one of America's most comprehensive holdings of German-Americana. The lending library contains some 70,000 books, both classic and contemporary, 85 percent of them in German. Among the rare books are a first edition of Whitman's *Leaves of Grass* and the text of General von Steuben's manual of military discipline, used from the Revolution to the Civil War. There is also *Some Account of the Province of Pennsylvania* (1682) by William Penn, who wanted to attract Germans to the colony because he admired their agricultural skills.

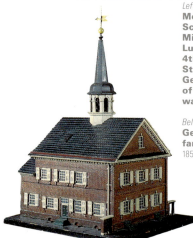

Left
Model of Old Schoolhouse of St. Michael's and Zion Lutheran Church, 4th and Cherry Sts., in which the German Society of Pennsylvania was founded

Below right
Germantown family dolls
1858–c. 1860

The first newspaper to announce the adoption of the Declaration of Independence—issued on 5 July 1776 by a local German printer—is here, as are three editions of the German quarto Bible of Christoph Saur (1743, 1763, and 1776) and German books printed by Benjamin Franklin.

The Society once taught English to immigrants. In the late 19th century, as German immigration declined, it instituted German lessons and cultural programs. Today, evening courses and opportunities for informal conversation are offered to people of all ages, and such annual festivities as the Oktoberfest are held in its Rathskeller.

196

Germantown Historical Society

5503–5505 Germantown Avenue
Philadelphia, PA 19144
Telephone 215 **844 0514** Museum
215 **844 8428** Library

The Germantown Historical Society is a local history museum and library dedicated to preserving and interpreting the physical and written evidence of Germantown's past. Prominently located on historic Market Square in central Germantown, the Society's stately building is a restoration of three 18th-century townhouses. The interior was designed in high Colonial Revival style by the Philadelphia architect G. Edwin Brumbaugh.

Exhibits and programs provide an overview of the rich and diverse history of this community, by turns an isolated settlement of German immigrants, a summer refuge for wealthy Philadelphians, an important Revolutionary battlefield, a major 19th-century textile and industrial center, and a fashionable residential and retail neighborhood.

Objects made or used in Germantown throughout its 300-year history make up the Society's collections: furniture,

Graeme Park

859 County Line Road
Horsham, PA 19044
Telephone 215 **343 0965**

paintings, household items, dolls and toys, quilts and coverlets, samplers, and more. An important costume collection comprises nearly 8,000 items, including rare examples of 18th- and 19th-century fashions. An extensive research library contains early German-language imprints, photographs, maps, and archival materials. There are also portraits by James Peale and examples of German and English cabinetmaking.

Since its founding in 1900, the Germantown Historical Society has worked with other organizations to acquire, restore, or preserve such sites as the Deshler-Morris House, Wyck, Maxwell Mansion, and the Concord School House. Today, the Society works with the historic houses of Germantown to further understanding of this significant community.

Formal parlor, Keith mansion

The rooms at Graeme Park, a Georgian manor, are almost bare. Visitors are encouraged to move freely throughout the house to experience the space and proportions of its rooms and to relate design elements to function. Their attention is directed to architectural elements rather than to the lives of past occupants. The original paint, wall paneling, chair rails, moldings, and fireplaces can be inspected. The few pieces of furniture in each room demonstrate the proportions and styles that were central to Georgian architecture between 1750 and 1775.

Built in the early 18th century by provincial governor William Keith as a country estate and an investment, the house was sold in 1739 to Dr. Thomas Graeme, who used it mostly as a summer residence.

After 1801 Graeme Park was lived in only sporadically, and its owners attempted to preserve it as a historic house.

The manor house is situated on 42.5 acres of land, which also contain an early 19th-century bank barn and a reconstructed summer kitchen. The barn has been refitted as a visitor center and exhibit area. Inventories of the three families that lived in the house are being used to design interpretive exhibits.

Graeme Park is a member of the Rural History Cooperative and is administered by the Pennsylvania Historical and Museum Commission. It offers a variety of public and school programs.

THE INSTITUTIONS

197

CULTURAL CONNECTIONS

Grand Army of the Republic Civil War Museum and Library

4278 Griscom Street
Philadelphia, PA 19124
Telephone 215 **289 6484**

Hagley Museum and Library

DE 141 north of DE 100
Wilmington, DE 19807
Telephone 302 **658 2400**

The Grand Army of the Republic Civil War Museum and Library is tucked unobtrusively among traditional row homes in the Frankford section of Philadelphia. The museum fills three floors of distinguished rooms in a Georgian mansion built by Dr. John Ruan in 1796. Its contents were largely hidden from the public for many years, but in 1985 the museum was reopened. Today, through the efforts of a dedicated group of volunteers, the museum and library are undergoing a major program of renovation and expansion.

The museum's goal is to preserve the heritage of the Civil War, to memorialize its history, and to educate the young about the events of that turbulent period. Volunteer guides dressed in the blue uniforms of the Union Army or in hoop skirts and bonnets stress the human impact of the war. Many are lineal descendants of Union soldiers.

The museum contains a 2,000-volume research archive and a collection of relics and artifacts, the belongings of members of the city's 40 original G.A.R. posts. Among the other holdings are a section of

Artifacts room

the stockade from the notorious Andersonville prison; personal possessions of Maj. Gen. George Gordon Meade, including his battered campaign hat, the chair used in his tent at Gettysburg, and his family Bible; a blood-stained piece of the pillow slip on which lay the head of the dying President Lincoln; and oil paintings and sculptures depicting the heroic personalities of the time.

At the Hagley Museum and Library, miniature models of colonial mills contrast with the huge 19th-century steel and stone restorations on the banks of the Brandywine River, while the lives of workers and owners are contrasted through tours of their homes. Exhibits relate work along the Brandywine to technological developments from the Lenni Lenape to the 20th century. Scale models of waterwheels depict their use in tanning leather, spinning cotton, grinding flour, and rolling steel.

Other exhibits relate the history of the du Pont family in France and America. Eleuthère Irénée du Pont de Nemours started a gunpowder mill on the Brandywine in 1802. A bus ride or a scenic two-mile stroll will take the visitor past rolling, graining, and glazing mills scattered along the river banks. Costumed powdermen and machinists demonstrate the use of sluice gates, waterwheels, and steam engines. At the Millwright Shop, scale models and an audio tape describe the making of explosives.

Tea is served on Blacksmith Hill, a restored community of workers' houses and a school. The contrast with Eleutherian Mills, du Pont's Georgian home, eloquently defines the worlds of owner and worker.

Haverford College Library

Highlands Historical Society

Haverford College
Haverford, PA 19041
Telephone 215 **896 1175**

7001 Sheaff Lane
Fort Washington, PA 19034
Telephone 215 **641 2687**

Founded at the opening of the College in 1833, Haverford's libraries have developed collections and interlibrary cooperative arrangements to support study and research. The James P. Magill Library houses general collections in the social sciences and humanities, a depository for selected U.S. government documents, and a variety of special collections. In addition, the College has libraries in Stokes Hall (specializing in chemistry, mathematics, and physics), Sharpless Hall (biology), the Union Building (musical scores and recordings), and the Observatory (astronomy).

Chief among the Library's special collections is the internationally eminent Quaker Collection of materials concerning the Religious Society of Friends. Other collections contain rare books, including the four folios of Shakespeare's works, autograph letters, and photographs.

The Highlands is a country estate comprising an elegant late Georgian mansion and nine outbuildings built by prominent Philadelphian Anthony Morris in 1796. The mansion was enlarged in the mid-19th and early 20th centuries by the owners, who also created the magnificent gardens. Visitors to The Highlands learn about the various owners and their imprint on the mansion and landscape. The Highlands is owned by the Commonwealth of Pennsylvania and administered by the Pennsylvania Historical and Museum Commission and the Highlands Historical Society. Tours of the mansion and gardens are available, and rentals of the mansion may be arranged.

The 230-acre Hagley complex includes natural scenic areas. School and public programs stress the social impact of industrialism and 19th-century technology. The Hagley collection includes local products, patent models, archaeological specimens, and scientific instruments. The library specializes in economic, industrial, and social history.

Above
Eleutherian Mills

Above right
Center Hall

THE INSTITUTIONS

CULTURAL CONNECTIONS

Historical Society of Delaware

505 Market Street
Wilmington, DE 19801
Telephone 302 **655 7161**

Historical Society of Pennsylvania

1300 Locust Street
Philadelphia, PA 19107
Telephone 215 **732 6200**

Once the center of Wilmington, the 500 block of Market Street now reflects the preservation efforts of the Historical Society of Delaware. The Old Town Hall, the Society's museum, served as the city's headquarters from 1798 to 1916. Permanent exhibits feature Chinese export porcelain, Delaware silver, paintings, furniture, children's toys, a magnificent Victorian dollhouse, and restored 19th-century jail cells. Changing exhibitions interpret a wide range of topics relating to Delaware's rich social, political, and cultural history. The collections are especially strong in costumes, Civil War artifacts, political memorabilia, and weapons.

Across the street the Research Library, the state's major genealogical resource, has a comprehensive collection of photographs, books, documents, and manuscripts relating to Delaware history. The Library is part of a cluster of restored buildings situated in scenic Willingtown Square, which are used by the Historical Society of Delaware for public programs and administrative offices.

In historic New Castle on the banks of the Delaware River, the Society operates the beautiful Federal mansion of George Read II as a house-museum open to the public. Elegantly restored interiors interpret the lives of members of the Read family as well as the colonial revival taste of the last private owners. Read (1765–1836) was a prominent lawyer and the son of a signer of the Declaration of Independence. The formal garden surrounding the house was added in 1847. It retains much of its original design.

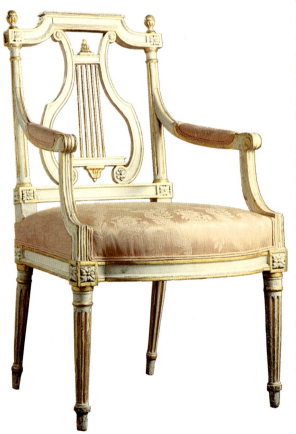

Below
Open armchair
c. 1790

The Historical Society of Pennsylvania, founded in 1824, is one of the oldest historical societies in the United States. Its library, museum, and manuscript holdings constitute the nation's largest independent research center on American and Pennsylvanian history.

HSP holds the first two drafts of the U.S. Constitution, the original plan for Independence Hall, the largest collection of William Penn's letters, and a nearly complete set of Franklin's *Poor Richard's Almanack*. Of special interest are the wampum belt presented to Penn by the Lenni Lenape in 1682 and the sash he wore at the signing of his treaty with them.

Collections include over 13 million business records of Philadelphia banks and craftsmen, 600,000 graphics, 7,500 maps, 200,000 rare books and pamphlets, 950 paintings, furniture, costumes, toys, coins, and the largest collection of Pennsylvania daily newspapers in existence.

Approximately 10 percent of the museum collections are on public view each year. "Finding Philadelphia's Past: Visions and Revisions" will be open to the public through the 1990s. It features a unique interactive video display that visitors view while seated in a recreated trolley car. Among the items on

200

Hope Lodge and Mather Mill

553 Bethlehem Pike
Fort Washington, PA 19034
Telephone 215 **646 1595**

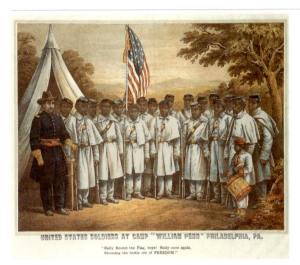

UNITED STATES SOLDIERS AT CAMP "WILLIAM PENN" PHILADELPHIA, PA.
"Rally Round the Flag, boys! Rally once again, Shouting the battle cry of FREEDOM!"

Above
Peter Duval & Son
United States Soldiers at Camp "William Penn," Philadelphia, Pa.
1864

Below right
Hope Lodge

display are Penn's wampum belt, Charles Willson Peale's portrait of Benjamin Franklin, a rare 18th-century doll, and James Wilson's first draft of the Constitution.

Adult programs include workshops, lectures, and the "history booth," which allows Philadelphians to discover who lived in their house in 1880. For young people, there are museum classes, history-on-the-go lessons, and a summer history camp.

Hope Lodge was built between 1743 and 1748 for the Quaker entrepreneur Samuel Morris. Its design is attributed to Edmund Woolley, a carpenter who doubled as architect for many Philadelphia buildings, including Independence Hall. Georgian architecture emphasizes symmetry, and Hope Lodge expresses perfect balance outside and inside. Ninety percent of the decorative details are in their original state, including the wide-board floors and chair rails. The elegant fireplaces, carved from King of Prussia marble, were copied exactly in the restoration of Independence Hall.

The house's early Georgian architecture was retained through its occupancy by five families. Its last private owners, William and Alice Degn, purchased the house in 1922 when a developer threatened to tear it down. They lovingly restored the original structure, even refusing to add central heating to the main house. Today two time periods are interpreted inside Hope Lodge—the colonial era of Samuel Morris and the colonial revival era of the Degns.

Hope Lodge is set on 45 acres, half of which are still farmed. Herb, kitchen, and flower gardens are maintained around the house. Mather Mill stands across Bethlehem Pike from the Lodge. This former grist mill, built c. 1820 by Joseph Mather, is used for meetings, displays, and programs.

Programs at the site range from a formal 1920s-style garden tea in June to a Quilt Exhibit and Forum in September, a 1777 encampment reenactment in November, and candlelight Christmas tours. Workshops, lectures, and concerts are held throughout the year.

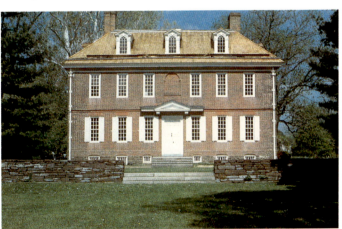

Independence National Historical Park

Independence Mall
Philadelphia, PA 19106
Telephone 215 **597 8974**

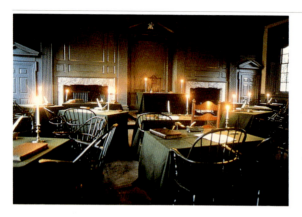

Above
**Assembly Room,
Independence Hall**

Below right
Charles Willson Peale
**Joseph Brant
(Thayendanegea,
Mohawk Chief)**
1797

"America's most historic square mile"—Independence National Historical Park—preserves symbols and documents of the struggle for independence and many of the places where the nation began.

The Liberty Bell, once housed in Independence Hall, has been enclosed in its own pavilion on Independence Mall since 1976. Glass walls and a recorded message make it available to visitors at any hour. Independence Hall's historic Assembly Room is where the Declaration of Independence was debated and adopted in 1776, the Articles of Confederation were ratified in 1781, and the Federal Constitution was framed in 1787. It also contains two of the most prominent symbols of our heritage: the rising sun chair from which George Washington presided over the Constitutional Convention, and a silver inkstand believed to have been used by delegates to sign the Declaration

and the Constitution.

On display at the Second Bank are a copy of the Constitution, an original broadside of the Declaration, and a copy of the Articles of Confederation. The Bank's portrait gallery holds the largest single collection of portraits by Charles Willson Peale and his children.

Buildings, monuments, and historic sites within the Park range from Welcome Park on 2nd Street, constructed as a map of William Penn's city, to the Graff House on 7th Street, where Thomas Jefferson composed the Declaration of Independence. The Visitor Center, 3rd and Chestnut, offers an interpretive exhibit, bookstore, and maps. City Tavern, at 2nd above Walnut, offers 18th-century fare. At 309 Walnut is the upper-middle-class home of Bishop White, the first Protestant Episcopal bishop of Penn-

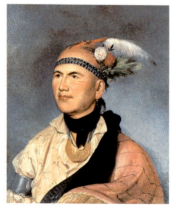

sylvania. A few doors away is the middle-class Quaker home of John and Dolley Todd. She later became Dolley Madison. Admission to INHP buildings is free, but tickets are required for the White and Todd houses.

Franklin Court, between Market and Chestnut, 3rd and 4th, contains an underground museum devoted to Franklin's many endeavors and a 3½ story steel outline of his house. On Market Street is the B. Free Franklin Post Office and a print shop that demonstrates printing methods of his time.

This listing merely suggests the treasures preserved under the auspices of this Federal park. Other INHP sites and buildings open to the public are:
Carpenters' Hall
Christ Church
Christ Church Cemetery
Deshler-Morris House
18th-century Garden
Free Quaker Meeting House
Gloria Dei (Old Swedes')
 National Historic Site
Thaddeus Kosciuszko National
 Memorial
Magnolia Garden
Mikveh Israel Cemetery
New Hall
Pemberton House
Pennsylvania Horticultural
 Society
Edgar Allan Poe National
 Historic Site
Rose Garden
Saint George's Church
Saint Joseph's Church
Slate Roof House Site

Institute of Contemporary Art

University of Pennsylvania
36th and Sansom Streets
Philadelphia, PA 19104
Telephone 215 **898 7108**

When the Institute of Contemporary Art moved into its new building in January 1991, it doubled its exhibition space and was able, for the first time in its history, to remain open to the public year-round, provide for a growing archival library, and expand its offerings of performance art, films, and concerts. It is now a component of "the center of gravity," the University's plan for well-lit night-time activity along the Sansom Street corridor.

For its inaugural exhibition in its new home, ICA chose 25 Philadelphia artists who would reflect the dimensions and dynamics of contemporary art in Philadelphia since 1963, the year of ICA's founding. Each of the 25 senior artists selected a lesser-known artist as a co-exhibitor. Painting, sculpture, photography, mixed media, installation, and performance were represented.

ICA has earned an international reputation as a barometer of artistic significance: it was the first museum to exhibit the works of Andy Warhol (1965), Laurie Anderson (1983), and David Salle (1986). Mid-career retrospectives cover the spectrum of new art, while "1967: At the Crossroads" re-examined the year when rising and waning movements such as minimal art, conceptual art, pop art, and environmental projects intersected. Those exhibiting included Christo, Sol LeWitt, Roy Lichtenstein, Agnes Martin, Robert Morris, Claes Oldenburg, Robert Rauschenberg, Robert Smithson, Frank Stella, and Andy Warhol. Red Grooms's *Philadelphia Cornucopia* was commissioned by ICA.

The Arcadia Archival Library houses drawings, photographs, artists' correspondence, slides, tapes, journals, and catalogues.

Jefferson Medical College of Thomas Jefferson University

Alumni Hall, 1020 Locust Street
Philadelphia, PA 19107
Telephone 215 **955 7736**

The Eakins Gallery of Jefferson Medical College contains portraits of three Jefferson physicians by the 19th-century Philadelphia painter Thomas Eakins. Visitors may request entry to the Gallery at the information desk in the main entrance to the building. Public hours are from 10 to 4 Monday through Saturday, and from noon to 4 on Sunday.

Eakins's *Gross Clinic* (1875) still shocks viewers with its graphically realistic portrayal of a surgical operation. Dr. Samuel D. Gross, presiding over the surgery, pauses momentarily to explain the procedure to students seated in the amphitheater.

The portrait of Benjamin H. Rand shows the chemist behind a desk cluttered with disparate objects ranging from a gleaming brass microscope to a red rose and, unexpectedly, his pet cat. The portrait of Professor William S. Forbes pays homage to the anatomist's contribution to medical education.

Landmarks Society

321 South 4th Street
Philadelphia, PA 19106
Telephone 215 **925 2251**

The Philadelphia Society for the Preservation of Landmarks maintains and interprets four historic house-museums that reflect the development of the Georgian and Federal styles in Pennsylvania.

Powel House, 244 South 3rd St., an elegant brick townhouse built in 1765, was purchased by Samuel Powel at the time of his marriage to Elizabeth Willing. Powel served as mayor of Philadelphia before and after the Revolution. The finely ornamented and appointed rooms attest to the high style of his public life.

The Hill-Physick-Keith House, 321 South 4th St., an imposing four-story brick house, was built in 1786 by Henry Hill, an importer of Madeira wine. The interior is furnished to reflect the early 19th-century period, when it was the home of surgeon Philip Syng Physick. The large city garden contains plants found in Philadelphia during that century.

Grumblethorpe, at 5267 Germantown Ave., was built in 1744 as a summer residence. Constructed of Wissahickon stone and oak, it reflects the German origins of its owner, wine importer John Wister. The Wisters were noted 18th- and 19th-century horticulturists, and some historic trees remain from their time.

Waynesborough, at 2049 Waynesborough Rd. in Paoli, was the home of Revolutionary War hero Anthony Wayne. Uniforms, survey maps, and military paraphernalia are on display along with furnishings of the period. A slide presentation highlights the general's military career and the histories of the Wayne family and the house itself. Several wooded acres are administered as a public park by Easttown Township.

204

La Salle University Art Museum

20th Street and Olney Avenue
Philadelphia, PA 19141
Telephone 215 **951 1221**

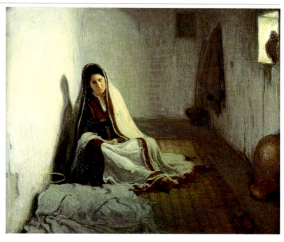

Below left
Breakfast room, Hill-Physick-Keith House

Above
Henry Ossawa Tanner
La Sainte Marie
c. 1898

The La Salle University Art Museum collection features a comprehensive survey of European and American art since the Middle Ages. Developed as a teaching resource, the permanent collection is open to the public on a daily basis. Prints, drawings, and special collections that are not on exhibit may be viewed by appointment.

Major artists represented include Jan Provost, Joos van Cleve, Jacopo Tintoretto, Sébastien Bourdon, Jacob van Ruisdael, Sir Henry Raeburn, Sir Thomas Lawrence, Hubert Robert, Benjamin West, Thomas Eakins, J. B. C. Corot, Edgar

Library Company
of Philadelphia

1314 Locust Street
Philadelphia, PA 19107
Telephone 215 **546 3181**

Degas, Camille Pissarro, Eugène Louis Boudin, Edouard Vuillard, and Georges Rouault. The museum also holds *La Sainte Marie* (1898) by Henry Ossawa Tanner.

The permanent collection of paintings and sculpture is supplemented by 3,280 Old Master prints and drawings and special collections of portrait prints of notable figures from the Renaissance to the present; 19th-century Japanese prints; Indian miniatures of the 16th through 20th centuries; and the Susan Dunleavy Collection of illustrated and finely printed Bibles, with important Catholic, Jewish, and Protestant examples.

Concerts and lectures are open to the public, and group tours can be arranged by appointment.

Below
Augustus Kollner
**Engel & Wolf's
Brewery & Vaults
at Fountain Green**
c. 1855

Benjamin Franklin and a few of his friends established the Library Company of Philadelphia in 1731. It soon became the largest library in the colonies and even functioned as the Library of Congress from 1774 to 1800, when the Continental Congress, the Constitutional Convention, and the U.S. Congress were meeting in Philadelphia.

Today it is an independent rare book and research library with collections that document the history of American culture from the early colonial period to the 1870s. It has the largest collection of rare books in the Philadelphia area and is the only major colonial American library that has survived virtually intact. Among its holdings are the library of James Logan, acquired in 1792, and that of Benjamin Rush, donated in 1869. Its growing collections of primary research materials on 18th- and 19th-century America cover fields as diverse as Afro-Americana, science and technology, architecture, agriculture, natural history, education, philanthropy, medicine, German-Americana, Philadelphia history, book collecting, the women's rights movement, household and family life, printmaking, mapmaking, and photography.

The Library Company mounts exhibitions several times a year, and its catalogues have become standard works of reference. In addition, works of art, historical objects, and documents are on exhibition in the reading rooms.

Franklin formed the institution on a subscription basis, with each shareholder paying an annual fee. Members are still shareholders, though the collections are available to the public for use in the building without charge.

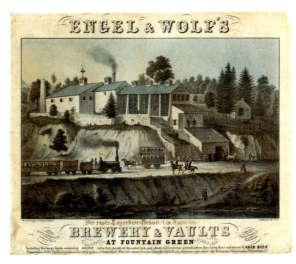

ENGEL & WOLF'S

Die erste Lagerbier-Brauerei in Amerika.
BREWERY & VAULTS
AT FOUNTAIN GREEN

Masonic Library and Museum

Ebenezer Maxwell Mansion

Grand Lodge of Free and Accepted Masons
of Pennsylvania
Masonic Temple, 1 North Broad Street
Philadelphia, PA 19107
Telephone 215 **988 1934**

200 West Tulpehocken Street
Philadelphia, PA 19144
Telephone 215 **438 1861**

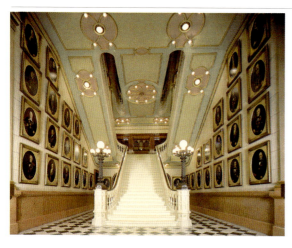

Above
**Rear staircase,
Masonic Temple**

Below right
**Christmas
decoration**

American Freemasonry was founded in Philadelphia in 1732. Masons met in various taverns and halls until 1873, when the Masonic Temple, one of Center City Philadelphia's architectural landmarks, was completed.

Each of the Temple's Lodge Halls represents a different style of architecture. Several—for example, Egyptian and Oriental halls—are patterned after specific sites. Egyptian Hall is modeled in part on the temples at Luxor. The tranquil Corinthian Hall is the largest of the halls, and serves as the meeting room of the Grand Lodge of Pennsylvania. Renaissance Hall has a vaulted ceiling and stained-glass windows; Gothic Hall has pointed arches, pinnacles, and spires; and Norman Hall features Romanesque

rounded arches and decorations reminiscent of illuminated manuscripts. Twenty-four ivory-hued columns line Ionic Hall, while Oriental Hall is fashioned after the Palace of the Alhambra in Spain.

The Masonic Library and Museum of Pennsylvania holds approximately 70,000 books, pamphlets, and periodicals, among them a Geneva "Breeches" Bible and the first Masonic book printed in America—by Benjamin Franklin. The museum draws attention to the connection between the Founding Fathers and Freemasonry with such items as George Washington's Masonic Apron and a lodge notice engraved by Paul Revere. Many paintings, sculptures, and items of Masonic memorabilia and regalia are on display. The archive contains manuscripts and professional and amateur photographs ranging from early daguerreotypes to contemporary snapshots.

The first Victorian house and garden museum in the Philadelphia area, the Ebenezer Maxwell Mansion sits on a tree-lined street in Germantown a few blocks from the railroad station that made the "good life" in the suburbs possible.

Built in 1859 of stone in the eclectic style, with Romantic Gothic and Second Empire elements, Maxwell's villa was intended to combine the best of urban and rural living in a new commuter community. Today the mansion, with its soaring three-story Italianate tower and patterned slate roof, continues to be part of a Victorian enclave of homes, gardens, and churches.

The museum offers a rare glimpse of life in a rising middle-class household between

Mennonite Heritage Center

565 Yoder Road
Harleysville, PA 19438
Telephone 215 **256 3020**

1860 and 1880. The first floor is restored to depict the upwardly mobile life of the 1860s. The formal parlor and dining room are rich with machine-made furniture and textiles of the Rococo Revival, while the kitchen is filled with labor-saving devices for the servants' use. On the second floor, restored to the style of the 1870s, the influence of the Philadelphia Centennial Exposition is apparent. Upstairs rooms are elaborately stenciled and painted with designs reminiscent of the Orient, Egypt, and Rome. Two period gardens reflect mid- and late 19th-century landscaping designs.

The museum promotes restoration of Victorian architecture through its resource library, educational programs, and workshops. It offers guided tours and special events, such as the annual Victorian Ice Cream Social and the Philadelphia Old House Fair.

The Sloth
c. 1820

The MeetingHouse of the Mennonite Heritage Center presents the story of Anabaptist-Mennonites from the beginning of the movement in 16th-century Switzerland through three centuries of Mennonite life in southeastern Pennsylvania. Though of recent construction, the building reflects an architectural as well as social heritage, with its long "welcoming" porch, sharply sloped roof, and walls partially faced with local fieldstone. The entrance is lined with stones brought to the groundbreaking in emulation of Joshua's charge to the children of Israel to pick up a stone as they crossed the river Jordan.

"Work and Hope," a permanent exhibit, begins in a room that resembles a 19th-century meetinghouse. A video presentation describes the Mennonite movement from its origins through the years of persecution and the struggle to find a place to worship according to the dictates of conscience. The exhibit concentrates on Mennonite life in southeastern Pennsylvania since the arrival of the first 17th-century settlers.

An exhibit of the folk art Fraktur contains illuminated writings, most of which were made by local schoolmasters and given to children as rewards for good work or good behavior. Changing exhibits reflect the expression in everyday life of traditional Mennonite culture, with its emphasis on family, community, simplicity, non-resistance, and work.

The Historical Library and Archives holds rare books (some from the 16th century), manuscripts, and genealogical and church records.

Mercer Museum

James A. Michener Art Museum

84 South Pine Street
Doylestown, PA 18901
Telephone 215 **345 0210**

138 South Pine Street
Doylestown, PA 18901
Telephone 215 **340 9800**

Henry Chapman Mercer set out in 1897 to rescue the "Tools of the Nation Maker." Forty thousand objects later, this is the world's most comprehensive collection of preindustrial tools and artifacts, exhibited in a unique manner.

The Mercer Museum is a six-story castle with dovecotes and turrets of reinforced concrete. Inside, Mercer's collection hangs from the ceiling, from five balconies, and on the walls, and is displayed in 70 rooms. More than 60 early American crafts and trades are represented by their tools and finished products.

There is a country store and blacksmithing, printing, woodworking, and broom-making shops. Shoemakers, hatters, clockmakers, miners, trappers, and healers are represented. There are musical instruments, a schoolroom, solar salt equipment, a gallows, and some caskets. A representative sample was not enough; Mercer wanted to show the diversity, the variety of cultural influences, and the creativity of the trades by displaying many examples of each object.

An orientation center prepares visitors for the visual impact of Mercer's collections. Interpretive labels have been added to provide a context for his unorthodox displays.

Mercer built Fonthill, his castle-like home (East Court St.), and the Moravian Pottery and Tile Works (Swamp Road, PA 313) within a mile of the museum. The factory continues to produce tiles using methods and formulas Mercer preserved.

An arts and crafts fair is held in May, and there are other folk events through the year. The Spruance Library is available for research on folk art and crafts and Bucks County history and genealogy.

Below
Ribbon box
18th century

The James A. Michener Art Museum was founded in 1987 as a private, nonprofit institution to foster and promote the arts in Bucks County, Pennsylvania. It preserves and exhibits works from across the country, but particularly from the region and the state, and conducts cultural and educational programs.

The museum is custodian of over 2,000 paintings, works on paper, and sculptures, including important pieces from the Pennsylvania Impressionists—artists of the New Hope School, who focused on the American landscape. There are several paintings by Edward Redfield and Walter Baum, and a recent acquisition is Daniel Garber's *River Bend.* Many works come from the Bucks County Fine Arts Collection, which contains regional works donated to the county since the 1940s by artists and collectors.

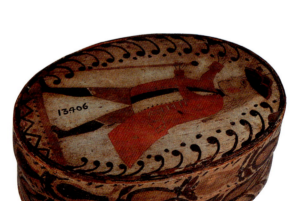

Morris Arboretum

9414 Meadowbrook Avenue
Entrance: 100 Northwestern Avenue
Philadelphia, PA 19118
Telephone 215 **247 5777** M–F
215 **247 5882** Sa–Su

Above
Daniel Garber
Haystacks near Kintnersville
Early 20th century

Below right
Formal rose garden

The museum has renovated the former county prison (listed on the National Register of Historic Buildings and Sites) into over 6,000 square feet of exhibition space and a small research library. The Bucks County Regional Library is adjacent to the Michener Museum, and the Mercer Museum is across the street.

The museum offers group tours during visiting hours. Special events and lectures are scheduled on weekends and in the evenings to serve a wide audience. A collaborative lecture series, held throughout the academic year at Delaware Valley College, is open to students and the general public. Outdoor concerts and other activities are presented on the museum grounds during the summer.

The Morris Arboretum of the University of Pennsylvania is a Victorian travelogue, offering borrowed landscapes from around the world, a nostalgic array of living, architectural, and sculptural forms, and an orchestrated journey through landscape history. John and Lydia Morris, brother and sister, planned these vistas to incorporate classical Greek, Italian Renaissance, English Garden-esque, American Rustic, and Japanese styles with the conserved native woodlands. The Rose Garden, Swan Pond, the Fernery, and seasonal flower displays offer typical Victorian variety.

As the Commonwealth's official arboretum, the Morris Arboretum houses the state tree collection including specimens of the official state tree, the Eastern Hemlock, *Tsuga canadensis.*

Over 6,800 labeled, temperate woody plants grow in this outdoor museum dedicated to environmental research and teaching. The fine arts collection includes *Two Lines* by George Rickey. Asian plants have been a major feature of the collection since its founding. The graceful century-old Katsura, *Cercidiphyllum japonicum,* is one of the rare specimens planted by the Morrises. Plant explorer E. H. Wilson sent them many other rarities from the Orient. Today the living collections are enriched by international explorations and seed exchanges.

The Morris Arboretum is a university center with programs in science, humanities, and the arts. The staff works to save threatened ecosystems, improve environmental education, understand forest ecology, and maintain a computer-accessed database of the state flora. Besides special events such as Arbor Day, performing arts productions, and the spring plant sale, the Arboretum offers lectures and workshops.

Mummers Museum

2nd Street and Washington Avenue
Philadelphia, PA 19147
Telephone 215 **336 3050**

The first Philadelphia mummers were Swedes and Finns, quickly joined by German, Welsh, and English settlers who added their own traditions of merry-making. In the 1840s, the amalgam was completed by the addition of the feathers, strut, and music of the minstrel show.

Until 1901 "Shooters" filled the week between Christmas and New Year's Day "shooting in the new year" with increasingly energetic costumed revelry and rival parades. Then city fathers banned gunplay and consolidated the celebrations into one big parade on January 1. The Mummers Museum is dedicated to the events of that day—and the year of preparation leading up to it.

In the lobby the Winner's Circle displays award-winning sequined and feathered costumes. Sights and sounds of the parade surround the visitor entering the first gallery, which is designed to look like Broad Street south of City Hall with 12-foot photo murals and a macadam floor. Here comic, fancy, and string band mummers are represented by revolving costumed mannequins. The history and origins of mummery are presented through interactive devices, including hand-cranked "movies" and an electronic quiz.

Sound tracks of mummers' instruments can be activated in the Hall of Music. Nearby an exhibit honors James Bland, the Black composer of "Oh, Dem Golden Slippers" (1879), the parade's theme song.

The research library offers English mummers' plays, videos, books, records, and newspaper clippings. From May to September there are free weekly string band concerts in the parking lot.

The Museum at Drexel University

32nd and Chestnut Streets
Philadelphia, PA 19104
Telephone 215 **895 2424**

Left
Parade recreation, the Broad Street room

Below
Frederigo Soulacroix
Conversation Piece with Lillie Belle Randell and Letitia Randell
1880

Anthony J. Drexel (1826–1893) was convinced that no person was truly educated until he or she understood the interdependence of art, science, and industry. He therefore established a museum as an integral part of the university he founded in 1891 as the Drexel Institute of Art, Science and Industry. In addition to fine arts, many of the objects he selected illustrate the transition from handicrafts to mass production. In 1992 the museum will occupy a new home in the Centennial National Bank, designed by Frank Furness.

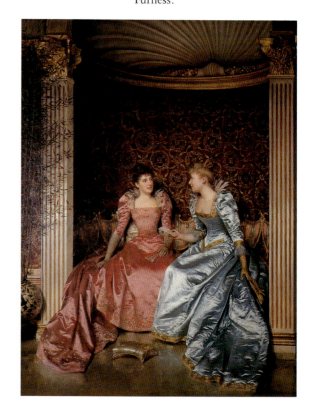

Mütter Museum

College of Physicians of Philadelphia
19 South 22nd Street
Philadelphia, PA 19103
Telephone 215 **563 3737**

The museum's 14,500 objects range from Greek Tanagra figures of the third century B.C. to contemporary photographs. There are paintings by 19th-century European academic artists, and sculptures by such leading practitioners as Denis-Antoine Chaude, William Wetmore Storey, and George Rickey. Other noteworthy items include a terra-cotta *modèle du comité* of the Statue of Liberty (1879) by Frédéric-Auguste Bartholdi. The decorative arts collection includes Wedgwood and Sevres porcelain, a clock and orrery by David Rittenhouse, and a chess table and mirror from Napoleon's exile on St. Helena. Works on paper include documentary photographs by William Henry Jackson, Old Master drawings, prints by Hogarth and Hiroshige, and contemporary works by Robert Rauschenberg and Red Grooms. Works from the Howard Pyle era (1896–1903) exemplify Drexel's heritage as the great school of American illustration.

There are thousands of textile samples and a costume collection that includes garments by 19th- and 20th-century European and American designers.

Office of Dr. Philip Gordon Kitchen, Highland Park general practitioner
1911–1923

The Mütter Museum documents three centuries of Philadelphia medicine through anatomical models, pathological specimens, instruments, and physicians' portraits and memorabilia. Housed within the elegant building of the College of Physicians of Philadelphia, one of the country's oldest medical societies, the museum provides a unique glimpse into historical and present-day medical practice.

Thomas Dent Mütter used the original collection to teach surgical anatomy and pathology to his students at Jefferson Medical College. The museum continues to be enlarged by donations. Almost every specialty is represented. Biology students will enjoy the exhibit on reproduction and fetal development. Anthropologists will appreciate the array of 139 skulls assembled by a 19th-century Viennese physician to show anatomical variations among European populations. The general visitor will be fascinated by the tumor removed from President Grover Cleveland's jaw during a secret operation in 1893; the medicine chest of Dr. Benjamin Rush, a founder of the College and a signer of the Declaration of Independence; a plaster cast of the bodies of the original Siamese Twins and their connected livers, removed when their autopsy was performed at the museum in 1874; a complete early 20th-century doctor's office; and a replica of the first successful heart-lung machine.

Exhibits explore such themes as the European roots of American medicine, the 19th-century revolution in diagnosis, changes in medical technology, and advances in pharmacology and surgery.

Complementing the museum are the rare books, manuscripts, archives, prints, and photographs of the College's Library.

National Archives

Room 135, Post Office Building
9th and Chestnut Streets
Philadelphia, PA 19107
Telephone 215 **597 3000**

The National Archives–Mid-Atlantic Region has materials of interest to historians, genealogists, attorneys, and those interested in civil rights, government operations, commerce, and industry. The Archives houses over 42,000 cubic feet of paper records. The largest collection consists of records of the federal courts in Pennsylvania, Delaware, Maryland, West Virginia, and Virginia. Materials relate to the Whiskey Rebellion of 1794, the taking of enemy ships during the War of 1812 and the Civil War, patent cases involving Samuel F. B. Morse and Thomas Edison, fugitive slave cases of the 1850s, school desegregation cases of the 1960s, and the Penn Central bankruptcy. All are carefully preserved in the Archives' temperature- and humidity-controlled stacks.

212

The regional Archives also holds a large collection of microfilm publications of records found in the National Archives in Washington, D.C. Among the most popular of these 55,000 rolls of microfilm are those dealing with genealogy: federal census records for the entire country from 1790 to 1910; passenger lists for the ports of Philadelphia and Balti-

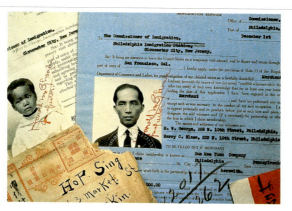

more from 1800 to 1950, and naturalization petitions from the early 18th century. The office also has the Papers of the Continental Congress, U.S. State Department consular dispatches, and records of the Bureau of Indian Affairs.

Two major exhibits a year feature the Archives' holdings. Public programs range from lessons for school groups to public workshops.

Above
Documents from the Philadelphia Chinese Exclusion Case Files
c. 1900

Below
Hands of Priestly Blessing, from the Shaarei Eli Torah ark
c. 1918

National Museum of American Jewish History

55 North 5th Street on Independence Mall East
Philadelphia, PA 19106
Telephone 215 **923 3811**

The only museum in this country exclusively dedicated to documenting Jewish life in the Americas, the National Museum of American Jewish History narrates, through its collections, programs, and exhibitions, more than three centuries of Jewish settlement in the Western Hemisphere, with particular emphasis on the United States.

Collections represent the material inheritance and cultural patrimony of American Jews. Numbering more than 5,000 objects and documents, the collections are diverse in media and broad in scope. A permanent exhibition, "The American Jewish Experience," dramatically depicts three centuries of Jewish participation in American life through a chronological survey highlighted by more than 300 works of art, artifacts, archival documents, and an audio-visual program. Showcasing objects from the museum's collections, the exhibition also

Noyes Museum

Lily Lake Road
Oceanville, NJ 08231
Telephone 609 **652 8848**

features materials from the historic congregation Mikveh Israel, known as "The Synagogue of the American Revolution," which shares the museum's building, and historic objects and documents borrowed from archives, museums, and private collections across the nation.

Extending the exhibitions beyond its walls are two sculptures on the museum's grounds. *Religious Liberty,* an allegorical statue created by Sir Moses Ezekiel for the 1876 Centennial celebration in Fairmount Park, was relocated to Independence Mall in 1985. A modern sculpture by Buky Schwartz, placed opposite the entrance to the museum, commemorates the heroism of Lt. Colonel Jonathan Netanyahu, who died leading the rescue at Entebbe in July 1976.

A shop has books and craft items.

Larry Francis
Sweet Spring Morning
1986

The Noyes Museum is perched on the brink of picturesque Lily Lake, which is just off Route 9 about 10 miles north of Atlantic City and adjacent to the Edwin B. Forsythe National Wildlife Refuge (Brigantine Division). This natural landscape provides a setting for the museum's sun-filled, terraced galleries.

The museum, founded in 1982 by Mr. and Mrs. Fred Winslow Noyes, Jr., of nearby Port Republic, features a small but growing permanent collection of contemporary American art, with an emphasis on New Jersey artists, and a collection of American working bird decoys. Included in the permanent collection are works by Richard Anuszkiewicz, Walter Darby Bannard, Clarence Carter, Jacob Landau, Robert Motherwell, Robert Natkin, and Jane Teller. Rotating exhibitions of American fine art, crafts, and folk art include artists of both national and local prominence.

Scheduled to coincide with special exhibitions are "Meet the Artist" days, when artists are invited to lead informal discussions and demonstrations of their particular medium. Other special events include concerts of contemporary and classical music, often highlighting new works by New Jersey composers, panel discussions, and poetry readings. In addition, decoy carving demonstrations are given in the museum's turn-of-the-century carving workshop.

Philadelphia College of Textiles and Science
4200 Henry Avenue
Philadelphia, PA 19144
Telephone 215 **951 2860**

400 Pennsbury Memorial Road
Morrisville, PA 19067
Telephone 215 **946 0400**

**American
jacquard coverlet**
Late 19th century

The Paley Design Center, on the campus of the Philadelphia College of Textiles and Science, collects and cares for textiles. The current collection of over 1.5 million items is used by students, researchers, and the textile community worldwide. In addition to Egyptian Coptic fragments dating from about the 4th century, the Center houses 16th-century lace, 18th- and 19th-century quilts, 19th-century Philadelphia-made textiles, American and European costumes from 1833 on, 20th-century designer clothing, and 19th-century christening gowns and crib covers.

There are also Chinese embroidered silk skirts, Japanese kimonos, and other traditional costumes from around the world. Clothing accessories include shoes, beaded bags, parasols, gloves, and fans. Mannequins display samples of these holdings. More than 100 swatch books and several thousand swatch cards tell the story of American and European textile manufacturing from 1840 to the present. Each card contains information about where, when, and how the swatch was made, its manufacturer, and other data. A filing system classifies swatches according to subject matter—for example, "butterfly motifs"—while a computer allows the user to call up information about a particular piece and produce a color image or print. Weaving and spinning tools and artifacts can also be seen here.

The Center hosts four exhibits yearly, and lectures accompany each exhibit. The gallery shop offers books, catalogues, and items related to textiles. The library contains books and materials on technical processes, fiber arts, design, and Philadelphia's role in the textile industry.

Pennsbury Manor's historical significance spans several centuries: it is the only 17th-century English country gentleman's estate in the United States, and the last public-works restoration of the New Deal era. It is also the only residence of William Penn, in Britain or America, that is open to the public.

Penn's manor house was built between 1683 and 1699; the present structure was built on the original foundations. Allowed to fall into ruins during the 18th century, Pennsbury attracted attention during the 1930s, when efforts to rebuild the site were coordinated with federal work relief programs. The reconstruction is a product of the 1930s, providing the Pennsylvania Historical and Museum Commission with a fascinating challenge: to preserve the 1930s interpretation of a 17th-century site while pursuing standards of accuracy appropriate to the 1990s. Recent research inspired a major reinterpretation of the interior, where bright, even bold, wall coverings and fabrics replaced the subdued colors once considered appropriate for a Quaker home.

Pennsylvania
Academy of the
Fine Arts

Broad and Cherry Streets
Philadelphia, PA 19102
Telephone 215 **972 7600**

Penn's dreams for his settlement are reflected in his gardens. He expected his vineyard to blossom into a successful wine industry; he planted hops and started a brewery; he imported livestock, roses, and fruit trees. Today, Pennsbury's gardens and barnyard display plants and animals similar to those he might have chosen.

Public programs include living history events, camps, and programs on 17th-century crafts, holidays, and farm techniques. A gift shop offers books, reproductions, and handmade items. The library specializes in social history, horticulture, decorative arts, and historic preservation.

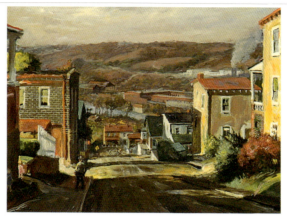

Below left
Governor's parlor

Above
Francis Speight
**Highland Avenue,
Manayunk**
1956

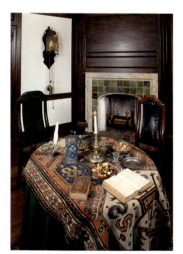

The fanciful High Victorian architecture of the Pennsylvania Academy of the Fine Arts (1876) is the work of Frank Furness. World-famous and locally familiar paintings inside the building include Benjamin West's *Penn's Treaty with the Indians*, portraits of George Washington by Gilbert Stuart and Rembrandt Peale, *Fox Hunt* by Winslow Homer, *The Cello Player* by Thomas Eakins, and *The Artist in His Museum* by Charles Willson Peale.

The grand stairhall, decorated with gold leaf, bronze ornaments, and silver stars, invites visitors to the upper galleries. Behind the Gothic arches is the West masterpiece *Death on the Pale Horse*, saved from destruction in 1845 by a quick-thinking fireman who cut away the 25-foot-long canvas just as the frame caught fire.

Collections focus on American art from 1700 to the present, with 1,700 paintings, 300 sculptures, and more than 14,000 works on paper. About 3 percent of the holdings are on exhibit at any one time. The recent addition of 2,500 works and possessions of Thomas Eakins makes the Pennsylvania Academy one of the major centers for the study of this artist, who was the first director of the Academy's school and revolutionized art education by emphasizing the study of anatomy. The Academy art school and museum, opened in 1805, are the oldest in the United States.

There is a growing collection of 20th-century artists, many of whom have been associated with the Academy. The first-floor Morris Gallery displays works by contemporary Philadelphia artists. The School Gallery at 1301 Cherry Street exhibits works primarily by faculty and students.

Exhibitions change every 8 to 10 weeks and are complemented by lectures, films, concerts, and family workshops. The library and archives are accessible to the public by appointment, and the Museum Shop offers a variety of books and gifts.

Pennsylvania Hospital

Pine Building
8th Street between Spruce and Pine Streets
Philadelphia, PA 19107
Telephone 215 **829 3998**

The Historic Library of the Pennsylvania Hospital was founded in 1762, the first medical library in the original colonies. At present it contains 13,163 volumes, with particular strengths in early American medicine and natural history. Its archives contain an unbroken line of records from 1751 to the present, including minutes of the Board of Managers, stewards' and matrons' records, and patient records for the Department of the Sick and Injured and the Psychiatric Department. They are accessible to researchers by appointment.

The hospital holds Benjamin West's *Christ Healing the Sick in the Temple* (1815) and many portraits. An early fire engine stands in the main hall. The country's first medical-surgical amphitheater is on the third floor, as is the History of Nursing Museum. An 18th-century herb garden has been recreated on the hospital grounds.

Pennypacker Mills

PA 73 and Haldeman Road
Schwenksville, PA 19473
Telephone 215 **287 9349**

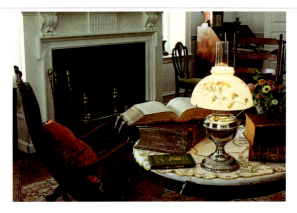

Library

Pennypacker Mills, a turn-of-the-century country gentleman's estate on 125 acres in rural Schwenksville, was the home of Samuel W. and Virginia Broomall Pennypacker from 1902 to 1916. The 20-room Colonial Revival mansion was used as a retreat and summer residence during Samuel's governorship of Pennsylvania (from 1903 to 1907) and as their year-round residence from 1907 to 1916, when Samuel died.

Samuel W. Pennypacker purchased the property in 1900 because of its associations with colonial Pennsylvania history and with his own family as the home of Hans Jost Hite (c. 1720), the home of Peter Pennebacker (1747), and Washington's headquarters during the Battle of Germantown. Pennypacker believed the Godshalk clock in the library to be the one that stood in the house when Washington visited.

From 1900 to 1902, architect Arthur Brockie made extensive renovations to transform the 18th-century farmhouse into the Colonial Revival mansion of today. Furnishings and decorative arts collected by the governor date from the 17th through the early 20th centuries.

A unique feature of the house is the 18th-century summer kitchen, used by the governor as his den and a museum for his prized 18th-century artifacts. Wallpaper depicting colonial scenes was added at the turn of the century.

The Montgomery County Department of History and Cultural Arts acquired the property in 1981 and opened it to the public in 1985.

Philadelphia Maritime Museum

321 Chestnut Street
Philadelphia, PA 19106
Telephone 215 **925 5439**

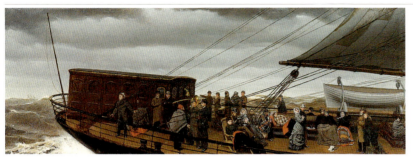

The Philadelphia Maritime Museum brings to life the people and ships of the region's rich maritime history. The energy that a great port generates is reflected in the museum's hoard of objects from the China trade and in a major collection displaying small craft from 1875 to the present, ship models from Chinese junks to passenger liners, and an array of naval vessels. Often incorporated into exhibits, the collections can also be viewed in the museum's unique visible storage area. The more than 10,000 artifacts in the collection include sculptures (among them William Rush's figurehead *Peace*) and paintings by Thomas Birch and George Bonfield.

Drawings, watercolors, prints and scrimshaw, gold and silver objects, ceramics and glass, uniforms, flags, ship fittings, and navigating instruments illustrate underwater exploration, commercial whaling and fishing, naval affairs, and yachting. Interactive devices reveal how engines work and provide insight into technological advances. Programs for adults and children include "Ships of the Explorers," "Privateers of the American Revolution," "Whales and Whalers," and "Waves of Immigration."

The library holds more than 10,000 volumes on maritime topics, periodicals, charts, maps, rare books, photographs, slides, microforms, and films. There are 350 linear feet of nautical manuscripts, a 12,000-item boat plan file, and other research material.

At the museum's floating Workshop on the Water, moored at Penn's Landing, boatbuilders construct tuckups, duckers, and other small craft that are indigenous to area waterways. The Workshop offers seasonal exhibitions and boatbuilding classes.

Above
George F. Wright
Mid-Ocean
1874

Below right
Pablo Picasso
Three Musicians
1921

Philadelphia Museum of Art

26th Street and Benjamin Franklin Parkway
Philadelphia, PA 19101
Telephone 215 **763 8100**

At the Philadelphia Museum of Art, spectacular paintings like *The Bathers* by Renoir, *Prometheus Bound* by Rubens, Van Gogh's *Sunflowers,* and Picasso's *Three Musicians* share the spotlight with Persian rugs, Far Eastern art, medieval armor, and American and European decorative arts.

A legacy of the Centennial Exposition of 1876, the PMA houses more than 300,000 works of art in over 200 galleries and period rooms. First located in Fairmount Park's Memorial Hall, the museum moved to its new home, a striking neoclassical building, in 1928.

Highlights include a fabulous array of works by Marcel Duchamp and the American decorative arts collection, which emphasizes works created by local craftspeople. The Rodin Museum, in a park-like setting at 22nd Street and the Parkway, offers an impressive display of sculptures—the largest col-

210 North 21st Street
Philadelphia, PA 19103
Telephone 215 **963 0666**

lection outside Paris—by Auguste Rodin.

The Far Eastern collection ranges from a cave-like 16th-century Hindu temple and a 20th-century Japanese tea house to Chinese ceramics, fans, scrolls, and embroidered silk robes. Medieval European art is represented by a 9th-century stone abbey, stained glass, tapestries, decorated altars, paintings, and sculpture. Renaissance works include early Italian and Flemish paintings, architectural elements, and sculptures. The explosion of creativity in 19th-century France can be seen in major paintings by Renoir, Van Gogh, Monet, and Cézanne. Landmarks of 20th-century art include works by Picasso, Miró, Klee, and Matisse, as well as more recent works by Rauschenberg, Oldenburg, and Lichtenstein.

218 The John G. Johnson Collection of some 1,200 paintings dating from the 14th to the 20th century occupies its own wing. Rogier van der Weyden's 15th-century panels of *The Virgin and Saint John and Christ on the Cross* are in this collection. The Arensberg Collection of 20th-century works includes the Duchamp collection as well as works by Brancusi, Gris,

Thomas Eakins
Between Rounds
1899

Braque, Dali, Ernst, and Tanguy. The Kienbusch Collection of arms and armor contains German, Italian, and English pieces dating from the high point of European armor-making in the late 15th and 16th centuries. There have also been stunning special exhibitions of collections assembled by Henry McIlhenny and Walter Annenberg.

Visitors are invited to attend lectures, tours, courses, performances, workshops, and films. The Museum Shop sells books and gifts related to the collections, and there is a sales and rental gallery.

Children with adults in tow can touch, climb, explore, test, and in many other ways experience the stuff of childhood in the Please Touch Museum, which combines hands-on activities with historical, cultural, and contemporary exhibits. This is a museum for and about young children, ages seven and younger.

The "Step Into Art" exhibit, opened in 1990, lets children climb in, around, and through *Artie* by Leo Sewell, *Space Geode* by Robert Woodward, and *Shadow Play* by Elaine Crivelli while discovering color, light, textures, and shapes. In "Happily Ever After," children can role-play folk or fairy tales in a cottage, forest, or castle, watch videos from other lands, or read a book.

Many children head first for the SEPTA bus, climb aboard, and pretend to drive. Others gravitate toward "Train Village" and the "Grocery Store." "KYW-TV3 Eyewitness News" lets children see themselves presenting the news on television. "Animals As Pets" shows how rabbits and fish move, eat, play, and communicate. The "Try-It Gallery" is a place to try out basic math and science principles.

Port of History Museum/Civic Center Museum

Port of History Museum:
Penn's Landing
Delaware Avenue at Walnut Street
Philadelphia, PA 19106
Telephone 215 **925 3804**

Civic Center Museum:
Civic Center Boulevard and 34th Street
Philadelphia, PA 19104
Telephone 215 **823 5600**

Please Touch systematically collects contemporary toys and games, maintaining continuity with the 6,000 artifacts in its toy, book, and photograph collection. Items from the collection are displayed in the Show and Tell Gallery.

Special programs include workshops, theater, subsidized admissions, and programs for children with special needs. The museum is completely accessible to the handicapped, and many exhibits carry Braille labels. The Education Store offers books, toys, and other items.

Below
"KYW-TV3 Eyewitness News" model set

Right
Anatomy of a Horse (Florentine)
*End of 16th century
Exhibited 15 October–28 November 1982 in "Florentine for Philadelphia," part of the ongoing cultural exchange between Florentine museums and the Port of History Museum*

The Port of History Museum is descended from the Commercial Museum, founded in 1894 and renamed the Philadelphia Civic Center Museum in the 1960s. It took its current name in the 1980s when it moved to the waterfront at Penn's Landing. For close to a century, it has mounted displays with local, national, and international themes. Continuing that tradition, the Port of History Museum seeks to interpret foreign cultures, develop economic and trade interests, and showcase contemporary talent in the fine arts, performing arts, crafts, and design.

As host institution for Philadelphia's economic trade and cultural exchange program, the museum accepts exhibits from sister cities. It also works with arts groups such as the American Clay Studio and generates its own exhibits. "Art Around the Edges" was one example.

Many exhibits draw on the approximately 16,000 ethnographic objects in the museum's collections—a small portion of the resources gathered by the Commercial Museum at fairs, expositions, and elsewhere. Among the most valuable are the African and Amur River (Siberia) collections. More than 3,000 specimens from Muslim

and Northeast African cultures, mostly of Senegalese origin, date to the turn of the century. The Amur River collection, from the same period, includes a dozen fish-skin coats.

Public programs and exhibits are held in the building at Penn's Landing, but the museum's unique educational programs remain at the Civic Center Museum, where dioramas and other legacies of the Commercial Museum allow Philadelphia schoolchildren to experience the world's cultures.

Rockwood Museum

610 Shipley Road
Wilmington, DE 19809
Telephone 302 **571 7776**

Built in 1851 by Joseph Shipley, Rockwood is a fine example of the English Country House ideal of the mid-19th century. The plans for this rural estate were brought to America by Shipley and executed according to the specifications of the architect, George Williams.

Cognizant of the latest English fashions in garden and building design, Shipley made sure his Rural Gothic home utilized irregular shapes and textures yet blended into the natural landscape. The Gardenesque exterior employs curving paths, expanses of lawn, and rounded clumps of trees set off by sharply pointed evergreens, rugged rock outcroppings, and exotic plants.

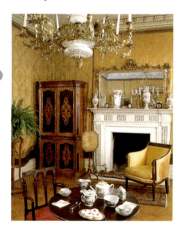

The museum's collections represent the stylish and eclectic tastes of Shipley and his descendants, the Bringhurst family. Edward and Anna Bringhurst combined 18th-century heirlooms with American and English furnishings collected over a 40- to 50-year period. The diversity and richness of the collections permit seasonal changes of accessories, flowers, food, and textiles. Superb photographic and archival collections enhance special programming on such topics as Rockwood's Irish servants and the travels and pastimes of the Bringhurst family.

Visitors are offered hour-long tours of the house. There is also a self-guided tour of the grounds. Speakers, luncheons, teas, and guided tours of the garden can be arranged. Lectures, concerts, and workshops are offered throughout the year. Annual events include a Victorian Christmas, an Old Fashioned Ice Cream Festival, a Victorian Garden Festival, and a Children's Victorian Summer Camp.

Rosenbach Museum and Library

2010 Delancey Place
Philadelphia, PA 19103
Telephone 215 **732 1600**

Left
Drawing room, set for tea

Above
Thomas Sully
Rebecca Gratz
1831

Rare books, manuscripts, and letters are gathered and displayed at the Rosenbach Museum and Library. There is an emphasis on Americana, literature, and works of art on paper. In the warm and intimate setting of a 19th-century townhouse, the document collection is housed in rooms filled with fine examples of English, French, and American furniture, silver, paintings, and sculpture.

Here are illuminated manuscripts of *The Canterbury Tales;* first editions of *Don Quixote, Robinson Crusoe,* and *Alice in Wonderland;* and manuscripts of several works by Charles Dickens, of James Joyce's *Ulysses,*

Ryerss Museum and Library

Burholme Park
Central and Cottman Avenues
Philadelphia, PA 19111
Telephone 215 **745 3061**

and of Dylan Thomas's *Under Milk Wood.* Letters by Spanish explorers, colonial and Civil War leaders, presidents, and noted Philadelphians are also part of the collection. There are drawings by 18th-century French masters, paintings by Thomas Sully, watercolors by William Blake, Honoré Daumier's illustrations for *Don Quixote,* Thackeray's sketches for his stories, Tenniel's drawings for *Through the Looking Glass,* and most of the work of the contemporary artist, author, and stage designer Maurice Sendak. For those who love baseball, free spirits, and poetry, there is the library of Marianne Moore and her literary archive.

Educational offerings are designed to promote interest in the humanities among diverse audiences. Curators and docents give special tours and presentations, and there are regularly scheduled classes on the collections. The collections of rare books, manuscripts, and works of art are open by appointment. There are three major exhibits, 16 smaller ones, and a number of traveling exhibits each year.

Japanese Buddha in contemplative attitude
c. 11th or 12th century

The Victorian enthusiasm for travel and mementos is well expressed in the collections left by Joseph Ryerss, his son, Robert, and Robert's wife, Mary Ann. Their taste was omnivorous; they collected carved ivories, stuffed birds, walking canes, boomerangs, and much more. Once home, every item was put on display, mostly in the front rooms of the mansion.

Standing in the midst of a 70-acre park, Burholme still reflects the family's tastes and interests. Joseph Ryerss built the Italianate mansion in 1859, naming it after his wife's ancestral estate in England. Her family—the Walns—included early merchants in the China trade. Items they brought back from the Orient and family heirlooms were the genesis of the Ryerss collection.

Childless, Robert Ryerss willed the estate to the city. The Fairmount Park Commission assumed responsibility in 1905, opened it to the public five years later, and continues operations to the present. In 1921, a wing was added to house most of the collection. During the latest restoration (1978 to 1980), the parlor and dining room were restored as nearly as possible to their original appearance. Alterations made at that time allow access to the handicapped.

The library holds over 15,000 titles, current fiction, nonfiction, and reference works in addition to Robert Ryerss's original library. Membership, limited to residents of surrounding communities, is free.

18th and Windrim Streets
Philadelphia, PA 19140
Telephone 215 **329 7312**

2721 North 5th Street
Philadelphia, PA 19133
Telephone 215 **426 3311**

Stenton is the 260-year-old country home of James Logan, secretary and agent of William Penn, and a scholar and trader highly visible in the politics and economy of the proprietary colony.

The house was carefully designed, probably by Logan himself, to afford official and family privacy in the front rooms, with ample scope for domestic and agricultural activities in the back. Many of the original outbuildings—including the English barn, privy, and ice house—remain on the extensive grounds. Furnishings are of the highest quality, many having belonged to Logan or to the two generations that followed his tenure at Stenton. Estate inventories indicate that Logan combined furniture made in Philadelphia with English pieces of the William and Mary and Queen Anne periods. His descendants added Chippendale and Federal pieces representing many of the finest Philadelphia artisans during the period when the city was the center for such crafts.

Logan was a dedicated scholar with one of the largest libraries in the colonies. He corresponded with the great thinkers of the day, published papers on astronomy and plant genetics, and learned the language of the Lenni Lenape, with whom he negotiated treaties for Penn and the colony.

Stenton is interpreted through three generations of resident Logans: James (1730–1751), William (1751–1776), and George and Deborah (1781–1830). The house was used first by George Washington and then by Sir William Howe during the Battle of Germantown.

There are public tours and a variety of school programs.

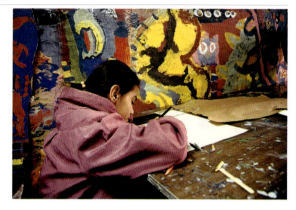

Below left
Parlor with Chippendale chairs

Above
Art class

Taller Puertorriqueño is a multidisciplinary, community-based art, cultural, and educational institution. Dedicated to the development, preservation, and promotion of Puerto Rican and Latin American artistic expressions and cultural traditions, Taller is the only organization of its kind in the Delaware Valley.

Taller was founded in 1974. The cultural center sponsors professionally directed art, dance, and drama classes and specialized cultural workshops for community children, youths, and adults; exhibitions of nationally recognized and local emerging artists; cultural-educational exhibitions; multidisciplinary visiting artist programs; poetry readings and literary arts projects; film, oral history, and photography projects; and community cultural

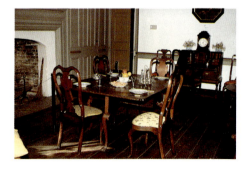

University Gallery, University of Delaware

Old College Hall
West Main Street
Newark, DE 19716
Telephone 302 **451 8242**

festivals. Taller's resource educational center houses reference materials on the arts and cultural traditions of Puerto Rico and Latin America. There is also a Spanish-English bilingual bookstore.

Taller sponsors cultural-educational tours, lectures, exhibits, workshops, and presentations to schools, universities, community organizations, and other interested groups. It directs its artistic and cultural services to the local Puerto Rican and Latin American communities in addition to serving as a resource to surrounding communities and the entire Philadelphia area.

Egypto-Roman mummy portrait
c. 150 A.D.

Works by John Sloan, Louis Lozowick, and an array of WPA artists constitute the bulk of the graphic arts collection at the University Gallery of the University of Delaware. Depicting urban street scenes, overpowering skyscrapers, industrial machinery, and working-class life, these etchings and drawings illustrate the organic, powerful style of the twenties, thirties, and forties.

Other works on paper include silk screens by Kandinsky and Leger, etchings by Picasso and Goya, a half-dozen works by Giovanni Piranesi, a gem of a watercolor by Violet Oakley,

drawings by Kathe Kollwitz, and works by Rockwell Kent and Grant Wood. Among the masters represented are Rembrandt and Dürer. Works by David Bates and Ed Ruscha are featured in the contemporary collection. A distinctive collection of photography from its early and experimental days includes the work of Gertrude Kasebier. The sculpture collection contains mostly American works of the late 19th and early 20th centuries.

African and pre-Columbian artifacts dominate the ethnographic collection, but Asia and Oceania are represented. A well-balanced collection of antiquities includes Roman, Greek, Egyptian, Etruscan, and Celtic objects. The rarest is a mummy portrait on wood from 150 A.D., showing a woman in her thirties who was probably a Greek immigrant living in Egypt.

Visiting scholars and the public may see the Gallery collections by appointment. Twelve exhibits mounted each year usually include objects from the collection. The Gallery offers lectures, films, tours, and special events. Many exhibits involve hands-on activities especially designed for children.

University Museum of Archaeology and Anthropology

University of Pennsylvania
33rd and Spruce Streets
Philadelphia, PA 19104
Telephone 215 **898 4000**
215 **898 3447** (recording)

Head of Ramses II
c. 1290–1224 B.C.

The bull-headed lyre and its companion piece from the royal tombs of Ur, *Ram in the Thicket,* may be the best-known items in the University Museum of Archaeology and Anthropology. Made of gold, silver, lapis lazuli, and carnelian, the lyre and the ram (2650–2550 B.C.) display the artistry of ancient Mesopotamia. Less beautiful, but possibly of even greater value, are 30,000 clay tablets, one important source from which a dictionary of Sumerian (the earliest written language) is being compiled. Prizing a roomful of clay tablets over gold and silver statuary points up the difference between an archaeological and an art institution: here, beauty is secondary to information.

The University Museum seeks to understand the history of mankind in all its cultural and biological diversity. The scope of its field research and its collections—approximately 1.5 million artifacts—has made the museum world-famous since the late 19th century. The Ur materials are centerpieces of the extensive ancient Near Eastern collection. The Egyptian collection spans all of Egyptian history from pre-dynastic (c. 4000 B.C.) through Greco-Roman times and into the Coptic period. It includes monumental sculptures, mummies, and architectural elements from a royal Egyptian palace.

Mediterranean materials include black- and red-figured pottery and the most important collection of Minoan artifacts outside Crete. Oceanic holdings —more than 18,000 objects from all the major island groups of the Pacific—depict changes in the islanders' lives from the early 19th century to the present.

About half of the museum's artifacts are from the New World. Highlights include ceremonial objects from the Northwest coast and Plains Indians; Mayan stelae from Guatemala; and pre-Columbian textiles and mummies from Peru. The Northwest collections include the "Raven of the Roof," a Tlingit clan hat.

Exceptionally fine Chinese sculptures from the T'ang period include two horse reliefs of the emperor T'ai Tsung and a 6th-century gilt bronze Buddhist Maitreya.

African collections include objects from nearly every major cultural area on that continent. The richest materials come from West Africa and the former Belgian Congo. The Benin brasses and ivories have been the basis for several exhibits.

Lectures, dance programs, concerts, workshops, field trips, and school programs are offered.

Upsala

6430 Germantown Avenue
Philadelphia, PA 19119
Telephone 215 **842 1798**

Valley Forge Historical Society

PA 23 within Valley Forge National Historical Park
Valley Forge, PA 19481
Telephone 215 **783 0535**

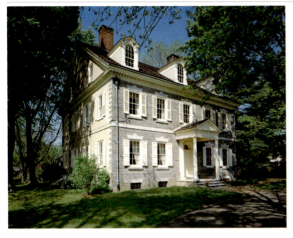

Upsala

Set back from the traffic of Germantown Avenue, Upsala is both a noted example of Federal architecture and furnishings and a major historic site. During the Battle of Germantown, Washington's army made a vain attempt, from what is now Upsala's front lawn, to dislodge British troops from the Cliveden estate across the road.

Built between 1795 and 1798 by John Johnson 3rd, Upsala exemplifies the elegance of the Federal period. Johnson employed the best craftsmen to design and construct an impressive house filled with fine furnishings. Its carefully dressed stone and carved wooden cornices, its portico raised on fluted Doric columns, and the fanlight over the front door are classic Federal elements. Inside there are delicately carved mantels with facings of Pennsylvania marble. Occupied by members of the Johnson family from 1798 to 1938, Upsala retains many original pieces of period furniture. Of particular interest are a dining table of Santo Domingo mahogany (1790) and a clock (dated 1768) by the Philadelphia cabinetmaker John Wood.

Damaged by fire and weather, Upsala was saved from demolition by a small group of Germantown citizens. The Upsala Foundation was formed in 1944, and the restoration, preservation, and interpretation of the house have been accomplished entirely through volunteer efforts. As a member of Historic Germantown Preserved, Upsala participates in cooperative educational programs and holiday tours. During Germantown Founders' Week, Upsala stages the Country Fair and participates in the reenactment of the Battle of Germantown.

Exhibits at the Museum of the Valley Forge Historical Society draw on the work of historians and archaeologists to separate legend from fact in the story of the Revolutionary War encampment. Washington memorabilia include the flag of the commander-in-chief, 12 silver camp cups, documents, scientific instruments, china, clothing, and W. T. Trego's *Washington Reviewing the Troops*. The museum also places Valley Forge in the context of its time and culture, describing the life of local farmers from the time of William Penn to the encampment of the Continental Army.

A gift shop offers books, souvenirs, and reproductions of colonial items. The Washington Memorial Library, open by appointment, contains nearly 1,000 volumes on the American Revolution.

Valley Forge National Historical Park

Junction of PA 23 and North Gulph Road
Valley Forge, PA 19481
Telephone 215 **783 1000**

Wagner Free Institute of Science

17th Street and Montgomery Avenue
Philadelphia, PA 19121
Telephone 215 **763 6529**

Valley Forge tells the story of an army's struggle to survive against hunger, disease, and the unrelenting forces of nature. The encampment lasted from 19 December 1777 through 19 June 1778. Undernourished and poorly clothed, living in crowded, damp quarters, the army was ravaged by disease.

The passing weeks of winter saw the army, under George Washington's inspirational leadership, undergo a dramatic transformation. Intensive daily training, increased supplies and equipment, new troops, and an alliance with France that guaranteed military support resulted in a strong, dependable force. The spirit of Valley Forge was now a part of the army, and the prospects for final victory were considerably brighter.

An introductory exhibit and orientation film can be 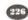 found at the Visitor Center, which also houses the George C. Neumann Collection of 18th-century military armaments and accoutrements and the John F. Reed Collection of period manuscripts. The latter includes Washington's famous warning to Congress that the army might "starve, dissolve, or disperse" if not assisted. The Park also holds period furnishings, archival materials, and archaeological assemblages.

Wagner Free Institute of Science exhibition hall

Founded by Philadelphia merchant and amateur scientist William Wagner, the Wagner Free Institute of Science began as a free lecture series for the general public. The program proved so popular that by 1855 Wagner formally incorporated the Institute, setting up a full curriculum on the natural sciences. The courses were free and open to any member of the public who wished to attend, and Wagner's own extensive and exotic collection of specimens was used to illustrate the lectures. Courses in geology, anthropology, paleontology, ecology, and physics continue,

free of charge, at area libraries and the Institute itself.

The Museum of the Institute is housed in a striking three-story exhibition hall, Victorian from the exposed trusses of the arched ceiling and dramatic natural lighting to the custom-built mahogany display cases. The collections of fossils, minerals, birds, insects, mammals, and shells were organized by the renowned anatomist Joseph Leidy in the 1880s and are largely unchanged, down to the hand-written labels. Among the specimens are dinosaur bones collected by Edward Drinker Cope and the first known specimen of a saber tooth tiger.

The library houses over 25,000 bound volumes and approximately 150,000 pamphlets and periodicals, some dating to the 16th century. Its archive contains the business and personal papers of the founder as well as the records of the Institute itself.

The Institute remains in its original building, constructed during the Civil War from designs by John McArthur, Jr., architect of Philadelphia's City Hall.

Washington Crossing
Historic Park

PA 32 between Yardley and New Hope
Washington Crossing, PA 18977
Telephone 215 **493 4076**

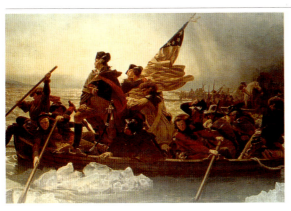

Above
Emanuel Leutze
**Washington
Crossing the
Delaware** (copy)
1852

Below right
Living room

Desperate to gain a victory that would inspire his ragged and demoralized troops, George Washington mounted a surprise attack on Hessian troops in Trenton on Christmas night, 1776. To reach them, he and three divisions of his men crossed the ice-choked Delaware in a blinding snowstorm. The site of that crossing and the area in which Washington's men bivouacked constitute Washington Crossing Historic Park.

McConkey's Inn, the only building in the area at the time, served as a guardpost during the encampment. Visitors can observe a re-creation of the crossing every Christmas afternoon, or absorb its historic significance through a 25-minute film in the Visitor Center, where *Washington Crossing the Delaware* is on display.

The Park also offers a sense of 18th- and 19th-century life in Bucks County. Five of the 13 buildings open to the public represent the village of Taylorsville, which grew up around McConkey's Inn and Ferry after the Revolution. Also open to the public are the Thompson-Neely house, barn, and seasonally operating gristmill. Craft demonstrations are offered in the blacksmith and pottery shops and in the Frye House. The Durham Boat House holds reproductions of 18th-century cargo boats.

Bowman's Hill was a sentinel post for Indians and trappers before it served the Continental Army. A tower built in 1930 offers a 14-mile view of the Delaware River Valley. Bowman's Hill itself (off PA 32 south of New Hope, 215 862 2924) is now a 100-acre wildflower preserve.

Peter Wentz
Farmstead

Shearer Road near intersection of
PA 363 and 73
Worcester, PA 19490
Telephone 215 **584 5104**

George Washington planned the Battle of Germantown while encamped at the Peter Wentz Farmstead. Following the battle, he returned there. The year 1777 is therefore the focus of interpretation at this site.

Restored and furnished as it was during Washington's residency, the Farmstead includes a stone barn built in 1744 and a Georgian mansion with Germanic details that was built in 1758. This is a living history site designed to depict late 18th-century farm life, complete with animals of the period and demonstration fields of flax, rye, broom corn, tobacco, mangel beets, and many more crops. Costumed interpreters provide guided tours and demonstrations of the crafts of the period.

The Peter Wentz Farmstead offers a wide variety of educational tours tailored to group interests.

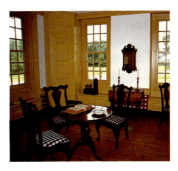

Walt Whitman Association and Library/Walt Whitman House

Association and Library:
326 Mickle Boulevard
Camden, NJ 08101
Telephone 609 **541 8280**

Walt Whitman House:
330 Mickle Boulevard
Camden, NJ 08101
Telephone 609 **964 5383**

The Walt Whitman Association is dedicated to maintaining the poet's physical as well as intellectual and spiritual legacies. Its library contains first editions, letters, photographs, memorabilia, journals, and publications devoted to Whitman scholarship. Open to the public on a limited schedule (the Library may be used by appointment), the Association holds symposia on Whitman themes. Conferences, poetry workshops, public readings, and art exhibits are held. The Association also helps promote the Walt Whitman House, located two doors away, which is operated by the State of New Jersey.

Whitman was 54 years old when he arrived in Camden and would remain there for the last 19 years of his life. He was nearly penniless, having used most of his earnings to care for the sick during the Civil War. A display in the Whitman House records donations from England, organized by a visitor who felt that America was allowing its leading poet to starve. Whitman purchased the property in 1884 with the proceeds from the seventh edition of *Leaves of Grass*. The two-story townhouse, with its simple Greek Revival details, was the only home he ever owned.

Left
Bedroom, Walt Whitman House

Winterthur

DE 52
Wilmington, DE 19735
Telephone 302 **888 4600**, 800 **448 3883**

Winterthur, formerly the home of Henry Francis du Pont, houses the world's largest and most complete collection of decorative arts made and used in America from 1640 to 1860. Its 196 period room settings contain over 89,000 objects, including furniture, textiles, silver, glass, paintings, and needlework. Visitors can trace America's stylistic progression from the pre-colonial period to the time just before the Civil War while exploring the influence of the China trade, the American Revolution, the rise of Napoleon, and other national and international events.

The strength of the collection lies in domestic furnishings made and used in America. American craftsmanship, an important theme, is illustrated by the cabinet- and clockmaking workshops and tools of the Dominy family of East Hampton. A mahogany chest and a cherry wood table are shown in the final stages of construction, while metal-working tools, clock parts, and cabinets in the clockmaking shed attest to the family's skill.

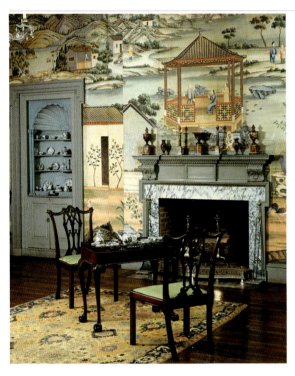

Above
Chinese parlor

Above right
Thomas Anshutz
Summertime

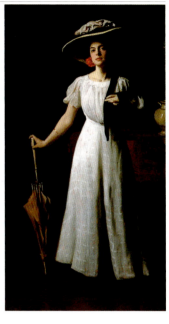

prominent citizens include Charles Willson Peale's companion paintings of Benjamin Rush and his wife, and works by Benjamin West and Gilbert Stuart.

The best-known room may be the one that contains the Montmorenci staircase, whose graceful lines seem to contradict the laws of gravity. Another unique offering is Shop Lane, a series of American storefronts and windows. The Du Pont Dining Room, now on display, was used by the family until 1951.

Winterthur's garden is as famous as its period room settings. The vast naturalistic garden features landscaped meadows and woodlands, as well as natural displays such as the Azalea Woods, the Pinetum, with its collection of conifers, and the Sundial Garden. Self-guided tours of the garden are available year-round, and tram tours are offered in spring, summer, and fall.

Each section of the country had its own distinct style. These differences are represented in the room furnishings as well as in the Court, with its facades from Rhode Island, Connecticut, Delaware, and North Carolina. Henry Francis du Pont also preserved a great deal of interior architecture, even if it required cutting the room or hallway out of a building and transporting it as a unit to Delaware.

Washington memorabilia range from portraits to pincushions. Portraits of other

Charles Knox Smith, Woodmere's founder, collected European and American paintings, sculpture, decorative arts, Oriental rugs, and furniture. His collection, willed to the citizenry of Philadelphia, became the basis for the Woodmere Art Museum.

Today Woodmere exhibits the art collection Smith amassed, portions of the permanent collection, and work by contemporary Delaware Valley artists. Throughout the year, eight galleries and salons display a changing parade of exhibitions,

Wyck

6026 Germantown Avenue
Philadelphia, PA 19144
Telephone 215 **848 1690**

offering a fresh view of the current art scene or new insights into art movements of the past.

Woodmere's permanent collection includes works by such American artists as Benjamin West, Frederick Church, Jasper Cropsey, James McNeill Whistler, Herbert Pullinger, Daniel Garber, Walter Schofield, Violet Oakley, and Joseph Pennell. The Fell Collection, which is on long-term loan to the museum, showcases works by Renoir, Vuillard, Corot, Boudin, Jongkind, and more. Woodmere's current collecting focus is on Philadelphia fine arts.

Educational programs range from art classes held in the George D. Widener Studio to the Kuch Lectures by a variety of experts on the fine arts and guided tours of the museum's exhibitions and collections. Students from local public and private schools are given exhibition space in the Helen Millard Gallery, where their work receives professional display and attention. Family Days, concerts, and trips to other museums are recent additions.

230

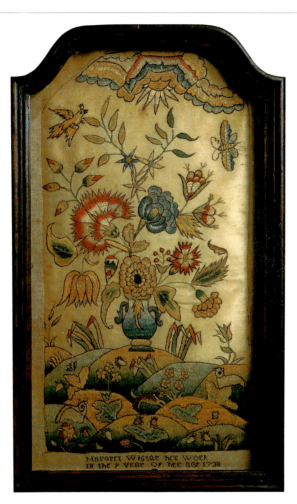

Margaret Wistar
**Embroidered
sconce**
1738

Wyck, one of the oldest houses in Germantown, reflects social changes from 1689 to the present through the personal stories of nine generations of the descendants of Hans Millan, a Dutch Quaker.

The garden features rare old roses, vegetables, fruit trees, and beehives. Though reduced from the original 60 acres, it exemplifies the family's maintenance of the essential qualities of a working country seat for 300 years, despite the press of urban life. In the early 19th century, Jane Bowne Haines planted more than 20 varieties of roses. Her daughter added wildflowers and ferns but largely preserved the earlier design.

The house remains unchanged since the 1824 remodeling by William Strickland, the leading architect of his time, who integrated two early 18th-century farmhouses into a single country mansion, retaining the essence of the colonial architecture while adding "modern" comforts.

More than 100,000 manuscripts describe the lives of seven generations of the Wistar/Haines branch of Millan's descendants. Diaries and correspondence with John James

Zoological Gardens

34th Street and Girard Avenue
Philadelphia, PA 19104
Telephone 215 **243 1100**

Audubon, Rembrandt Peale, and Bronson Alcott are preserved, along with ledgers that detail daily farm operations. The Wyck Papers are now on deposit at the American Philosophical Society. Rare and unusual possessions include Wistarburgh glass, made at the first successful glass works in America, needlework, and an early 19th-century herbarium.

Wyck remained a private residence until 1973. In 1979 a nonprofit corporation was created to operate it as a public museum. Wyck offers school programs, lectures, a Garden Festival, and a New Year's Tea.

Bim the orangutan, World of Primates exhibit

Retaining much of its Victorian landscape and architecture, the Philadelphia Zoological Gardens, the nation's first zoo, offers 42 acres of exotic animals, habitat reproductions, gardens, and sculpture.

Animals representing tropical, desert, arctic, and temperate ecosystems from all continents can be seen in conditions that simulate their natural environments. Bears, gorillas, elephants, and tigers are on display along with lesser-known species such as binturongs and fennec foxes.

Peacocks freely roam the grounds. Scattered through the zoo are exhibits containing ostriches, eagles and vultures, penguins and owls, and rare and beautiful tropical birds.

The Treehouse discovery center encourages children to crawl into a four-story tree, a beehive, giant eggs, and other fabricated habitats. Animals in the Children's Zoo can be touched and fed.

Animal sculpture is ubiquitous. Henry Mitchell's *Impala Fountain* is the focus of a zoo restaurant. Nearby is a marble elephant statue to climb, and in other sections of the zoo are Eric Berg's bronze warthog and *Massa the Gorilla*.

A picnic grove, monorail, stroller and wheelchair rentals, and the large ZooShop (constructed in the Victorian style) are among the services provided. A noncirculating library is accessible by appointment.

Bear Country, World of Primates, Penn's Woodland Trail, African Plains, and the Bird House are a far cry from the barren cages of an earlier period. Today's visitors can watch swimming polar bears through an underwater window and see gorillas, chimpanzees, and other primates explore the grass and trees of their own islands.

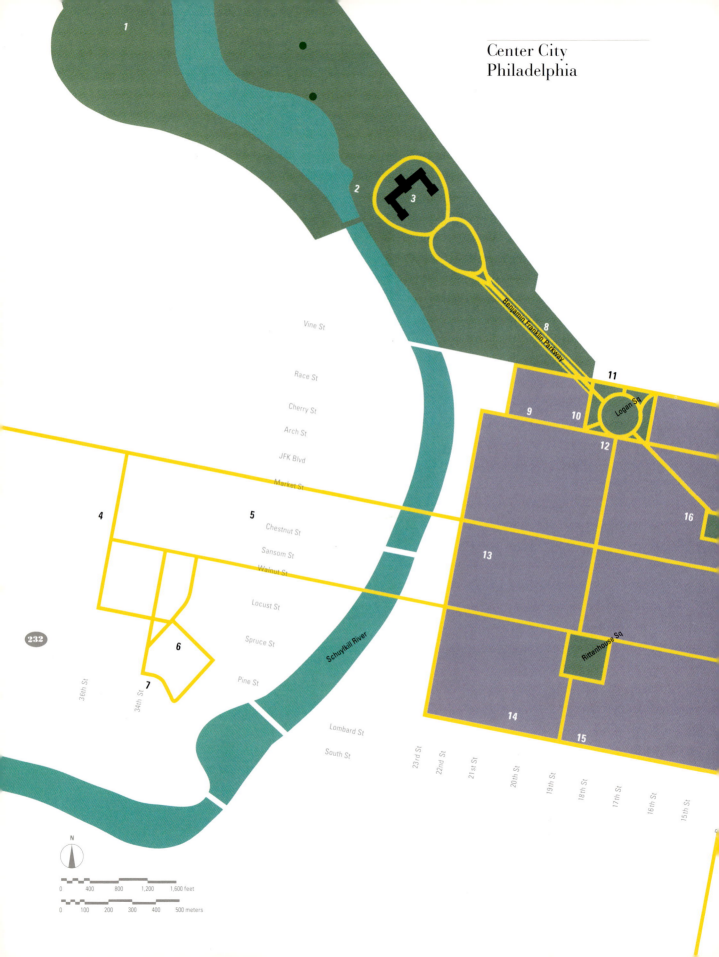

Center City
Philadelphia

1

2

3

8

Benjamin Franklin Parkway

Vine St

Race St

Cherry St

Arch St

JFK Blvd

Market St

Chestnut St

Sansom St

Walnut St

Locust St

Spruce St

Pine St

Lombard St

South St

Schuylkill River

11

9

10

12

Logan Sq

16

13

Rittenhouse Sq

14

15

4

5

6

7

232

36th St

34th St

23rd St

22nd St

21st St

20th St

19th St

18th St

17th St

16th St

15th St

N

0 400 800 1,200 1,600 feet

0 100 200 300 400 500 meters

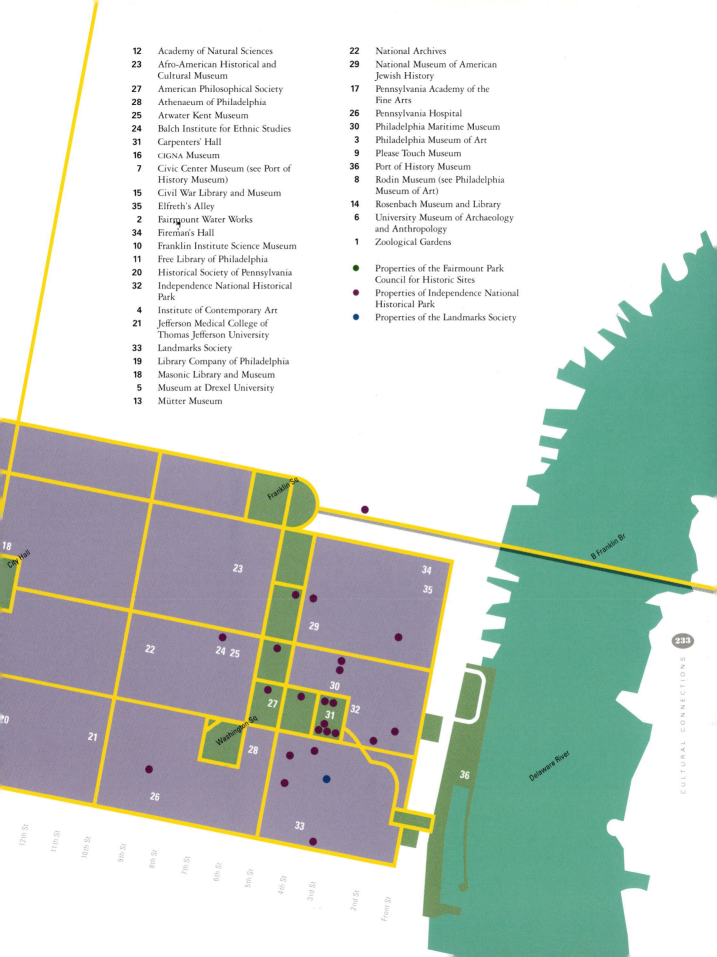

12 Academy of Natural Sciences

23 Afro-American Historical and Cultural Museum

27 American Philosophical Society

28 Athenaeum of Philadelphia

25 Atwater Kent Museum

24 Balch Institute for Ethnic Studies

31 Carpenters' Hall

16 CIGNA Museum

7 Civic Center Museum (see Port of History Museum)

15 Civil War Library and Museum

35 Elfreth's Alley

2 Fairmount Water Works

34 Fireman's Hall

10 Franklin Institute Science Museum

11 Free Library of Philadelphia

20 Historical Society of Pennsylvania

32 Independence National Historical Park

4 Institute of Contemporary Art

21 Jefferson Medical College of Thomas Jefferson University

33 Landmarks Society

19 Library Company of Philadelphia

18 Masonic Library and Museum

5 Museum at Drexel University

13 Mütter Museum

22 National Archives

29 National Museum of American Jewish History

17 Pennsylvania Academy of the Fine Arts

26 Pennsylvania Hospital

30 Philadelphia Maritime Museum

3 Philadelphia Museum of Art

9 Please Touch Museum

36 Port of History Museum

8 Rodin Museum (see Philadelphia Museum of Art)

14 Rosenbach Museum and Library

6 University Museum of Archaeology and Anthropology

1 Zoological Gardens

● Properties of the Fairmount Park Council for Historic Sites

● Properties of Independence National Historical Park

● Properties of the Landmarks Society

Franklin Sq

City Hall

B Franklin Br

233

CULTURAL CONNECTIONS

23

34

35

29

22

24 25

30

20

27

31 32

21

Washington Sq

28

26

33

36

Delaware River

18

12th St 11th St 10th St 9th St 8th St 7th St 6th St 5th St 4th St 3rd St 2nd St Front St

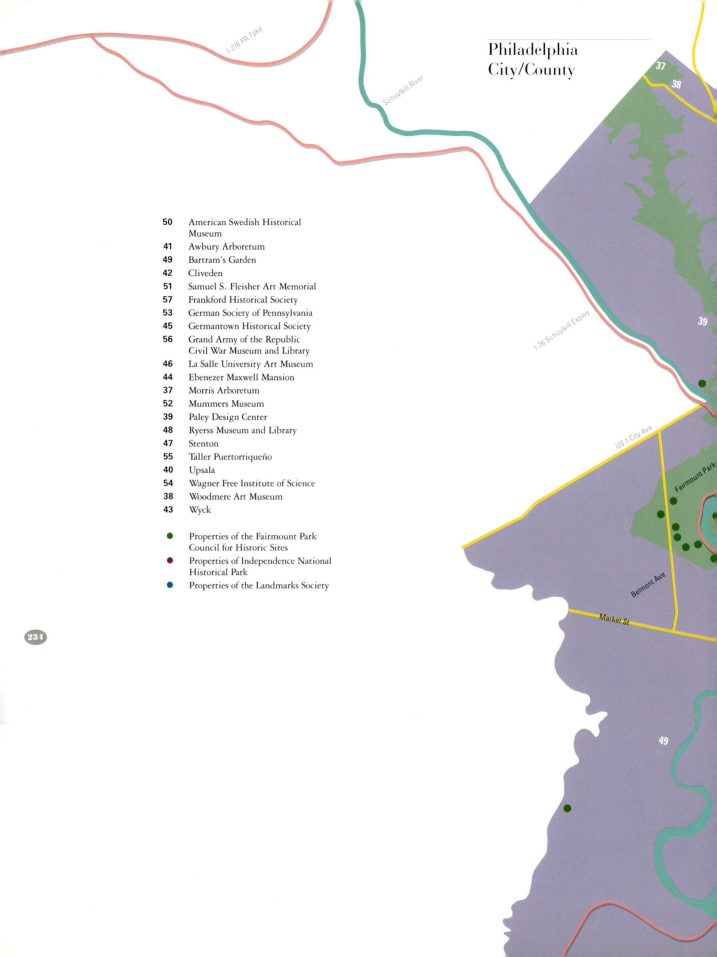

● Properties of the Fairmount Park Council for Historic Sites

● Properties of Independence National Historical Park

● Properties of the Landmarks Society

US 611

US 611

Germantown Pike

40

41

42

43

45

46

47

US 1 Roosevelt Blvd

57

56

I-95

Delaware River

Broad St-US 611

55

54

48

I-676

53

B Franklin Br

51

52

Broad St-PA 291

I-95

I-676

W Whitman Br

235

N

0 1 2 miles

0 1 2 3 kilometers

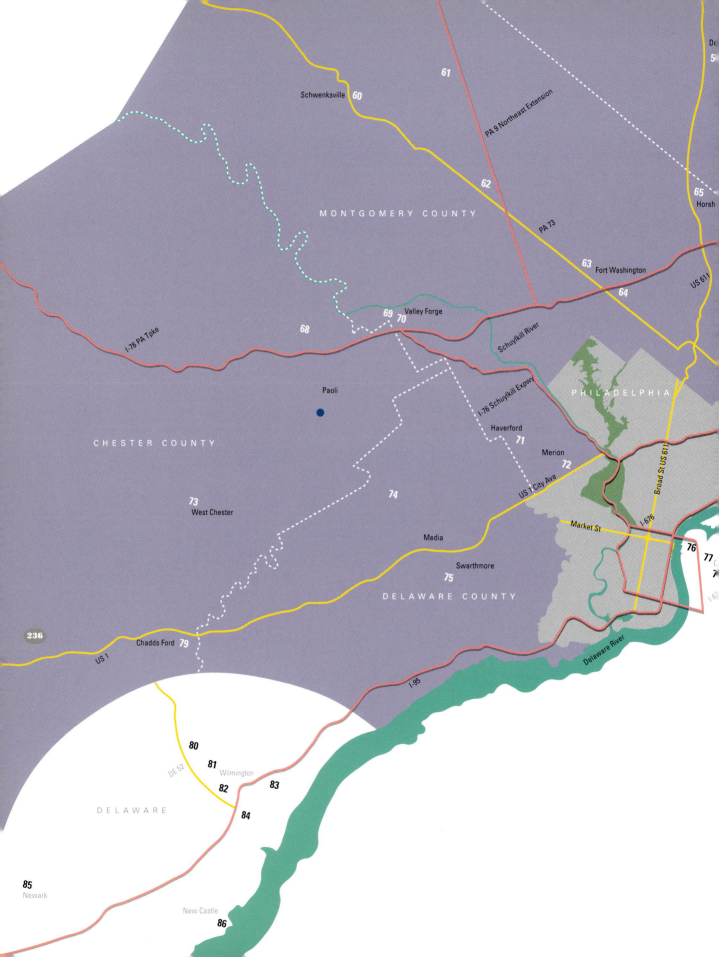

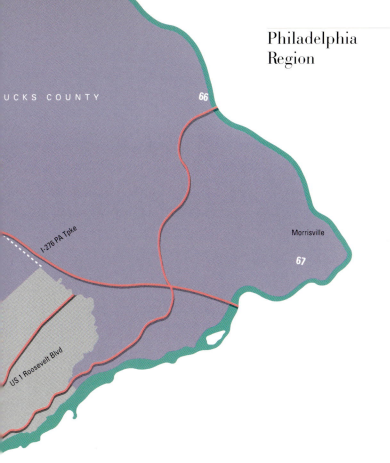

Philadelphia Region

UCKS COUNTY

66

I-276 PA Tpke

Morrisville

67

US 1 Roosevelt Blvd

W JERSEY

● Properties of the Landmarks Society

87

N

| 0 | | 2 | | 4 | | 6 miles |

| 0 | | 3 | | 6 | | 9 kilometers |

Illustrations are listed in page sequence; numbers to the left of the entries indicate pages. Measurements are given in order of height, width, and depth.

The publisher would like to thank the institutions represented here for making available materials from their collections. Without their kind assistance and cooperation this volume would not have been possible.

3
Charles Willson Peale
The Artist in His Museum
(detail)
1822
Oil on canvas
103 ¼″ × 79 ⅞″
Pennsylvania Academy of the Fine Arts
Gift of Mrs. Sarah Harrison
(The Joseph Harrison, Jr., Collection)
Acc. no. 1878.12

18
Edward Redfield
Brooklyn Bridge at Night
1909
Oil on canvas
36″ × 50″
CIGNA Museum and Art Collection

19
Thomas Eakins
Walt Whitman
1888
Oil on canvas
30 ⅛″ × 24 ¼″
Pennsylvania Academy of the Fine Arts
General Fund
Acc. no. 1971.1

20
Pierre Gentieu
The Gaino Family
1890
Hagley Museum and Library
Gentieu Collection #216

21
Venturi and Rauch, architects
Benjamin Franklin House
1973–1976
Located in Franklin Court, between 3rd and 4th Streets and between Market and Chestnut Streets, Philadelphia
Independence National Historical Park
Photograph: Tom Crane

22
Ganook hat
Possibly 18th century
Painted maple wood with top stock of woven spruce root
H: 38 cm
Collected 1917–1919 by Louis Shotridge
The University Museum of Archaeology and Anthropology, University of Pennsylvania
Acc. no. Sitka NA 6864 (87)

24
Super Sunday
1989
The Academy of Natural Sciences of Philadelphia
Photograph: Ken Kirby

24
Mandell Futures Center
1990
Franklin Institute Science Museum
Photograph: © Peter Olson

239

65

Majolica pottery
1880s
Earthenware
9 ¼″ × 13 ¾″ oval
Chester County Historical Society
Photograph: George J. Fistrovich

67

Jacques Bruyant
Ci commence le livre du chastel de labour de pourete et de richesse
c. 1425
Ink, pigment, and gold leaf
8 ½″ × 5 ½″
Free Library of Philadelphia, Rare Books Collection
Photograph: Rick Echelmeyer

68

Charles Rubican, builder
St. Charles Hotel
1851
60–66 North 3rd Street, Philadelphia
Photograph: Tom Crane

69

Addison Hutton
Elevation of Gimbels' building
1890
Ink and wash
26″ × 40″
Athenaeum of Philadelphia
Photograph: Louis W. Meehan

70–71

Maxwell Mansion
1859
Parlor and exterior
200 West Tulpehocken Street, Philadelphia
Photographs: Tom Crane

72

Jasper Cropsey
Mounts Adam and Eve
1884
Oil on canvas
18 ¼″ × 36 ¼″
CIGNA Museum and Art Collection

73

Samuel Sloan
Frontispiece, The Model Architect: A Series of Original Designs for Cottages, Villas, Suburban Residences, etc.
1852
Lithograph
14 ½″ × 10 ½″
Athenaeum of Philadelphia
Photograph: Louis W. Meehan

74

Wedding dress
1880
Ivory silk with ivory silk brocade overskirt, lace, beads, satin buttons
Gift of Mrs. Peyton R. Biddle
Atwater Kent Museum

74

[Henry B.?] Wechsler
The River Drive—Fairmount Park
1897
Color offset lithograph
11 ½″ × 15 ½″
Atwater Kent Museum

75

W. T. Smedley
The Rich and the Poor
1891
Watercolor and gouache on paper
19 ¼″ × 27 ¼″
Brandywine River Museum Collections
Museum Volunteers Purchase Fund

77

Benin plaque
1550–1650
Bronze
15 ⅜″ × 18 ¾″
The University Museum of Archaeology and Anthropology, University of Pennsylvania
Photograph: © Malcolm Varon

78

Ram in the Thicket
c. 2650–2550 B.C.
Gold, silver, lapis lazuli, shell, and red sandstone on wood base
H: 38 cm
The University Museum of Archaeology and Anthropology, University of Pennsylvania
Acc. no. 30-12-702

80

G. F. Atkinson
Indian Spices for English Tables
1860
Lithograph
10″ × 11 ½″
Ryerss Museum and Library
Photograph: Rick Echelmeyer

81

Chinese puppet theater
Possibly 19th century
Papier-mâché
59″ × 88″ (as exhibited)
Ryerss Museum and Library
Photograph: Tom Crane

82

Japanese Buddhist temple
Late 19th century
The University Museum of Archaeology and Anthropology, University of Pennsylvania

83

Maxwell Summerville posing in his Buddhist temple
c. 1904
The University Museum of Archaeology and Anthropology, University of Pennsylvania, Photo Archives
Photograph: F. Gutekunst

84

Joseph Hyrtl skull collection
Assembled mid-19th century
Mütter Museum
Photograph: Seymour Mednick

85

Auditorium, Wagner Free Institute of Science
Built 1859–1865; remodeled late 1880s
Photograph: Tom Crane

85

Case of monkey and human bones
1880s
Wagner Free Institute of Science
Photograph: Tom Crane

86

Katsura tree
Planted c. 1887–1909
Morris Arboretum of the University of Pennsylvania
Photograph: Nick Kelsh

86

Entrance, Zoological Society of Philadelphia
1874
Zoological Society of Philadelphia, Photo Library Archives

87

Philadelphia Commercial Museum
1926
Silver gelatin print
7″ × 9″
Port of History Museum

89

Victorian Christmas
1990
Rockwood Museum
Photograph: Tom Crane

90–91

Christopher Schissler
Sundial
1578
Brass and alloy
Bowl-shaped sundial dia: 12″; base dia: 5 ¾″
American Philosophical Society
Photograph: Frank Margeson

92

Psalterium
c. 1260
Pigment and gold leaf on vellum
9″ × 6 ½″
Free Library of Philadelphia, Rare Books Collection

CULTURAL CONNECTIONS

92

Stained glass window from the Almoner's Chapel
c. 1400
Stone and stained glass
8′ 11 ¾″ × 6′ 8″ (maximum)
Philadelphia Museum of Art
Given in memory of Edward B.
Smith and Laura Howell Smith
by their sons, Albert L. Smith,
Edward B. Smith, Jr., Geoffrey
S. Smith, and John Storr Smith
Acc. no. '29-131-1

94

Christopher Columbus
Epistola . . . de Insulis Indie supra Gangem Nuper Inventis
1493
8″ × 5 ½″
Free Library of Philadelphia, Rare
Books Collection
Photograph: Rick Echelmeyer

95

Bartolemeu Lasso
Portolan chart of the Atlantic Ocean
c. 1590
Ink on vellum
29″ × 34″
Rosenbach Museum and Library

96

Copernicus
De Revolutionibus Orbium Coelestium
1543
10 ½″ × 7 ¼″
Haverford College Library, Quaker
Collection
Photograph: Rick Echelmeyer

96–97

Fels Planetarium
Composite photograph
Franklin Institute Science Museum
Photograph: Ed Wheeler

98

Andreas Vesalius
De Humani Corporis Fabrica
c. 1543
Woodcut
14 ¾″ × 10″
Historical Collections of the Library
of the College of Physicians
Photograph: Rick Echelmeyer

99

Hans Baldung Grien
Dissection of the Scalp and Exposure of the Hemispheres of the Brain
1541
Hand-colored woodcut
12″ × 15 ⅛″
Philadelphia Museum of Art
Purchased: SmithKline Beckman
Corporation Fund
Acc. no. 1982-40-1h, i

100

Immediate follower of Giotto
The Annunciation, Nativity, and Crucifixion
c. 1310–1320
Tempera and tooled gold on wood
24 ⅞″ × 11 ⅞″
Philadelphia Museum of Art
John G. Johnson Collection
Acc. no. J#1

100–101

Jansz Pieter
Saint Bavo in Haarlem
1631
Oil on wood
32 ⅝″ × 43 ½″
Philadelphia Museum of Art
John G. Johnson Collection
Acc. no. J#599

102

Isaac Newton
Letter to Robert Hooke
1675/6
11 ¾″ × 7 ½″
Historical Society of Pennsylvania

104

David Rittenhouse
Telescope
c. 1769
Brass
33 ½″ tube on 25″ axis
American Philosophical Society

104–105

David Rittenhouse
Clock
1773
Honduran mahogany (case)
9′ x 27″
The Museum at Drexel University
Photograph: Owen McGoldrick

107

Benjamin West
Benjamin Franklin Drawing Electricity from the Sky (detail)
1805
Oil on paper
13 ¼″ × 10″
Philadelphia Museum of Art
Mr. and Mrs. Wharton Sinkler
Collection
Acc. no. '58-132-1

108

Mason Chamberlin
Benjamin Franklin
1762
Oil on paper on panel
50 ⅜″ × 40 ¾″
Philadelphia Museum of Art
Mr. and Mrs. Wharton Sinkler
Collection
Acc. no. '56-88-1

108

Battery of Leyden jars
c. 1770
Wood and glass
18″ × 13″ × 14″
American Philosophical Society
Photograph: Frank Margeson

109

James Earle Fraser
Benjamin Franklin
c. 1938
White seravezza marble statue on
rose aurora marble base
H: 20′ 10 ½″ (including base)
Franklin Institute Science Museum
Photograph: © Burk Uzzle

110

Thomas Sully
Benjamin Rush
1813
Oil on canvas
83″ × 62″
Pennsylvania Hospital Archives
Acc. no. PA.29
Photograph: Rick Echelmeyer

111

Benjamin Rush's medicine chest
Late 18th century
Mahogany
9″ × 10 ½″ × 7 ½″
Mütter Museum
Photograph: Seymour Mednick

112

Thomas Sydenham
Medical Observations
1809
7″ × 4 ½″
Historical Collections of the Library
of the College of Physicians

112

William Wood Gerhard
Journal medical
1834
14 ½″ × 9″
Historical Collections of the Library
of the College of Physicians
Photograph: Rick Echelmeyer

113

T. C. Wild [?]
South East View of the Pennsylvania Hospital
c. 1800
Oil on canvas mounted to plywood
panel
30 ½″ × 44 ½″
Pennsylvania Hospital Archives
Photograph: Rick Echelmeyer

115

Thomas Eakins
The Gross Clinic
1875
Oil on canvas
96″ × 78″
Jefferson Medical College, Thomas
Jefferson University

116

Eadweard Muybridge
Animal Locomotion, human series
1887
Photogravure
10″ × 11 ½″
Atwater Kent Museum

117

Marcel Duchamp
Nude Descending a Staircase, No. 2
1912
Oil on canvas
58″ × 35″
Philadelphia Museum of Art
Louise and Walter Arensberg
Collection
Acc. no. 50-134-59

118–119

Eadweard Muybridge
Animal Locomotion, horse series
1887
Photogravure
7⅜″ × 16¼″
Atwater Kent Museum

120

Charles Darwin
Draft title page, On the Origin of Species
1859
8″ × 5″
American Philosophical Society
Photograph: Frank Margeson

121

Charles Darwin
Drawing of geological strata
1849
7½″ × 8¾″
American Philosophical Society
Photograph: Frank Margeson

121

Joseph Leidy with thigh bone of dinosaur
c. 1858
Stereopticon card
3⁵⁄₁₆″ × 6¾″
Library, The Academy of Natural
Sciences of Philadelphia

123

American Eugenics Society album
1923
4½″ × 6½″
American Philosophical Society
Photograph: Frank Margeson

124–125

Anthony Petr Gorny
Centers of Power
1982–1986
Lithograph and woodcut on
handmade Japanese *oka* (mulberry)
paper, printed on both sides
Composition: 31⅛″ × 50¹¹⁄₁₆″;
irregular sheet: 36½″ × 55½″
Pennsylvania Academy of the Fine
Arts
John Lambert Trust Fund Purchase
Acc. no. 1986.12

125

Hana Geber
O the Chimneys *(detail)*
1984
Cast bronze, lost wax technique
H: 25″; base dia: 13″
National Museum of American
Jewish History
Photograph: Seymour Mednick

126–127

Maurice Sendak
Where the Wild Things Are
1963
Pen, ink, and watercolor on paper
9″ × 19⅞″
Rosenbach Museum and Library
© 1963 by Maurice Sendak

128–129

La Bible historiale
2nd half of 15th century
Ink, pigment, and gold leaf on
vellum
18″ × 12½″
Free Library of Philadelphia, Rare
Books Collection
Photograph: Rick Echelmeyer

130

Enmerkar and the Lord of Aratta
c. 1750 B.C.
Clay tablet
6½″ × 3½″ × 1.6″ (maximum)
The University Museum of
Archaeology and Anthropology,
University of Pennsylvania
Acc. no. CBS 10436

131

Stele
8th century
Limestone
2.95 m × .85 m × .4 m
The University Museum of
Archaeology and Anthropology,
University of Pennsylvania
On loan from Guatemala
Loan no. L-16-382

132

Book of Isaiah, Gutenberg Bible facsimile
1913
Lithograph
16½″ × 12″
Free Library of Philadelphia, Rare
Books Collection
Photograph: Rick Echelmeyer

132

Maitreya
536 A.D. (Wei Dynasty)
Gilt bronze
H: 61 cm
The University Museum of
Archaeology and Anthropology,
University of Pennsylvania
Acc. no. C 355

133

Arapaho [?] Ghost Dance shirt
c. 1890
Painted hide, sinew stitching
32″ × 72″ (fringe to fringe)
The University Museum of
Archaeology and Anthropology,
University of Pennsylvania
Acc. no. NA 3495

134

Edward Hicks
The Peaceable Kingdom
c. 1827–1832
Oil on canvas
29″ × 36″
Located in the List Gallery,
Performing Arts Center, Swarthmore
College
From the collection of Friends
Historical Library of Swarthmore
College

134–135

Wampum belt
1682
Leather and oyster shells
5¾″ × 34″
Historical Society of Pennsylvania

135

Edward Hicks
Noah's Ark
1846
Oil on canvas
26½″ × 30½″
Philadelphia Museum of Art
Bequest of Lisa Norris Elkins
(Mrs. William Elkins)
Acc. no. '50-92-7

136

Harper's Weekly
Philadelphia Mummers' Parade
14 January 1888
Lithograph
14″ × 11″ (copy)
Mummers Museum

138–139

Seymour Mednick
Mummer
1985
35 mm transparency
© Seymour Mednick

140
Alexander Rider
Camp Meeting
1830
Lithograph
14¼″ × 18½″
Library Company of Philadelphia

143
Nathan Wheeler
Andrew Jackson
1815–1816
Oil on canvas
30″ × 25¾″
Historical Society of Pennsylvania

144
John Howard Payne
Home, Sweet Home
c. 1850
Lithograph
34 cm × 26 cm
Free Library of Philadelphia, Music
Collection
Photograph: Rick Echelmeyer

145
Stephen Foster
Old Black Joe
1860
Lithograph
34 cm × 26 cm
Free Library of Philadelphia, Music
Collection
Photograph: Rick Echelmeyer

147
Frank Leslie's Historical Register of the
United States Centennial Exposition, 1876
The New England Kitchen
1877
Wood engraving
7″ × 9¼″
Free Library of Philadelphia, Prints
and Pictures Collection
Photograph: Rick Echelmeyer

147
**Colonial Pennsylvania
Plantation**
Photograph: Tom Crane

244

148
D'Ascenzo Studios
Stained glass window
c. 1920–1928
Seal dia: 10½″; quill: 13½″
Valley Forge Historical Society
Museum
Photograph: Rick Echelmeyer

150
Port Royal hall
1762
The Henry Francis du Pont
Winterthur Museum
Photograph: Lizzie Himmel

151
Stenton
1720s
18th and Windrim Streets,
Philadelphia
Photograph: Owen McGoldrick

152–153
Cliveden
1760s
6401 Germantown Avenue,
Philadelphia
Photograph: Tom Crane

154
Hope Lodge
Built 1743–1748; restored 1920s–1930s
553 Bethlehem Pike,
Fort Washington, PA
Photograph: Owen McGoldrick

155
Pennypacker Mills
Built c. 1730; remodeled and reconstructed
1901–1902
5 Haldeman Road,
Schwenksville, PA
Photograph: Tom Crane

156
Sulgrave Manor replica
1926
200 West Willow Grove Avenue,
Chestnut Hill, PA
Photograph: Tom Crane

157
Pennsbury
Reconstruction, 1938–1939
400 Pennsbury Memorial Road,
Morrisville, PA
Photograph: Tom Crane

158–159
Strap hinge
Early 19th century
Wrought iron
1″ × 27″
Barnes Foundation
Photograph: © 1990 The Barnes
Foundation

160
Henry Chapman Mercer
Spinning Wool
c. 1903
Tile mosaic
25″ square
Moravian Tile Works

161
G. Bush
Clock wheel–cutting engine
c. 1812–1837
Wood, iron, and brass
15½″ × 19½″ × 14″
Mercer Museum
Photograph: Seymour Mednick

162
Nicola D'Ascenzo
**Presentation sketch for
stained glass window**
c. 1920
Pencil and watercolor on board
2⅝″ × 9½″ (image only)
Athenaeum of Philadelphia
Photograph: Louis W. Meehan

162
Woven cloth
1940
75″ × 16¼″
Pennsylvania Hospital Library
Photograph: Rick Echelmeyer

163
John LaFarge
Art, Education and Music
1907
Stained glass
65″ × 24″
Samuel S. Fleisher Art Memorial
Given by Mrs. Efrem Zimbalist
(Mary Louise Curtis Bok), 1955
Acc. no. F'55-3
Photograph: Eric Mitchell

164
Samuel Yellin and Richard Geite
Wrought iron lock
1911
496 mm × 425 mm
Philadelphia Museum of Art
Purchased: Temple Fund
Acc. no. '11-237 a,b,c

165
William De Morgan
Peacock plate
c. 1885
Luster glazed earthenware
H: 3½″; dia: 15¾″
Delaware Art Museum

167
The Chocolate Works
Built 1902–1920; reconstructed 1984
231 North 3rd Street, Philadelphia
Photograph: © Elliot Kaufman

168
Steam engine governor
Early 20th century
Cast iron and spring steel
H: 12″; dia: 10″
Hagley Museum and Library

169
Hagley
Hagley Museum and Library

171
Liberty Bell
1752
Bronze
H: 36″; dia: 47″
Located in the Bell Pavilion, Market
Street between 5th and 6th Streets,
Philadelphia
Independence National Historical
Park
Photograph: © Ed Wheeler

173
Iron-age pottery
c. 500 B.C. (Middle Period)
Clay
H: 49 cm; dia: 40.8 cm
Inset: Broken pottery from the 1975
excavation season at Ban Chiang,
Burial 20
The University Museum of
Archaeology and Anthropology,
University of Pennsylvania

174–175
Gas jet eagle
c. 1848
Iron
69″ × 100″
Manufactured at Northern Liberties
Gasworks
Atwater Kent Museum
Gift of Phinias T. Green
Photograph: Philadelphia Museum
of Art

176
Serengeti waterhole diorama
8′ × 30′ (window size)
Located in African Hall, Academy
of Natural Sciences
Photograph: Library, The Academy
of Natural Sciences of Philadelphia

177
Romare Bearden
Captivity and Resistance
1976
Fabric collage
7′ × 10′
Afro-American Historical and
Cultural Museum

177
**Wedgwood antislavery
medallion**
1788
Basalt and jasper
1 ¼″ × 1″
Manufactured by Josiah Wedgwood
American Philosophical Society
Photograph: Frank Margeson

178
Carl Larsson
Kräftfisket (Crayfishing) (detail)
1898
Oil on canvas
106″ × 138″
American Swedish Historical
Museum

179
Members' reading room
Athenaeum of Philadelphia

179
**Porringer (Thomas Frye
imprint)**
1753–1758, excavated at Head House
Square, Philadelphia, 1963–1964
English porcelain
5 ½″ × 7″ × 2 ½″
Atwater Kent Museum

180
**The Awbury pond and
wetland**
Awbury Arboretum Association
Photograph: Alan Ash

181
**U.S. government World War I
poster**
Lithograph
30″ × 20″
Balch Institute for Ethnic Studies

181
Pierre Auguste Renoir
The Artist's Family
1896
Oil on canvas
68″ × 54″
The Barnes Foundation
Photograph: © 1991 The Barnes
Foundation

182
**A botanist's study, c. 1770
addition to Bartram House**
John Bartram Association

182
**Farmhouse at Colonial
Pennsylvania Plantation**
Bishop's Mill Historical Institute
Photograph: Peter Olson

183
N. C. Wyeth
**Nothing Would Escape Their
Black, Jewel-Like, Inscrutable
Eyes (The Guardians)**
1911
Oil on canvas
118.1 cm × 95.3 cm
Brandywine River Museum
Warner Collection of Gulf States
Paper Corporation, Tuscaloosa, AL

184
Colonial kitchen, Pomona Hall
1726
Camden County Historical Society
Photograph: Peter Olson

185
Soup tureen
c. 1755
Tin-enameled earthenware (faïence)
Campbell Museum
Gift of J. T. Dorrance, Jr.
Acc. no. 1983-1

185
Carpenters' Hall
1770–1774
Photograph: Owen McGoldrick

186
High chest of drawers
1695–1740
Walnut and pine
66 ⅜″ × 41 ⅞″ × 23″
Chester County Historical Society

187
Charles Washington Wright
**Benjamin Franklin, the
Fireman**
c. 1850
Oil on canvas
29 ½″ × 24 ½″
CIGNA Museum and Art Collection
Photograph: Will Brown

187
Thomas Hicks
Meade at Gettysburg
1876
Oil on canvas
95″ × 60″
Civil War Library and Museum

188
Entrance hall
1760s
Cliveden, Inc.
Photograph: John Chew, Jr.

189
John Sloan
Spring Rain
1912
Oil on canvas
20 ¼″ × 26 ¼″
Delaware Art Museum, Wilmington
John Sloan Memorial Foundation

189
Elfreth's Alley
1702–1704
Photograph: Owen McGoldrick

190
Dining room
Built 1926; 1941 addition to original studio
Wharton Esherick Museum

190
**Oval drawing room, Lemon
Hill**
1799
Fairmount Park Council for Historic
Sites
Photograph: Beth Cooper

191
Fairmount Water Works
1812–1872
Photograph: Philadelphia Water
Department

192
**Hand- and horse-drawn
apparatus**
c. 1820–1907
Fireman's Hall

193
Pau Vergos
St. Accursius
Before 1495
Tempera and tooled gold on wood
68″ × 39″ (including frame)
Samuel S. Fleisher Art Memorial
Fleisher Sanctuary

245

CULTURAL CONNECTIONS

213
Larry Francis
Sweet Spring Morning
1986
Oil on canvas
47″ square
Collection of the Noyes Museum
Acc. no. 86.9
Photograph: Will Brown

214
American jacquard coverlet
Late 19th century
Cotton warp; cotton and wool weft
217 cm × 240 cm
Paley Design Center
Acc. no. 74-8-1

215
Governor's parlor, Pennsbury Manor
Reconstruction, 1938–1939
Photograph: Brian R. Tolbert/
BRT Photo

215
Francis Speight
Highland Avenue, Manayunk
1956
Oil on canvas
20⅙″ × 26″
Pennsylvania Academy of the Fine Arts
Gift of James P. and Ruth Marshall Magill
Acc. no. 1957.15.31

216
Library
Pennypacker Mills

217
George F. Wright
Mid-Ocean
1874
Oil on canvas
31″ × 60″
Philadelphia Maritime Museum

217
Pablo Picasso
Three Musicians
1921
Oil on canvas
80″ × 74″
Philadelphia Museum of Art
A. E. Gallatin Collection
Acc. no. 52-61-96

218
Thomas Eakins
Between Rounds
1899
Oil on canvas
50¼″ × 40″
Philadelphia Museum of Art
Given by Mrs. Thomas Eakins and Miss Mary Adeline Williams
Acc. no. '29-184-16

219
"KYW-TV3 Eyewitness News" model set
Please Touch Museum
Photograph: Rick Echelmeyer

219
Anatomy of a Horse
End of 16th century
Bronze
H: 91.5 cm
From the Charles Loeser Collection, Florence
Exhibited 15 October–28 November 1982
Port of History Museum

220
Drawing room, set for tea
Rockwood Museum
Photograph: George Fistrovich

220
Thomas Sully
Rebecca Gratz
1831
Oil on panel
19¾″ × 16¾″
Rosenbach Museum and Library

221
Japanese Buddha in contemplative attitude
c. 11th or 12th century
Carved wood with gold leaf overlay
H: 79″
Ryerss Museum and Library
Photograph: Rick Echelmeyer

222
Parlor with Chippendale chairs
Stenton Manor

222
Art class
Taller Puertorriqueño
Photograph: Rick Echelmeyer

223
Egypto-Roman mummy portrait
c. 150 A.D.
Encaustic painting on wood panel
16″ × 8″
University Gallery, University of Delaware
Acc. no. 58.2.3

224
Head of Ramses II
c. 1290–1224 B.C.
Limestone (restored)
H: 171 cm
The University Museum of Archaeology and Anthropology, University of Pennsylvania
Acc. no. 69-29-1
Photograph: Terry Wild

225
Upsala
1795–1798
Upsala Foundation
Photograph: Owen McGoldrick

226
Wagner Free Institute of Science
Built 1859–1865; remodeled late 1880s
Photograph: Tom Crane

227
Emanuel Leutze
Washington Crossing the Delaware *(copy)*
1852
Oil on canvas
12′5″ × 21′4″
Located in the Visitor Center
Washington Crossing Historic Park

227
Living room
1758
Peter Wentz Farmstead

228
Bedroom, Walt Whitman House
c. 1840
Walt Whitman Association and Library

229
Chinese parlor
The Henry Francis du Pont Winterthur Museum

229
Thomas Anshutz
Summertime
Oil on canvas
72″ × 40″
Woodmere Art Museum

230
Margaret Wistar
Embroidered sconce
1738
Silk yarn stitching on silk satin
17″ × 10⁵⁄₁₆″ × 2″ (shadowbox frame)
Wyck Charitable Trust

231
Bim the orangutan, "World of Primates" exhibit
Zoological Society of Philadelphia
Photograph: Bud Turner

247

249

Author
MORRIS J. VOGEL

Manuscript editor
JANE BARRY

Institutional liaison
JOHN V. ALVITI

Profiles
MARLENE ROBINSON

ANDREW MOSSIN

HENNA R. REMSTEIN

PATRICIA R. ROBBINS

Publisher
DAVID M. BARTLETT

Katz Wheeler Design
JOEL KATZ

ALINA R. WHEELER

ANGIE HURLBUT

ANNETTE CHANG VANDER

MARTHA A. WITTE

DAVID E. SCHPOK

RITA S. COHEN

Production director
CHARLES AULT

Production editor
GABRIELLE GOODMAN

Composition
DUKE & COMPANY

Printing
NISSHA PRINTING COMPANY

*This book was composed in Garamond 3,
Bodoni, and Univers typefaces.
It was printed on Mitsubishi 157.0 gsm
Super Mat Art paper and
bound in Asahi "T" Saifu cloth.*